Matila Ghyka

THE GEOMETRY OF ART AND LIFE

DOVER PUBLICATIONS, INC.
NEW YORK

This Dover edition, first published in 1977, is a
slightly corrected republication of the work first
published by Sheed and Ward, New York, in 1946.

International Standard Book Number: 0-486-23542-4
Library of Congress Catalog Card Number: 77-78586

Manufactured in the United States of America
Dover Publications, Inc.
31 East 2nd Street, Mineola, N.Y. 11501

TO
RODERICK O'CONOR, R.E.

Acknowledgments

Most of the plates in this book are reproduced from *L'Esthetique des Proportions dans la Nature et dans les Arts, Le Nombre d'Or,* and *Essai sur le Rhythme,* by courtesy of the publishers, Gallimard, Paris. Many have been drawn especially for this book. The remaining plates are from the following sources: Plate XXXIII, E. Wasmuth, Berlin; Plate XXXIV, Bibliographisches Institut, Leipzig; Plate XXXV, Wendingen; Plate XXXVIII, Alinari; Plates LI and LII, *The Geometry of the Greek Vase,* by D. Caskey, Yale University Press; Plates LIII, LIV, LV, from *The Diagonal,* Yale University Press; Plates LXVIII, LXXII, The Medici Society; Plates LXIX, LXX, G. Crès, Paris; Plate LXXVIII, Morancé.

Introduction

And it was then that all these kinds of things thus established
received their shapes from the Ordering One, through the
action of Ideas and Numbers.

(Plato, *Timaeus*)

IT IS NOT generally suspected how much the above pronounce-
ment of Plato—or in a more general way, his conception of
Aesthetics—has influenced European (or, let us say, Western)
Thought and Art, especially Architecture. In the same way that
Plato conceived the "Great Ordering One" (or "the One ordering
with Art," ὁ τεχνιτής θεός) as arranging the Cosmos harmoniously
according to the preexisting, eternal, paradigma, archetypes or
ideas, so the Platonic—or rather, neo-Platonic—view of Art con-
ceived the Artist as planning his work of Art according to a pre-
existing system of proportions, as a "symphonic" composition,
ruled by a "dynamic symmetry" corresponding in space to musical
eurhythmy in time. This technique of correlated proportions was
in fact transposed from the Pythagorean conception of musical
harmony: the intervals between notes being measured by the
lengths of the strings of the lyra, not by the frequencies of the
tones (but the result is the same, as length and numbers of vibra-
tions are inversely proportional), so that the chords produce com-
parisons or combinations of ratios, that is, systems of proportions.
In the same way Plato's Aesthetics, his conception of Beauty,
evolved out of Harmony and Rhythm, the role of Numbers
therein, and the final correlation between Beauty and Love,
were also bodily taken from the Pythagorean doctrine, and then
developed by Plato and his School. A great factor in Plato's
Mathematical Philosophy—and, in a subsidiary manner, in his

system of Aesthetics—was the importance given to the five regular bodies and the interplay of proportions which they reveal; we shall see this point of view transmitted all through the Middle Ages to the Renaissance and beyond, with the study, and the application to artistic composition, of the same proportions. The name of the geometrical proportion $\left(\dfrac{a}{b} = \dfrac{c}{d}\right)$ was in Greek, and in Vitruvius, *analogia*; harmoniously ordered or rhythmically repeated proportions or "analogies" introduced "symmetry" and analogical recurrences in all consciously composed plans. Let us point out at once that "symmetry" as defined by Greek and Roman architects as well as the Gothic Master Builders, and by the architects and painters of the Renaissance, from Leonardo to Palladio, is quite different from our modern term symmetry (identical disposition on either side of an axis or plane "of symmetry"). We cannot do better than to give the definition of Vitruvius: "Symmetry resides in the correlation by measurement between the various elements of the plan, and between each of these elements and the whole. . . . As in the human body . . . it proceeds from proportion—the proportion which the Greeks called *analogia*—(it achieves) consonance between every part and the whole. . . . This symmetry is regulated by the modulus, the standard of common measure (belonging to the work considered), which the Greeks called the number. . . . When every important part of the building is thus conveniently set in proportion by the right correlation between height and width, between width and depth, and when all these parts have also their place in the total symmetry of the building, we obtain eurhythmy."

For this notion of symmetry seen as correlating through the interplay of proportions the elements of the parts and of the whole, the Renaissance coined the suggestive words "*commodulatio*" and "*concinnitas*." The mention of eurhythmy as a result of well-applied "symmetry" underlines the affinity between this correct (also etymologically sound) interpretation of symmetry (as opposed to the modern, static meaning usually applied to the

word) and rhythm; an old but correct definition of rhythm was: "Rhythm is in time what symmetry is in space."

This classical meaning of the word "symmetry" has been, with the technique itself, brought into light again within the last thirty years, and will henceforth be used in this work; we will meet later on the expression "dynamic symmetry" found in Plato's *Theaetetus*, and examine the special "eurhythmical" planning system covered by this term. It is also quite recently that, in the field of biology too, it was found that certain morphological intuitions of the Pythagorean and Platonist schools, and their interpretation by the Neo-Platonist thinkers and artists of the Renaissance, are confirmed by modern research. The Pythagorean creed that "Everything is arranged according to Number" (taken up by Plato) [1] is justified not only in Art (it was a Gothic Master Builder who in 1398 said, *"Ars Sine Scientia Nihil"*) but also in the realm of Nature. The use of Geometry in the study and classification of crystals is obvious, but it is only lately that its role in the study of Life and Living Growth has begun to be recognized.[2]

Curiously enough, the patterns, themes of symmetry, spirals, discovered in living forms and living growth, show those same themes of proportion which in Art seem to have been used by Greek and Gothic architects, and, paramount amongst them, the ratio or proportion called by Leonardo's friend Luca Pacioli "the Divine Proportion," by Kepler "one of the two Jewels of Geometry," and commonly known as "The Golden Section," appears to be the principal "invariant" (to use an expression popular in

[1] "Numbers are the highest degree of Knowledge" (*Epinomis*), and "Number is Knowledge itself" (Id.).

[2] Leonardo and Dürer had no doubts about this point. The most important books published in England concerning the Geometry of Life are: *The Curves of Life*, by Sir Theodore Cook (the illustrative material in itself gives the reader complete aesthetic satisfaction); *Lectures on the Principles of Symmetry*, by Professor Jaeger; and *Growth and Form*, by Professor D'Arcy Thompson, a masterly treatise, as suggestive by its plates and diagrams as by its text, lately reprinted by the Cambridge University Press.

modern Mathematical Physics), as remarkable by its algebraical and geometrical properties as by this role in Biology and in Aesthetics. There are then such things as "The Mathematics of Life" and "The Mathematics of Art," and the two coincide. The present work tries to present in a condensed form what we may call a "Geometry of Art and Life."

Contents

xiii

CHAPTER V

CHAPTER VI

CHAPTER VII

CHAPTER VIII

CHAPTER IX

List of Plates

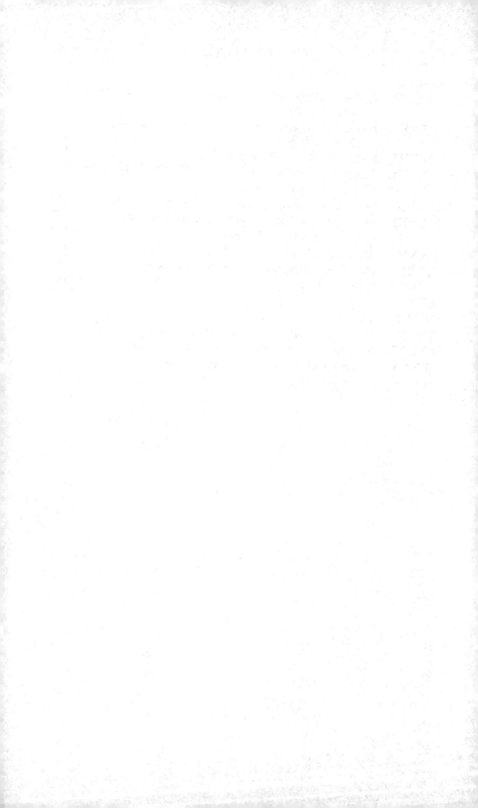

CHAPTER I

Proportion in Space and Time

THE NOTION of proportion is, in logic as well as in Aesthetics, one of the most elementary, most important, and most difficult to sort out with precision; it is either confused with the notion of *ratio*, which comes logically before it, or (especially when talking of proportions in the plural) with the notion of a chain of characteristic ratios linked together by a *modulus*, a common sub-multiple; we have then the more complex concept which the Greeks and Vitruvius called *"Symmetria,"* and the Renaissance architects, *"Commodulatio."* Let us start from the definition of ratio.

RATIO

The mental operation [1] producing "ratio" is the *quantitative comparison* between two things or aggregates belonging to the same kind or species. If we are dealing with segments of straight lines, the ratio between two segments AC and CB will be symbolized by $\frac{AC}{CB}$, or $\frac{a}{b}$ if a and b are the lengths of these segments measured with the same unit. This ratio $\frac{a}{b}$, which has not only the appearance but all the properties of a fraction, is also the measure of the segment AC = a if CB = b is taken as unit of length.

[1] This comparison of which a *ratio* is the result is a particular case of *judgment* in general, of the typical operation performed by intelligence. Judgment consists of: (1) perceiving a functional relation or a hierarchy of values between two or several objects of knowledge; and (2) discerning the relation, making a comparison of values, qualitative or quantitative. When this comparison produces a definite measuring, a quantitative "weighing," the result is a *ratio*.

1

GEOMETRICAL PROPORTION

The notion of proportion follows immediately that of ratio. To quote Euclid:

"Proportion is the equality of two ratios." If we have established two ratios $\frac{A}{B}, \frac{C}{D}$, between the two "magnitudes" (comparable objects or quantities) A and B on one side, and the two magnitudes C and D on the other, the equality $\frac{A}{B} = \frac{C}{D}$ (A is to B as C is to D) means that the four magnitudes A, B, C, D are connected by a *proportion*. If A, B, C, D are segments of straight lines measured by the lengths a, b, c, d, we have between these measurements, these numbers, the equality $\frac{a}{b} = \frac{c}{d}$; this is the *geometrical proportion*, called discontinuous in the general case when a, b, c, d, are different, and continuous geometrical proportion if two of these numbers are identical. The typical continuous proportion is therefore $\frac{a}{b} = \frac{b}{c}$, or $b^2 = ac$.

$b = \sqrt{ac}$ is called the proportional or geometrical mean between a and c. It is the geometrical proportion, discontinuous or continuous, which is generally used or mentioned in Aesthetics, specially in architecture.

The equation of proportion can have any number of terms, $\frac{a}{b} = \frac{c}{d} = \frac{e}{f} = \frac{h}{g}$, et cetera, or $\frac{a}{b} = \frac{b}{c} = \frac{c}{d} = \frac{d}{e}$, et cetera; we have always the *permanency* of a *characteristic ratio* (this explains why the notions of ratio and proportion are often confused, but the concept of proportion introduces besides the simple comparison or measurement the idea of a new permanent quality, which is transmitted from one ratio to the other; it is this *analogical invariant* which besides the measurement brings an ordering principle, a relation between the different magnitudes and their measures). The second series of equalities $\frac{a}{b} = \frac{b}{c} = \frac{c}{d} = \frac{d}{e}$, et cet-

era, represents the characteristic continuous proportion, geometrical progression or series, like 1, 2, 4, 8, 16, 32, et cetera.

The simplest asymmetrical section and the corresponding continuous proportion: The Golden Section.

The Golden Section.—The Greeks had already noticed that three terms at least are necessary in order to express a proportion; [1] such is the case of the continuous proportion $\frac{a}{b} = \frac{b}{c}$. But we can try to obtain a greater simplification by reducing to two the number of the terms, and making $c = a + b$. So that (if for example a and b are the two segments of a straight line of length c) the continuous proportion becomes: $\frac{a}{b} = \frac{b}{a+b}$ or $\left(\frac{b}{a}\right)^2 = \left(\frac{b}{a}\right) + 1$.

If one makes $\frac{b}{a} = x$, one sees that x, positive root of the equation $x^2 = x + 1$, is equal to $\frac{1 + \sqrt{5}}{2}$ (the other, negative, root being $\frac{1 - \sqrt{5}}{2}$). [2] This is the ratio known as "Golden Section";

[1] Cf. Plato, *Timaeus:* "But it is impossible to combine satisfactorily two things without a third one: we must have between them a correlating link. . . . Such is the nature of proportion . . ."

[2] There is another way of finding the Golden Section as the most logical asymmetrical division of a line AB into two segments AC and CB; if we call a, b, c, the respective lengths of AC, CB, AB, measured in any system of units, we get 6 different possible ratios: $\frac{a}{b}, \frac{a}{c}, \frac{b}{a}, \frac{b}{c}, \frac{c}{a}, \frac{c}{b}$; then the simplest possible proportions are obtained by applying here also "Ockham's Razor" and writing that any two of these ratios are equal; the fifteen possible combinations are reduced to the symmetrical division $a = b$, and the asymmetrical ones $\frac{a}{b} = \frac{c}{a}$ (a = AC being the longest of the two segments of AB) and $\frac{b}{a} = \frac{c}{b}$ (b = CB being the longest segment) which leads again to the equation of the Golden Section $x^2 = x + 1$ and the two roots $\frac{1 + \sqrt{5}}{2}$ and $\frac{1 - \sqrt{5}}{2}$.

when it exists between the two parts of a whole (here the segments a and b, the sum of which equals the segment c) it determines between the whole and its two parts a proportion such that "the ratio between the greater and the smaller part is equal to the ratio between the whole and the greater part."

This proportion, called in the text-books "division into mean and extreme ratio," has got, as we will see in the next chapter, the most remarkable algebraical properties. The Greek geometers of the Platonic school called it ἡ τομή, "the section" *par excellence,* as reported by Proclus (*On Euclid*); Luca Pacioli, Leonardo's friend, called it "The Divine Proportion."

GENERALISATION OF THE CONCEPT OF PROPORTION

The geometrical proportion (resulting from the equality between two or several ratios) is only a particular case of a more general concept, which is "a combination or relation between two or several ratios."

The more usual proportions, besides the geometrical, are: (1) The arithmetic proportion in which the middle term (if we take the minimum of three terms for a proportion) overlaps the first term by a quantity equal to that by which it is itself overlapped by the last term, or (if a, b, c, are the three terms) $\frac{c-b}{b-a} = 1$ (example: 1, 2, 3) and (2) the harmonic proportion, in which the middle term overlaps the first one by a fraction of the latter equal to the fraction of the last term by which the last term overlaps it, or $b - a = (c - b)\frac{a}{c}$ equivalent to $\frac{c-b}{b-a} = \frac{c}{a}$ (example: 2, 3, 6 or 6, 8, 12).

There are in all ten terms of proportions, established by the neo-Pythagorean School.

	Example			*Example*	
$\frac{c-b}{b-a} = \frac{c}{c}$	(1,2,3)	...arithmetic proportion	$\frac{c-b}{b-a} = \frac{c}{a}$	(2,3,6)	...harmonic proportion
$\frac{c-b}{b-a} = \frac{c}{b}$	(1,2,4)	...geometrical proportion	$\frac{b-a}{c-b} = \frac{c}{a}$	(3,5,6)	

Example

$$\frac{b-a}{c-b} = \frac{b}{a} \quad (2,4,5)$$

$$\frac{b-a}{c-b} = \frac{c}{b} \cdot \quad (1,4,6)$$

$$\frac{c-a}{b-a} = \frac{c}{a} \quad (6,8,9)$$

Example

$$\frac{c-a}{c-b} = \frac{c}{a} \quad (6,7,9)$$

$$\frac{c-a}{b-a} = \frac{b}{a} \quad (4,6,7)$$

$$\frac{c-a}{c-b} = \frac{b}{a} \quad (3,5,8)\ldots\text{Fibonacci series}$$

The tenth corresponds to the additive series 1, 1, 2, 3, 5, 8, 13, 21, 34, 55, . . . et cetera, in which each term is equal to the sum of the two preceding ones; it is intimately connected with the Golden Section and plays an eminent role in Botany. We will meet it again in the next chapter.

We have seen in the Introduction that the technique by which, in a complex plan or design, the proportions were linked so as to get the right correlation (or "commodulation") between the whole and its parts was called by the Greek architects and Vitruvius "Symmetry"; and the result obtained where this technique was correctly applied was the "eurhythmy" of the design and of the building. We generally associate the terms of "rhythm" and "eurhythmy" with the Arts working in the time dimension (Poetry and Music) and the notion of Proportion with the "Arts of Space" (Architecture, Painting, Decorative Art). The Greeks did not care for these distinctions; for them, for Plato in particular, Rhythm was a most general concept dominating not only Aesthetics but also Psychology and Metaphysics. And Rhythm and Number were one.[1] (*Rhythmos* and *Arithmos* had the same root: rheîn = to flow.)

For them, indeed, Architecture was not only "Frozen Music"

[1] "Everything is arranged according to Number" was the condensation of the Pythagorean doctrine. And Plato, who developed Pythagoras' Aesthetics of Number into the Aesthetics of Proportion, wrote in his *Epinomis*: "Numbers are the highest degree of knowledge" and: "Number is knowledge itself." Plato (*Timaeus*) mentions the concordance between the rhythm of the harmoniously balanced soul and the rhythm of the Universe; he even establishes in one of his mathematical puzzles (in the *Timaeus* again) what he calls the "Number of the World-Soul," a super-scale of thirty-six notes based, of course, on his theory of proportions.

(Schelling) but living Music. The notions of periodicity and proportion, and their interplay, can be used for succession in time as well as for spatial associations. If periodicity (static like a regular beat, or dynamic) is the characteristic of rhythm in time, and proportion the characteristic of what we may call rhythm or eurhythmy in space, it is obvious that in space, combinations of proportions can bring periodical reappearances of proportions and shapes, just as in a musical chord or in the successive notes or chords of a melody we may really perceive an interplay of proportions.[1]

If Architecture is petrified or frozen Music, so is Music "Drawing in Time."[2] But we will, in what follows, leave aside the "numbers" of Music and Poetry in order to elucidate how the Greek and Gothic Master Builders applied their knowledge of proportion and "Symmetry," and how and where their Geometry of Art meets the Geometry of Life.

[1] Here are three definitions of Rhythm:

(1) Rhythm is a succession of phenomena which are produced at intervals, either constant or variable, but regulated by a law. (Francis Warrain)

(2) Rhythm is perceived periodicity. It acts to the extent to which such a periodicity alters in us the habitual flow of time. . . . (Pius Servien)

(3) Rhythm is this property of a succession of events which produces on the mind of the observer the impression of a proportion between the duration of the different events or groups of events of which the succession is composed. (Professor Sonnenschein)

Although the authors of these three distinct but excellent definitions are here thinking of Rhythm in time, we see how even in that temporal frame, proportion can play its part. To sum up: there *are* proportions in time, and rhythm in space, and one could say, to cover both fields, that "Rhythm is produced by the dynamic action of Proportion on a uniform (static) beat or recurrence."

[2] Or, to quote Francis Warrain: *"La Musique est au Temps ce que la Géométrie est à l'Espace."*

The Golden Section

THE "GOLDEN SECTION," the geometrical proportion defined in the preceding chapter, $\frac{1 + \sqrt{5}}{2} = 1.618\ldots$ positive root of the equation $x^2 = x + 1$, has a certain number of algebraical and geometrical properties which make it the most remarkable algebraical number, in the same way as π (the ratio between any circumference and its diameter) and $e = \lim \left(1 + \frac{1}{n}\right)^n$ are the most remarkable transcendent numbers.

If, to follow Sir Theodore Cook's example (in *The Curves of Life*) we call this number, or ratio, or proportion Φ, we have the following equalities:

$$\Phi = \frac{\sqrt{5} + 1}{2} = 1.61803398875\ldots\text{(so that 1.618 is a very accurate approximation)}$$

$$\Phi^2 = 2.618\ldots = \frac{\sqrt{5} + 3}{2}$$

$$\frac{1}{\Phi} = 0.618\ldots = \frac{\sqrt{5} - 1}{2}$$

$$\Phi^2 = \Phi + 1 \qquad \Phi^3 = \Phi^2 + \Phi \text{ and more generally}$$

$$\Phi^n = \Phi^{n-1} + \Phi^{n-2}$$

(this applies also to negative exponents so that:

$$\Phi = 1 + \frac{1}{\Phi}, \text{ or } \Phi^1 = \Phi^0 + \Phi^{-1},$$

$$\Phi^{-2} = \Phi^{-3} + \Phi^{-4}, \text{ or } \frac{1}{\Phi^2} = \frac{1}{\Phi^3} + \frac{1}{\Phi^4}, \text{ et cetera).}$$

7

We have also $2 = \Phi + \dfrac{1}{\Phi^2}$ and $\Phi = \dfrac{1}{\Phi - 1}$

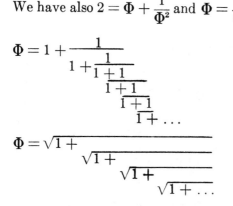

$$\Phi = 1 + \cfrac{1}{1 + \cfrac{1}{1 + \cfrac{1}{1 + \cfrac{1}{1 + \ldots}}}}$$

$$\Phi = \sqrt{1 + \sqrt{1 + \sqrt{1 + \sqrt{1 + \ldots}}}}$$

In the geometrical progression or series 1, Φ, Φ^2, Φ^3,..., Φ^n..... each term is the sum of the two preceding ones; this property of being at the same time additive and geometrical is characteristic of this series and is one of the reasons for its rôle in the growth of living organisms, specially in botany.

In the diminishing series 1, $\dfrac{1}{\Phi}$, $\dfrac{1}{\Phi^2}$, $\dfrac{1}{\Phi^3}$, $\dfrac{1}{\Phi^m}$, we have $\dfrac{1}{\Phi^m} = \dfrac{1}{\Phi^{m+1}} - \dfrac{1}{\Phi^{m+2}}$ (each term is the sum of the two following ones) and: $\Phi = \dfrac{1}{\Phi} + \dfrac{1}{\Phi^2} + \dfrac{1}{\Phi^3} + \ldots + \dfrac{1}{\Phi^m} + \ldots$, when m grows indefinitely.

The rigorous geometrical construction of the ratio or proportion of Φ is very simple, because of its value $\dfrac{1 + \sqrt{5}}{2}$. Figures 1 and 2 show how, starting from the greater segment AB, to construct the smaller segment BC such that $\dfrac{AB}{BC} = \Phi$, and how inversely, starting from the whole segment AC, to place the point B dividing it into the two segments AB and BC related by the golden section ratio (another construction in Figure 3). This most "logical" asymmetrical division of a line, or of a surface, is also the most satisfactory to the eye; this has been tested by

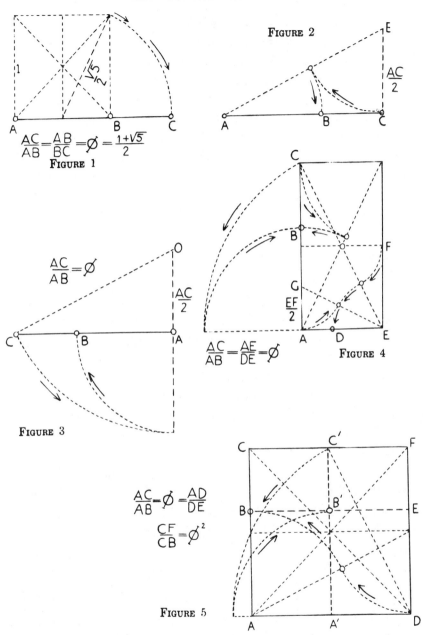

$$\frac{AC}{AB}=\frac{AB}{BC}=\emptyset=\frac{1+\sqrt{5}}{2}$$

FIGURE 1

FIGURE 2

$$\frac{AC}{2}$$

$$\frac{AC}{AB}=\emptyset$$

$$\frac{AC}{2}$$

FIGURE 3

$$\frac{AC}{AB}=\frac{AE}{DE}=\emptyset$$

$$\frac{EF}{2}$$

FIGURE 4

$$\frac{AC}{AB}=\emptyset=\frac{AD}{DE}$$

$$\frac{CF}{CB}=\emptyset^{2}$$

FIGURE 5

Fechner (in 1876) for the "golden rectangle," for which the ratio between the longer and the shorter side is $\Phi = 1.618\ldots\ldots$ In a sort of "Gallup Poll' asking a great number of participants to choose the most (aesthetically) pleasant rectangle, this golden rectangle or Φ rectangle obtained the great majority of votes. This rectangle (Figure 6) has also the unique property that if we construct a square on its smaller side (the *minor* term of the Φ ratio), the smaller rectangle aBCd formed outside this square in the original rectangle is also a Φ rectangle, similar to the first. This operation can be repeated indefinitely, getting thus smaller and smaller squares, and smaller and smaller golden rectangles [1] (the surfaces of the squares and the surfaces of the rectangles forming geometrical diminishing progressions of ratio $\dfrac{1}{\Phi^2}$), as in Figure 7. Even without actually drawing the square, this operation and the continuous proportions characteristic of the series of correlated segments and surfaces are subconsciously suggested to the eye; the same kind of suggestion operates in the simple case of a straight line divided into two segments according to the golden section, or when three horizontal lines are separated by intervals obeying this proportion (Figure 9; for example, the horizon between the upper and lower bar of the frame in a painted seascape). Professor Timerding sums up this subconscious operation and the resulting aesthetic satisfaction in the short sentence: ". . . . the reassuring impression given by what remains similar to itself in the diversity of evolution." We shall

[1] The simplest method for obtaining a similar rectangle inside a given rectangle is to draw a diagonal of the latter one, and from one of the remaining vertices a perpendicular to the diagonal. In Figure 8 this construction is shown on the Φ rectangle. J. Hambidge, whose theory of "dynamic rectangles" is explained in Chapter VIII, calls the similar smaller rectangle, thus produced in the original one, his "reciprocal rectangle." The other rectangle, formed within the original one, can be called, to borrow Sir D'Arcy Thomson's terminology (inspired itself by the Greek theory of figurate numbers), the *gnomon* of the reciprocal rectangle—the gnomon being the smallest surface which, added to a given surface, produces a similar surface. The Φ or golden rectangle is the only rectangle the gnomon of which is a square.

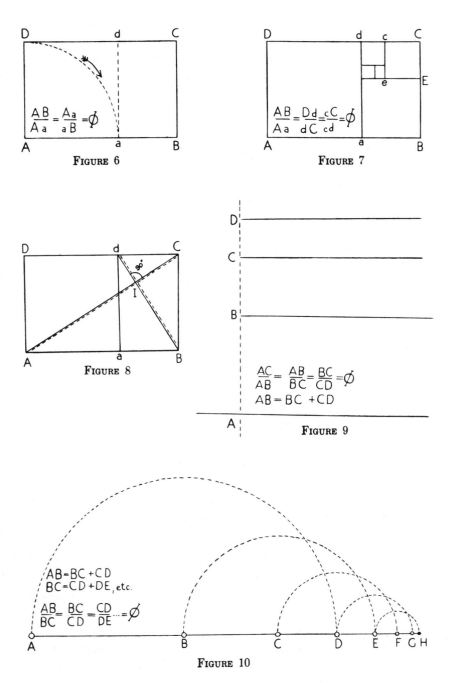

$$\frac{AB}{Aa} = \frac{Aa}{aB} = \phi$$

FIGURE 6

$$\frac{AB}{Aa} = \frac{Dd}{dC} = \frac{cC}{cd} = \phi$$

FIGURE 7

FIGURE 8

$$\frac{AC}{AB} = \frac{AB}{BC} = \frac{BC}{CD} = \phi$$
$$AB = BC + CD$$

FIGURE 9

$$AB = BC + CD$$
$$BC = CD + DE, \text{etc.}$$

$$\frac{AB}{BC} = \frac{BC}{CD} = \frac{CD}{DE} \cdots = \phi$$

FIGURE 10

see in another chapter that this is but a particular case of a very general aesthetic law, the "Principle of Analogy." [1]

The principle applies whenever in a design the presence of a characteristic proportion or of a chain of related proportions (this is an imported notion which will be illustrated later on) produces the recurrence of similar shapes, but the subconscious suggestion mentioned above is specially associated with the Golden Section because of the property of any geometrical progression of ratio Φ or $\frac{1}{\Phi}$ (like a, aΦ, aΦ^2, aΦ^3, aΦ^n, . . ., or a, $\frac{a}{\Phi}$, $\frac{a}{\Phi^2}$, $\frac{a}{\Phi^3}$,, $\frac{a}{\Phi^n}$,) of having each term equal to the sum of the two preceding ones or (respectively) of the two following ones. To this particularity (which combines the properties of additive and multiplicative, geometrical, series) corresponds the geometrical illustration of the progression; that is: a series of straight segments with lengths proportional to the terms of this series can be constructed by additions or subtractions of segments, by simple moves of the compass. On Figure 10 (a diminishing series of segments, with ratio $\frac{1}{\Phi}$, having the unit of measure as first term) we see how out of the first two terms the whole series may be thus obtained; we see also how this progression or continuous proportion combines the most important asymmetrical division or cut with the symmetrical division into two equal parts (AB = BC + CD, et cetera).

To quote Timerding again: "The golden section therefore imposes itself whenever we want by a new subdivision to make two equal consecutive parts or segments fit into a geometric progression, combining thus the threefold effect of equipartition, succession, continuous proportion; the use of the golden section being only a particular case of a more general rule, the recurrence of the same proportions in the elements of a whole." The Sym-

[1] Figures 4 and 5 show the construction of the Golden Section or Φ ratio on the sides of the double-square and of the square (the square is thus divided into two rectangles having Φ and Φ^2 as characteristic proportions).

metria-producing *analogia* of Vitruvius. It is this property of producing, by simple additions, a succession of numbers in geometrical progression, or of similar shapes (what Sir D'Arcy Thompson called "gnomonic growth") which explains the important rôle played by the Golden Section and the Φ series in the morphology of life and growth, especially in the human body and in botany.

We must here introduce another additive series which is very nearly related to the Φ progression; it is the series:
1, 1, 2, 3, 5, 8, 13, 21, 34, 55, 89, 144,......, in which, starting from 1, each element is (as in the Φ series) equal to the sum of the two preceding ones. The ratio of two consecutive terms tends to approximate very quickly to the "Golden Section" $\Phi = 1.618.....$, by values alternatively greater and smaller than

$$\Phi \left(\frac{8}{5} = 1.6 \quad \frac{13}{8} = 1.625 \quad \frac{21}{13} = 1.6154... \quad \frac{34}{21} = 1.619... \quad \frac{55}{34} = \right.$$
$$\left. 1.6176..., \quad \frac{89}{55} = 1.61818... \right).$$

We can therefore say that this "two-beat" additive series 1, 1, 2, 3, 5, 8, 13, 21,..., et cetera, called the series of Fibonacci (from the nickname, *Filius Bonacci*, of Leonardo of Pisa who rediscovered it in 1202) tends asymptotically towards the Φ progression with which it identifies itself very quickly; and it has also the remarkable property of producing "gnomonic growth" [1] (in which the growing surface or volume remains homothetic, similar to itself) by a simple process of accretion of discrete elements, of integer multiples of the unit of accretion, hence the capital rôle in botany of the Fibonacci series. For example, the fractionary series

$$\frac{1}{1}, \frac{1}{2}, \frac{2}{3}, \frac{3}{5}, \frac{5}{8}, \frac{8}{13}, \frac{13}{21}, \frac{21}{34}, \frac{34}{55}, \frac{55}{89}, \frac{89}{144}, \cdots \quad [2]$$

[1] Or rather, quasi-gnomonic, as here the process is only an approximation. But, as we have seen, the approximation becomes so quickly rigorous that we obtain practically a geometric progression.

[2] Here each fraction has as numerator the denominator of the preceding one and as denominator the sum of the two terms, numerator and denominator, of the preceding one.

appears continually in phyllotaxis (the section of botany dealing with the distribution of branches, leaves, seeds), specially in the arrangements of seeds. A classical example is shown in the two series of intersecting curves appearing in a ripe sunflower (the ratios $\dfrac{13}{21}$, $\dfrac{21}{34}$, $\dfrac{34}{55}$, or $\dfrac{89}{144}$ appear here, the latter for the best variety.) The ratios $\dfrac{5}{8}$, $\dfrac{8}{13}$, appear in the seed-cones of fir-trees, the ratio $\dfrac{21}{34}$ in normal daisies.

If we consider the disposition of leaves round the stems of plants, we will find that the characteristic angles or divergencies [1] are generally found in the series

$$\frac{1}{2}, \frac{1}{3}, \frac{2}{5}, \frac{3}{8}, \frac{5}{13}, \frac{8}{21}, \frac{13}{34}, \frac{21}{55}, \cdots$$

The reason for the appearance in botany of the golden section and the related Fibonacci series is to be found not only in the fact that the Φ series and the Fibonacci series [2] are the only ones which by simple accretion, by additive steps, can produce a "gnomonic," homothetic, growth (we will see that these growths, where the shapes have to remain similar, have always a logarithmic·spiral as directing curve), but also in the fact that the "ideal angle" (constant angle between leaves or branches on a stem producing the maximum exposition to vertical light) is given by

$$\frac{\alpha}{\beta} = \frac{\beta}{\alpha + \beta}, \quad \alpha + \beta = 360°;$$ one sees that β divides the angular cir-

[1] If we develop round the stem an helix passing through the intersection points of the leaves, we will after some time meet a leaf situated exactly over the first leaf. If n is the number of leaves passed on the way, and p the number of turns (complete circles in projection) made around the stem, then $\dfrac{p}{n}$ is the divergency (or angle of divergency), constant in the same plant.

[2] The Fibonacci series is only a particular case of the general "two-beat" additional series a, b, (a + b), b + (a + b), b + 2 (a + b), 2b + 3 (a + b), 3b + 5 (a + b),..., or a, b, a + b, a + 2b, 2a + 3b, 3a + 5b, 5a + 8b,, where the ratio between two consecutive terms has also Φ for limit. It is also identical to the tenth type of proportion of the Pythagoreans (Chapter I).

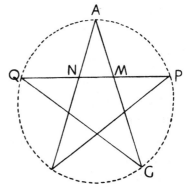

FIGURE 11

FIGURE 12

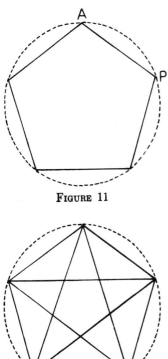

FIGURE 13

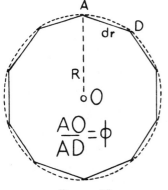

FIGURE 14

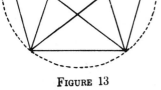

$$\frac{AO}{AD} = \phi$$

FIGURE 15

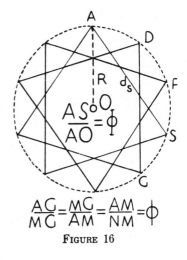

$$\frac{AS}{AO} = \phi$$

$$\frac{AG}{MG} = \frac{MG}{AM} = \frac{AM}{NM} = \phi$$

FIGURE 16

cumference (360°) according to the golden section. $\beta = \dfrac{360°}{\Phi}$ $= 220° \; 29' \; 32''$; $\alpha = \dfrac{\beta}{\Phi} = 137° \; 30' \; 27'' \; 95$. The name of "ideal angle" was given to α by Church, who first discovered that it corresponds to the best distribution of the leaves; the mathematical confirmation was given by Wiesner in 1875.

The Golden Section also plays a dominating part in the proportions of the human body, a fact which was probably recognized by the Greek sculptors, who liked to put into evidence a paralellism between the proportions of the ideal temple and of the human body (cf. Vitruvius), or even to trace a harmonious correspondence (a proportion or *analogia*, in fact) between the terms Universe-Temple-Man. The correlation Universe-Man as macrocosmos-microcosmos was studied later on by the Kabbala as well as by the Christian mystics of the Middle Ages, and by later dabblers in white and black magic. The bones of the fingers form a diminishing series of three terms, a continuous proportion 1, $\dfrac{1}{\Phi}$, $\dfrac{1}{\Phi^2}$, (in which the first, longest term, is equal to the sum of the two following ones), but the most important appearance of the golden section is in the ratio of the total height to the (vertical) height of the navel; this in a well-built body is always $\Phi = 1,618 \ldots$ or a near approximation like $\dfrac{8}{5} = 1,6$ or $\dfrac{13}{8} = 1,625$. One can, in fact, state that if one measures this ratio for a great number of male and female bodies, the average ratio obtained will be 1.618. It is probable that the famous canon of Polycletes (of which his "Doryphoros" was supposed to be an example), was based on this dominant rôle of the golden section in the proportions of the human body; this rôle was rediscovered about 1850 by Zeysing, who also recognized its importance in the morphology of the animal world in general, in botany, in Greek Architecture (Parthenon) and in music. The American Jay Hambidge (his first results were published in 1919), guided by a line in Plato's

Theaetetus about "dynamic symmetry," established carefully
the proportions and probable designs not only of many Greek
temples and of the best Greek vases in the Boston Museum, but
also measured hundreds of skeletons, including "ideal" specimens
from American medical colleges, and confirmed Zeysing's results,
but with the following precisions:

A rigorous, mathematical interplay of proportions based on
the Golden Section or directly related proportions (especially
those produced by the $\sqrt{5}$ and Φ; we know that $\Phi = \dfrac{\sqrt{5}+1}{2}$)
is shown by any normal human skeleton (in the living body the
presence of skin, hair, introduces millimetrical deviations). In
the most healthy specimens this interplay of proportions shows
a really "symphonic" subtlety, the geometrical diagrams being
often the same as exhibited by Greek temples, vases, mirrors.

The purely geometrical properties of the Golden Section intro-
duce another unexpected reason for its preponderance in botany
and in living organisms in general; as could be suspected from
the formula $\Phi = \dfrac{\sqrt{5}+1}{2}$, this proportion is intimately associated
with the regular pentagon and with the regular star-pentagon or
pentagram, so much so that the construction of the pentagon
(Figures 17 and 18), discovered by the Pythagoreans and given
by Euclid, is directly based on the Golden Section and on the
formula:

$$p_r \text{ side of regular pentagon} = \frac{R}{2}\sqrt{10 - 2\sqrt{5}}.$$

(In Figure 17, AP is the side of the pentagon, AD the side
of the regular decagon, A'S' that of the star-decagon). If we call:
p_s the side of the star-pentagon, or pentagram, (AG = A'S'), d_r
the side of the regular decagon, d_s the side of the star-decagon,
R (as above) the radius of the circumscribed circle, we have
$p_s = \dfrac{R}{2}\sqrt{10 + 2\sqrt{5}}$ and $\dfrac{ps}{pr} = \Phi$; this very important relation
between the diagonal of the regular pentagon and its side shows

FIGURE 17 FIGURE 18

us the intimate relation between the Golden Section, the pentagon, and pentagonal symmetry in general (Figures 12 and 14).

We have also $d_r = \dfrac{R}{\Phi}$, $ds = R.\Phi$ (the side of the regular decagon, the radius of the circumscribed circle, and the side of the star-decagon form a Φ progression of three terms).

And because of this connection between the Golden Series or Φ series, the Fibonacci Series, and homothetic growth, and between the Golden Section and the pentagon, we shall not be surprised to see the preponderance of pentagonal symmetry in living organisms, especially in botany [1] and amongst marine animals (starfishes, jellyfishes, sea-urchins).

The pentadactylism (five fingers, or corresponding bones or cartilages) general in the animal kingdom is a manifestation of the same predominance of the number 5 and pentagonal sym-

[1] Let us note among five-petalled flowers (the number of petals can here also be 10 or any multiple of 5) all fruit-blossoms, water-lilies, brier-roses and all the genus *rosa*, honeysuckle, carnations, geraniums, primroses, marshmallows, campanulas, passion-flowers, et cetera.

Lilies, tulips and hyacinths, on the contrary, show the hexagonal symmetry which we will see is mainly connected with crystals.

metry. We will see in another chapter that this predominance is indeed a characteristic of living forms and living growth, and that pentagonal forms or lattices do not, can not, appear among crystals.

CHAPTER III

Geometrical Shapes on the Plane

IF N POINTS are given in a plane, such that no straight line meets more than two of them, and if we draw all the straight lines joining two of these points together so that two lines (and two only) meet in each point (instead of the n − 1 possible ones), we obtain all the possible types of polygons with n vertices, numbering $\frac{(n-1)!}{2}$. The polygons having equal sides and equal angles at the vertices are called regular; they can be inscribed into a circumference. If α, β, γ . . . are the prime factors of n (n = αp, βq, γr . . .) the number m of regular polygons with n sides is

$$m = \frac{n}{2}\left(1 - \frac{1}{\alpha}\right) \cdot \left(1 - \frac{1}{\beta}\right) \cdot \left(1 - \frac{1}{\gamma}\right) \ldots$$

If n is a prime number, α = n, $m = \frac{n-1}{2}$. For each value of n, we have one regular convex polygon; the other are star-polygons. So that there are

1 star-pentagon
2 star-heptagons
1 star-octagon
2 star-enneagons (9 sides)
1 star-decagon, et cetera.

One sees immediately that the number of regular convex polygons is infinite, as n can take any integer value.

Gauss proved that a regular convex polygon of n sides can be constructed with compass and rule (in an "euclidian" manner). if (and only if):

(1) n = 2p (p being any integer)

20

(2) n is a prime number of the type $n = 2^k + 1$;[1] or

(3) if n is a product of different factors of that type, that is, if $n = 2^p . (2^k + 1) . (2^r + 1)\ldots\ldots, 2^k + 1, 2^r + 1,\ldots\ldots$ being *distinct* prime numbers (the enneagon, $n = 9 = 3 \times 3$, or the polygon with 18 sides, $n = 18 = 2 \times 3 \times 3$, cannot be constructed rigorously, because $3 = 2^1 + 1$ is repeated twice). From Gauss' theorem it follows that we can construct rigorously the regular polygons of 3, 4, 5, 6, 8, 10, 12, 15, 16, 17, 20, 24,....sides[1] (that is, we can divide a circumference into the corresponding numbers of equal segments), but that we cannot construct those with 7, 9, 11, 13, 14, 18, 19, 21, 22, 23, 25,.....sides. It is therefore impossible to construct exactly a regular convex polygon with seven sides (heptagon), or to divide a circumference in seven equal parts;[2] so that the heptagon is very rarely used in architectural plans (Viollet-le-Duc mentions one Romanesque pillar in Rheims with heptagonal base, and Notre-Dame shows an heptagonal stained-glass rose).[3]

We will examine here the most remarkable of the regular polygons and some of their irregular cousins.

[1] In this case we have always $k = 2^q$; but the inverse is not true; $n = 2^{2q} + 1$ is not always a prime number. For instance, n is prime for.

q = 0	n = 3
q = 1	n = 5
q = 2	n = 17
q = 3	n = 257
q = 4	n = 65,537

but not for q = 5, 6, 7, 9, 11, 12, 18, 23, 36, 38, 73.

[1] The theorem of Gauss derives from the fact that the roots of the equation $x^n - 1 = 0$ can be represented by a combination of square roots when (and only when) one of the conditions above is fulfilled.

[2] In Pythagorean Number-Mystic, seven was the Virgin-Number.

[3] We have seen that in theory the regular polygons with 257 and 65,537 sides can be constructed rigorously, as both numbers are prime-numbers of the type $2^k + 1$. This has been done not only for the 257-gon (by Richelot in 1832), but even for the one with 65,537 sides (in 1894), by Professor Hermes of Göttingen, who spent ten years in studying this formidable geometrical entity.

TRIANGLES

In the equilateral triangle (Figure 19) having angles of 60° at its three vertices:

If t be the side of this triangle, R the radius of the circumscribed circle, we have $R = \dfrac{t\sqrt{3}}{3}$.

S (the surface of the triangle) is $\dfrac{t^2\sqrt{3}}{4}$.

The most important of the non-equilateral triangles are:

(1) The right-angled triangle with sides proportional to 3, 4 and 5 (Figure 20) already known to the ancient Egyptians; it enabled them (and later the Greeks) to draw a right angle on the ground with a rope knotted at intervals of 3, 4 and 5 equal units.[1] This triangle is also the only (right-angled) one having its sides in an arithmetical progression. It is sometimes called the sacred triangle of Pythagoras, or of Plutarch.

(2) The "Great Pyramid" right-angled triangle, or triangle of Price (W. A. Price noticed that the meridian section of the Great Pyramid was formed of two such triangles having in common the greater of the right-angle sides)[2] which has its sides proportional to 1, $\sqrt{\Phi} = 1.273\ldots$ and $\Phi = 1.618\ldots$ (Φ being the "Golden Section" ratio). This triangle can be derived from the "Golden" rectangle (OPQM, having Φ as ratio between the longer and the shorter side) by the simple construction shown in

[1] The rope was actually divided in twelve units, and knotted at intervals $\dfrac{3}{12}, \dfrac{4}{12}, \dfrac{5}{12}$. The Persian (Achemenid and Sassanid) architects made use of this triangle to establish the profile of their elliptic domes (Figure 21).

[2] The specifications of the Great Pyramid (Howard Vyse) are:

Height OS 148m,2 (Figure 23)
AB Side of base-square 232m,8

$$OM = \frac{232,8}{2} = 116,4 \qquad \frac{148,2}{116,4} = 1.273 = \sqrt{\Phi}$$

(we have $1.273 \times 1.273 = 1.618 = \Phi$).

The angle SMO, measured by Howard Vyse on the Great Pyramid, is 51°50′, which is exactly the value of the corresponding angle in the triangle 1, $\sqrt{\Phi}$, Φ.

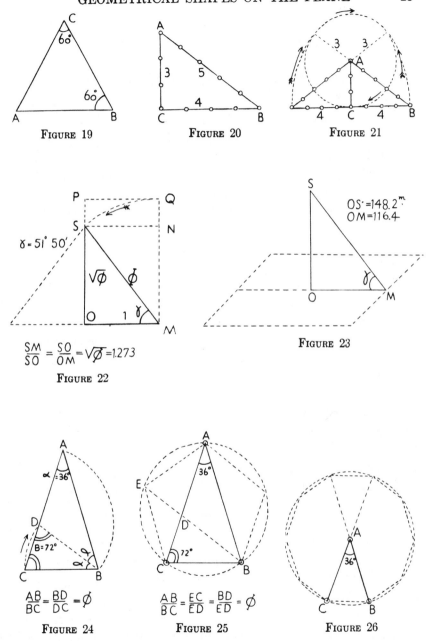

FIGURE 19

FIGURE 20

FIGURE 21

$$\frac{SM}{SO} = \frac{SO}{OM} = \sqrt{\phi} = 1.273$$

FIGURE 22

$$OS = 148.2^m$$
$$OM = 116.4$$

FIGURE 23

$$\frac{AB}{BC} = \frac{BD}{DC} = \phi$$

FIGURE 24

$$\frac{AB}{BC} = \frac{EC}{ED} = \frac{BD}{ED} = \phi$$

FIGURE 25

FIGURE 26

Figure 22. Mr. Price proved also that this triangle is the only (right-angled) triangle having its sides in geometrical progression.

(3) The isosceles triangle having 36° as angle at the isosceles (sharp) vertex, or "Sublime Triangle," or Triangle of the Pentalpha. The last term is another name for the Pentagram which can indeed be considered as formed of five interlocking A's.

This triangle (Figure 24) is not only an element of the pentagon (joining a vertex to the opposite side) and pentagram, but also of the decagon, joining the centre of the latter to any of its sides (Figures 25 and 26). It follows that the ratio between the longer (isosceles) side and the shorter, $\dfrac{AB}{BC}$, is equal to Φ (the Golden Section); also that the two angles at the base, ACB and ABC, are equal to 72°, the double of the sharp angle CAB = 36°. Those two relations confer to the "sublime" triangle the most interesting "harmonic" properties; Plates I, II and III give examples of designs based on it, designs in which the pentagon appears in a more or less explicit form.

THE SQUARE

The construction of the square inscribed in a given circle, of the square having a side or diagonal of given length, are all particular cases of the elementary construction: through the middle of a line to draw a perpendicular to it. We will find the square an important element of rectangular "modulations."

RECTANGLES

(1) We have already examined the Golden Rectangle, or Φ rectangle, or Rectangle of the Whirling Squares, and its property of having the square as *gnomon*, that is: the addition of an outer square to (on the longer side), or the subtraction of an inner square from the Φ rectangle produces a similar or reciprocal rectangle; we have also noted that the inner square can be obtained by drawing a diagonal, and a perpendicular to it from one of the

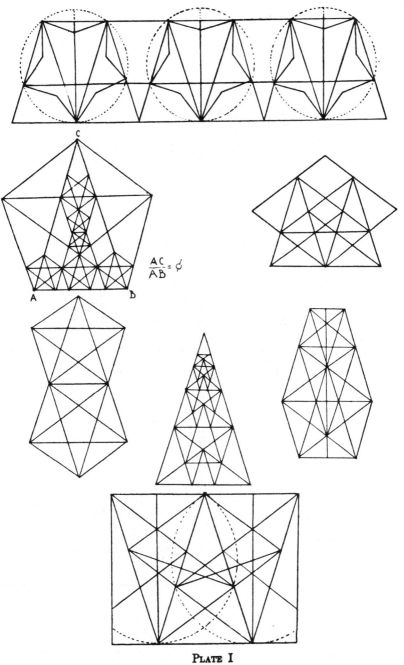

$$\frac{AC}{AB} = \phi$$

PLATE I
The Triangle of the Pentagon

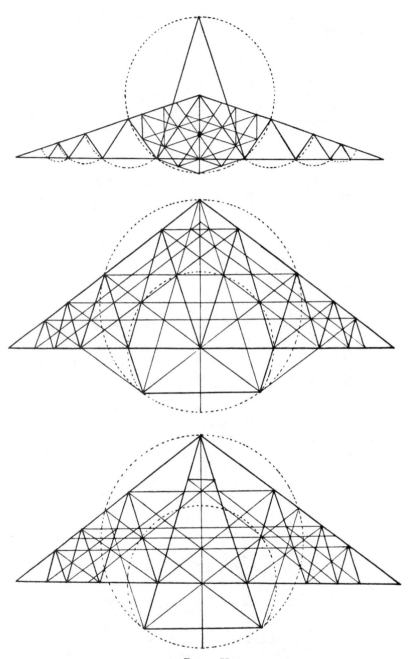

PLATE II
The Triangle of the Pentagon

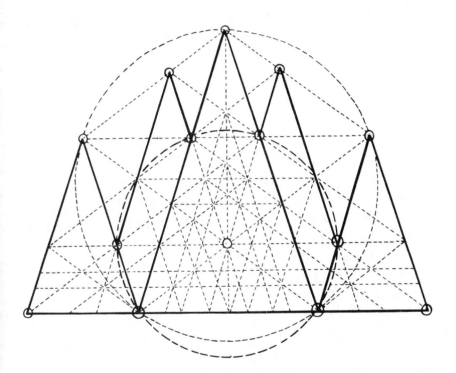

PLATE III
The Triangle of the Pentagon, Harmonic Composition

remaining summits (Figure 8). The diagonal of the Φ rectangle is also equal to the side of the star-pentagon inscribed in a circle having the shorter side as radius (if a is the length of this shorter side, we have the diagonal $d = a \sqrt{\Phi^2 + 1}$. The addition of a square on the shorter side produces the rectangle Φ^2 (Φ^2 being the ratio between the longer and the shorter side).

(2) The Double-Square Rectangle. This rectangle plays an important rôle in the surface modulations associated with the Golden Section; its diagonal, if a is the smaller side, is equal to a. $\sqrt{5}$, hence the affinity to $\Phi = \dfrac{\sqrt{5} + 1}{2}$. If keeping a as smaller side we take the length of this diagonal as longer side of another rectangle, we obtain the very important $\sqrt{5}$ rectangle, which, like the double-square, and for a similar reason, is intimately associated with the Golden Section theme of "symmetry." We will find the double-square as basis of the interesting "Volume of the Chamber of the King" in the Great Pyramid. In Figure 5 we have shown several ways of dividing the sides of this rectangle in the Φ ratio.

(3) If starting from the Φ rectangle OMPQ (Figure 27) we take its longer side MP as diagonal SM to another rectangle, we see that this latter has as ratio between its longer and shorter sides the number $\sqrt{\Phi} = 1.273$ (because if the shorter side, OM, is taken as unit of measurement, the longer side of the new rectangle OMNS will be equal to $\sqrt{\Phi^2 - 1} = \sqrt{\Phi}$, as $\Phi^2 = \Phi + 1$). We see by referring to the paragraph on triangles that this rectangle $\sqrt{\Phi}$ (the number attached to a rectangle as specification means always the ratio between its longer and its shorter side) is formed of two right-angled triangles with sides proportional to 1, $\sqrt{\Phi}$, Φ, that is, halves of the meridian triangle of the Great Pyramid, or triangles of Price.

This rectangle $\sqrt{\Phi} = 1.273$, related of course to the Φ theme, has many interesting properties; for instance, it can be divided into three similar rectangles (Figure 28) and so *ad infinitum*, the

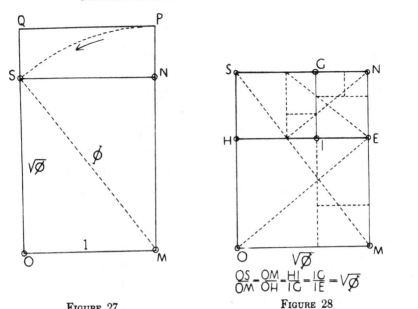

FIGURE 27

$$\frac{QS}{OM} = \frac{OM}{OH} = \frac{HI}{IG} = \frac{IG}{IE} = \sqrt{\emptyset}$$

FIGURE 28

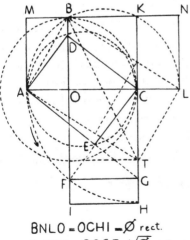

BNLO = OCHI = \emptyset rect.
DCEA = OCGF = $\sqrt{\emptyset}$ rect.

FIGURE 29

BNLO = OGHI = \emptyset rect.
MNLA = $\sqrt{5}$ rect.
OCGF = $\sqrt{\emptyset}$ rect.
BKHI = \emptyset^2 rect.

FIGURE 30

surfaces of those rectangles forming a geometric progression of ratio $\frac{1}{\Phi}$ (this being an illustration of the Greek notion of "Dynamic Symmetry," or *commensurability in the square* as rediscovered by J. Hambidge—cf. Chapter VIII).

Figure 29, starting from the construction of the side AB of the pentagon inscribed in a given circle of radius OC, shows on the same diagram not only the sides of the pentagon (AB), pentagram (BL), decagon (AO) and star-decagon (AC = OL), but also the rectangles Φ (BNLO and BLTA), $\sqrt{\Phi}$ (ADCE and OCGF), Φ^2 (BKHI) and $\sqrt{5}$ (MNLA). Another simpler combination of the same rectangles is given in Figure 30. Plate IV represents a $\sqrt{\Phi}$ rectangle divided "harmonically" according to the Φ and the $\sqrt{\Phi}$ proportions, the two themes blending together.[1] We may state here the principle called "rule of the non-mixing of discordant themes," or symmetries, already stated by Alberti and rediscovered by Hambidge (see Chapter VIII). It is for instance a mistake to mix on the same plane design the themes or proportions $\sqrt{2}$ and Φ, or $\sqrt{3}$ and Φ, or $\sqrt{2}$ and $\sqrt{3}$; but the themes Φ, $\sqrt{\Phi}$, Φ^2, $\sqrt{5}$, 1 (the square), 2 (the double-square), can be mixed, as they belong to the same symmetry (the square can be used with any theme, being universal). In three dimensions, on the contrary, two different planes, projections or faces can be treated with two different, "discordant" themes (like $\sqrt{2}$ and Φ), as long as the principle is respected within each face. In Figure 5 we have shown a simple construction for dividing the side AC of the square into the Φ ratio. ADEB is then a Φ rectangle (if AD = 1, AB = $\frac{1}{\Phi}$), CBEF a Φ^2 rectangle (CB = $1 - \frac{1}{\Phi} = \frac{1}{\Phi^2}$).

[1] Among the interesting properties of the $\sqrt{\Phi}$ proportion is the one that in a diminishing series of ratio $\sqrt{\Phi}$, the sum of two consecutive terms is equal to the sum of the next four ones. This ratio $\sqrt{\Phi} = 1.273$ (more seldom the ratio $\Phi = 1.618$) is often found between the heights of the drawers of Queen Anne and Chippendale chests of drawers and tallboys.

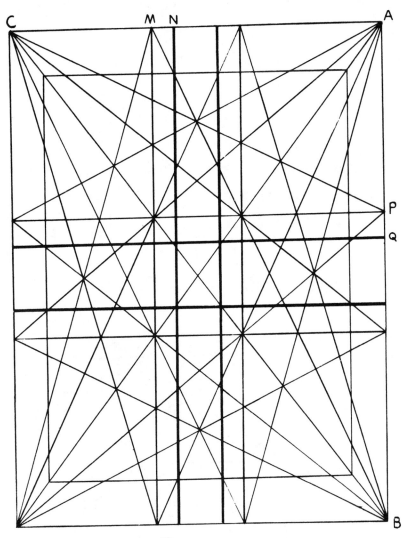

RECTANGLE $\sqrt{\phi}$

$$\frac{AB}{AC} = \frac{AN}{NC} = \frac{BQ}{QA} = \sqrt{\phi}$$

$$\frac{AM}{MC} = \frac{BP}{PA} = \phi$$

PLATE IV

The $\sqrt{\Phi}$ Rectangle

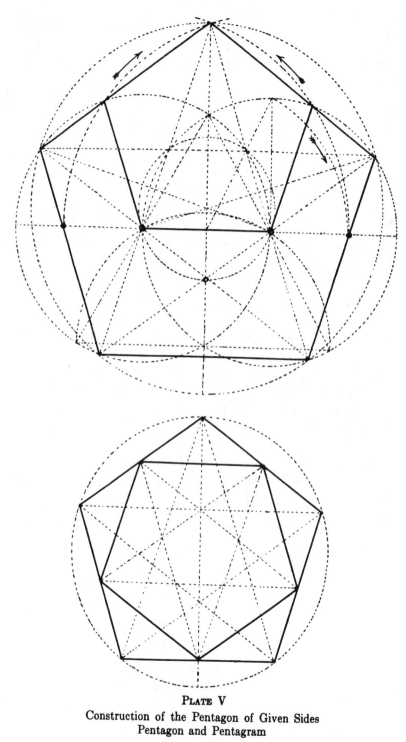

PLATE V
Construction of the Pentagon of Given Sides
Pentagon and Pentagram

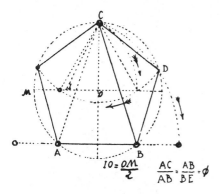

$$10 = \frac{OM}{2} \qquad \frac{AC}{AB} = \frac{AB}{BE} = \phi$$

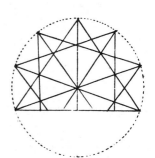

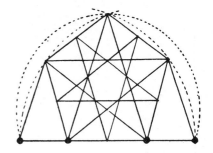

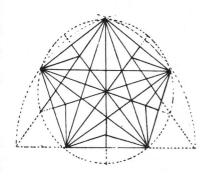

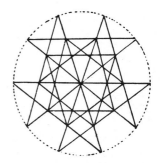

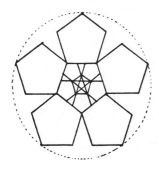

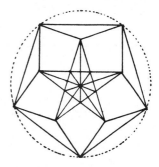

PLATE VI
Variations on the Pentagon

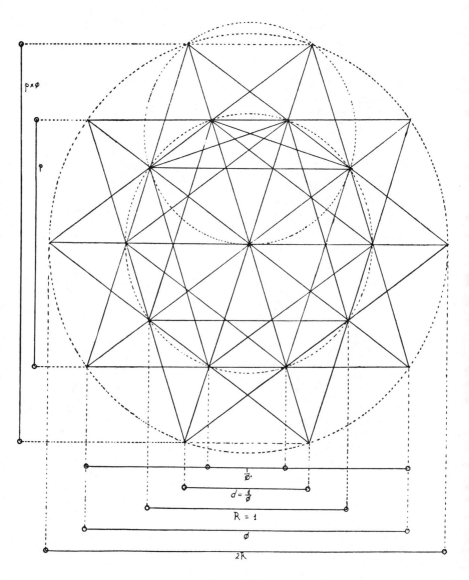

PLATE VII
Interplay of Proportions between Pentagon, Pentagram,
Decagon and Star-Decagon

PENTAGON AND DECAGON

We have already shown in Chapter II the rôle of the Golden Section ratio or proportion in the symmetry of the pentagon, pentagram, decagon and star-decagon, and illustrated this by the corresponding figures.

Figure 31 shows the construction of a pentagon of given side AB; Plate V shows an amplification of the same construction,

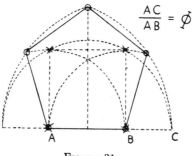

$$\frac{AC}{AB} = \phi$$

FIGURE 31

also the interplay of pentagon and pentagram. Plate VI gives different variations on the same theme.

We have seen that the side of the decagon, the radius of the circumscribed circle and the side of the star-decagon, form a Φ progression ($\frac{R}{d_r} = \frac{d_s}{R} = \Phi$). Incidentally, this radius is also equal to the side of the inscribed regular hexagon. The same Φ ratio exists also between the sides p_s and p_r of the pentagram and of the pentagon (they meet in the "sublime triangle").

Plate VII shows (after Moessel) the interplay of proportions in the same circle between the sides of pentagon, pentagram (star-pentagon), decagon and star-decagon, and the radius of the circle, the whole within the network of the star-decagon. The surface of the pentagon is $S_p = \frac{p_r^2}{4} = \sqrt{5(5 + 2\sqrt{5})}$, of the decagon $S_d = \frac{5}{2} d_r^2 \sqrt{5 + 2\sqrt{5}}$.

Curiously enough, although the pentagon and the Φ rectangle obey the same Φ proportion, it is not easy to combine them on the same design in a direct way; Figure 32 gives the nearest approach to this interesting problem (also the lower figure on Plate XLIII).

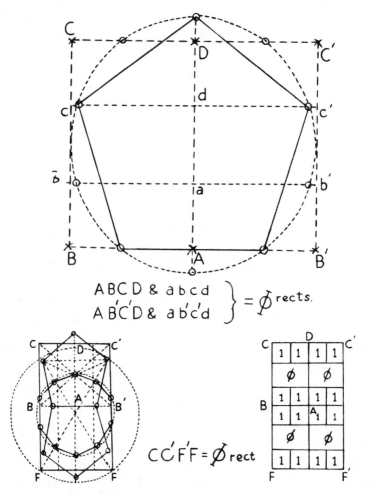

FIGURE 32

We have the following relation between R, radius of the circumscribed circle, and pr side of regular pentagon,

ps side of regular star-pentagon,

dr side of regular decagon,

ds side of regular star-decagon

$$p_r = \frac{R}{2}\sqrt{10 - 2\sqrt{5}} \qquad p_s = \frac{R}{2}\sqrt{10 + 2\sqrt{5}}$$

$$d_r = \frac{2R}{1 + \sqrt{5}} = \frac{R}{\Phi} \qquad d_s = \frac{2R}{\sqrt{5}-1} = R.\Phi \qquad \frac{p_s}{p_r} = \Phi.$$

HEXAGON

The side of the regular hexagon (Figure 33) is, as noted before, equal to the radius of the circumscribed circle; this confers to the hexagon an important rôle in the equipartitions or regular lattices of the plane, as also does the fact that it can be divided into six equal equilateral triangles.

Figure 34 shows the star-hexagon, hexagram or "Shield of David" (or "Seal of Solomon"), which is really composed of two independent equilateral triangles.

If h = R be the side of the hexagon, its surface $S = \frac{3R^2 \sqrt{3}}{2}$.

OCTAGON

The regular octagon (Figure 35) has played a great rôle in architecture, and was used in the planning of many churches, domes, towers, especially in the byzantine, arab, and romanesque schools (San-Vitale of Ravenna, Carlovingian cathedral of Aachen, Mosque of Omar in Jerusalem, St. Nectaire, et cetera). Its symmetry is obviously related to that of the square and of the "theme" $\sqrt{2}$ (diagonal of the square). If R be the radius of the circumscribed circle, the side of the octagon is equal to

$o = \dfrac{2R}{\sqrt{2(2 + \sqrt{2})}}$. The surface is $S = 2o^2(1 + \sqrt{2})$.

The star-octagon (Figure 36) and the pseudo star-octagon composed of two overlapping squares (Figure 37) have been used

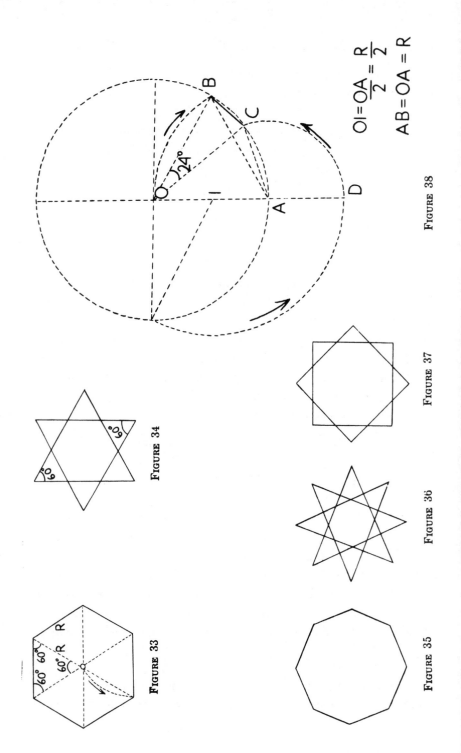

FIGURE 33

FIGURE 34

FIGURE 35

FIGURE 36

FIGURE 37

FIGURE 38

$OI = \dfrac{OA}{2} = \dfrac{R}{2}$

$AB = OA = R$

as geometrical patterns of ornamentation in Arab, Moslem, and Indian-Moghul decorative art.

The circle is often (in Gothic designs) subdivided into 20 parts instead of 10, but this leaves the same "symmetry," based on the Golden Section. With that exception (and that of the pentedecagon of 15 sides, found in Gothic roses, a simple construction of which is given in Figure 38 [1]) the polygons of more than 10 sides have no interest, as the essential symmetries in Art and Life are based on the themes $\sqrt{2}$, $\sqrt{3}$ and $\sqrt{5}$ (or Φ).

[1] One constructs first $AC = AD$, side of the regular decagon inscribed in the circle with radius $OA = R$ (one has $AC = \frac{R}{\Phi}$), then $AB = R$, side of the inscribed hexagon. BC will be the side of the pentedecagon, as it is the chord to an angle of $\frac{360°}{6} - \frac{360°}{10} = 24° = \frac{360°}{15}$. This side BC is equal to $\frac{R}{2}\left(\sqrt{\Phi + 2 - \frac{\sqrt{3}}{\Phi}}\right)$. The formula given at the beginning of this chapter shows that there are also three star pentedecagons.

The cathedrals of Rouen and Amiens have each got a pentadecagonal rose-window.

CHAPTER IV

Geometrical Shapes in Space

WE HAVE SEEN that the number of regular polygons (characterized by the number of their sides) has no limit, like the number of the integers. N being any integer number, we can (in theory) produce a regular polygon with N sides, of which we have seen that only a certain number, satisfying the conditions set down by Gauss, can be constructed with rule and compass (in an "euclidian" way). But this number is also infinite. Curiously enough, this property has no correspondent in three dimensions; the number of regular polyhedra (solids with equal sides, equal regular faces, equal solid angles, inscribable in a sphere), far from being infinite, is limited to five, called since the time of the neo-Pythagoreans the five "platonic" bodies:

Name	Number of Vertices	Number of Sides	Number of Faces
Tetrahedron	4	6 (3 per vertex)	4 eq. triangles (3 per vertex)
Octahedron	6	12 (4 per vertex)	8 eq. triangles (4 per vertex)
Cube	8	12 (3 per vertex)	6 squares (3 per vertex)
Icosahedron	12	30 (5 per vertex)	20 eq. triangles (5 per vertex)
Dodecahedron	20	30 (3 per vertex)	12 pentagons (3 per vertex)

The number of vertices, v, the number of sides, s, and the number of faces, f, are related in each polyhedron by Euler's formula [1]

$$v + f = s + 2.$$

[1] We shall see that Euler's formula is only a special case of Schläfli's formula for any number of dimensions. The fact that there are only five regular solids (and their specifications) can be proved in several ways. Descartes did it by observing that there were eight solid right-angles round

Plate VIII shows the five regular polyhedra. Those five solids are connected to each other in a subtle way. The octahedron and the cube are reciprocal; that is, if we take the centres of figure of the surfaces limiting one body, we obtain the other one (the number of faces becomes the number of vertices and inversely, the number of total sides does not change). The same is true for the couple icosahedron-dodecahedron. The tetrahedron is auto-reciprocal, that is, reproduces itself by taking the centres of its faces.

Whereas in the plane the triangle, the square and the pentagon were irreducible to each other morphologically, the same antagonism does not subsist in three dimensions; we can in space pass from dodecahedron or icosahedron to cube, from cube to tetrahedron. For instance: the 12 vertices of the icosahedron (and 6 of its sides) are on the surface of a cube; the 8 vertices of this cube coincide with 8 of the vertices of a dodecahedron having its side equal to that of the icosahedron. The 12 other vertices of the dodecahedron and 6 of its sides are situated on the surface of another, enveloping, cube, such that its side and the side of the first cube should be in the Φ ratio. In the same way the 6 sides of any tetrahedron can be set as diagonals on the 6 faces of a cube, the 4 vertices of the tetrahedron coinciding with 4 of the vertices of the cube (the 4 remaining vertices of the cube and the 6 other diagonals producing another tetrahedron).[1]

any point in three-dimensional space, and that if (for a regular body) α be the number of solid angles belonging to each body, and γ the number of faces, then $\dfrac{2\alpha - 4}{\gamma}$ and $\dfrac{2\gamma - 4}{\alpha}$ must be integers.

Also, if β be the number of plane angles on the surface of a convex body, $\dfrac{\beta + 8}{4}$ must be an integer.

[1] Also: the 20 vertices of the dodecahedron are also the vertices of 5 tetrahedra, or of 5 cubes (2 cube vertices for each dodecahedron vertex). Figure 39 shows how the tetrahedron can be derived from the cube, Figure 40 how the octahedron can be derived from the tetrahedron, Figure 41 the connection between dodecahedron and cube. Let us mention here that the 12 vertices of the icosahedron are also the vertices of three Φ rectangles perpendicular to one another and having a common centre of symmetry. One of these rectangles appears on the projection of the enveloping icosahedron on Plate XI.

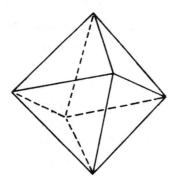

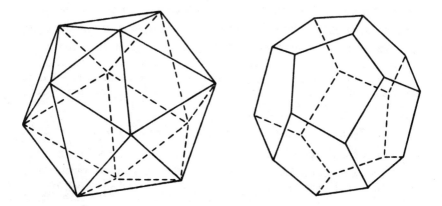

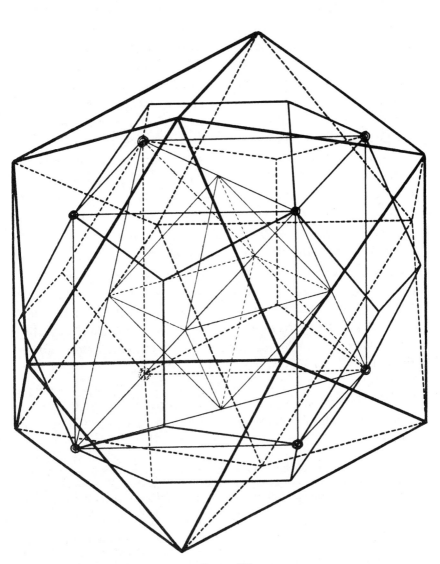

PLATE IX
The Five Regular Solids Inscribed within Each Other

Those affinities between the five regular bodies were mentioned by Campanus of Novara (thirteenth century), as also the fact that the Golden Section which directs the "symmetry" of the two "higher" ones (dodecahedron and icosahedron—this presence of the Golden Section is natural, as dodecahedron and icosahedron together constitute the projection in three dimensions of the pentagon and of its properties) seems to dominate the morphological relations between the five bodies.[1]

Those relations were given a great importance not only in Aesthetics but in Philosophy; Plato in the *Timaeus* establishes a correspondence between each regular body and some element of Nature, the dodecahedron being taken as a geometrical symbol for the harmony of the Whole, or Cosmos.

In the sixteenth century Kepler, for whom the Golden Section was "a precious gem, one of the two treasures of Geometry," [2] attached a great importance to these morphological interconnections between the five regular bodies, and used them, together with Platonico-Pythagorean ideas about correspondence between the orbits of the planets and musical intervals, to establish the famous astronomical laws bearing his name.

Figures 39, 40 and 41 show some of the connections between cube, tetrahedron, octahedron, dodecahedron; Plate IX shows a modern version of the Keplerian interlocking of the five regular solids.[3]

[1] Campanus of Novara states in a subtle verbal antithesis that the Golden Section (*proportionem habentem medium duoque extrema*) brings together the five regular bodies in a logical way (*rationabiliter*) but by a symphony ruled by an irrational (geometrical) proportion (*irrationali symphonia*).

[2] "*Mysterium Cosmographicum de admirabili proportione orbium caelestium*," 1596. The other "treasure" was the theorem of Pythagoras.

[3] In his diagrams (*op. cit.*) Kepler adds to each solid the corresponding circumscribed spheres, which allows the arbitrary introduction of planetary orbits. In spite of his (to our minds, gratuitous) starting point, Kepler's Laws are perfectly valid; still more curiously, the fanciful correlations between planetary orbits and musical intervals are not as absurd as they sound.

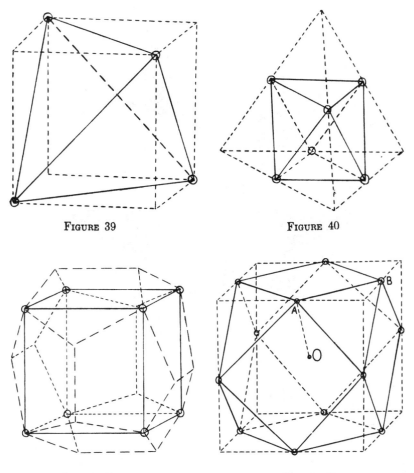

FIGURE 39 FIGURE 40

FIGURE 41 FIGURE 42

There is another way of passing from dodecahedron to icosa-
hedron, and from icosahedron to dodecahedron; it is to lengthen
out all the sides (or the planes of the faces—the result is the
same) of either of these solids until they meet; this operation on
the dodecahedron produces the twelve vertices of an enveloping
icosahedron, on the icosahedron the twenty vertices of an envel-
oping dodecahedron. These operations can be repeated indefi-

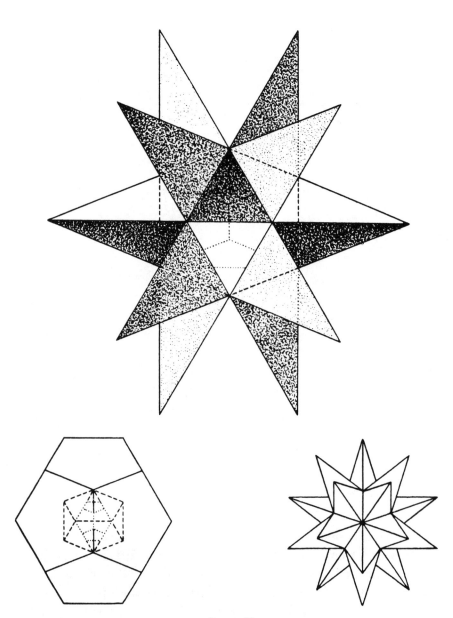

PLATE X
Star-Dodecahedron with Twenty Vertices

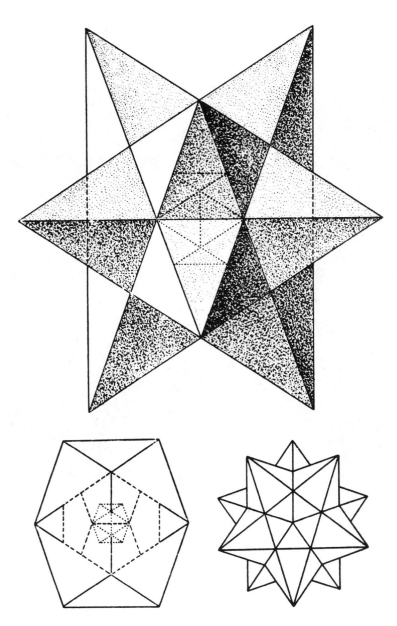

PLATE XI
Star-Dodecahedron with Twelve Vertices

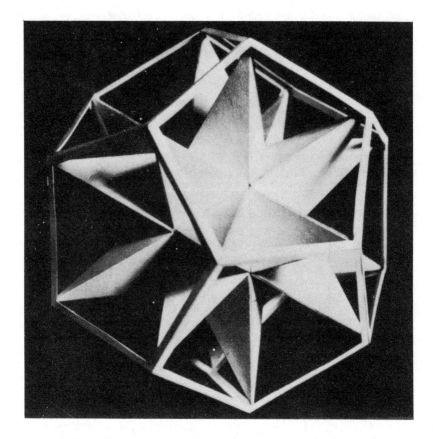

PLATE XII
Model of Star-Dodecahedron with Twenty Vertices

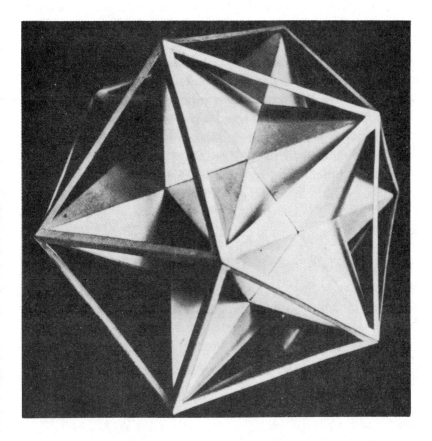

PLATE XIII
Model of Star-Dodecahedron with Twelve Vertices

nitely, producing alternating ever-growing dodecahedra and icosahedra, and we obtain thus a "pulsation" of growth in which lines, surfaces, volumes, are ruled by the golden section or Φ proportion. But these same operations, in their first step (and if we do not link together the vertices obtained in prolonging sides or faces), produce also the two star-dodecahedra [1] called star-polyhedra of Kepler, shown on Plates X and XI. The bigger figure on Plate XI shows an orthogonal projection of the star-dodecahedron of the first order, derived from the inner dodecahedron (vertices of this star-dodecahedron coincide with those of an enveloping icosahedron), which plays an important part in the symmetry of the human body, as we shall see in Chapter VI.

Plate XIII is the photography of a model of this star-polyhedron, Plate XII of its companion; they are seen inside the network of the reciprocal enveloping icosahedron, respectively dodecahedron.[2]

Let us return to convex polyhedra. We have here, besides the five platonic bodies (regular, convex and continuous), thirteen *semi-regular* solids, which can also be inscribed in a sphere, and have as faces two or three different kinds of regular polygons (triangles, squares, pentagons, hexagons, octagons or decagons). They are called "Archimedian" solids or polyhedra; here are their specifications:

[1] These two star-polyhedra of Kepler (there are two others, less important for us, but also with pentagonal symmetry, called the star-polyhedra of Poinsot) are indeed dodecahedra, being each composed of twelve interlocking pentagrams. Together they represent the expansion of the pentagram in three dimensions, in the same way that the dodecahedron and icosahedron represent the expansion of the pentagon.

[2] There is also a pseudo-star-polyhedron composed of two tetrahedra cutting each other (one vertex of each through one face of the other), with the same centre of symmetry, and an inner octahedron as common nucleus. This is the *"Stella Octangula"* of Kepler, corresponding to the pseudo-star-hexagon or "Shield of David" in the plane.

SEMI-REGULAR ARCHIMEDIAN SOLIDS

Number of Vertices (the index on the top right shows the number of sides meeting at each vertex)	Number of Sides	Number and Specification of Faces	
12^3	18	4 hexagons,	4 triangles
12^4	24	6 squares,	8 triangles
30^4	60	12 pentagons,	20 triangles
24^3	36	8 hexagons,	6 squares
24^3	36	6 octagons,	8 triangles
60^3	90	20 hexagons,	12 pentagons
60^3	90	12 decagons,	20 triangles
24^4	48	18 squares,	8 triangles
60^4	120	12 pentagons,	30 squares, 20 triangles
48^3	72	6 octagons,	8 hexagons, 12 squares
120^3	180	12 decagons,	20 hexagons, 30 squares
24^5	60	6 squares,	32 triangles
60^5	150	12 pentagons,	80 triangles

Euler's formula, $v + f = s + 2$, applies also to the vertices, faces, sides, of these thirteen Archimedian bodies.

To them we must add two infinite series of equally semi-regular inscribable polyhedra: (1) The regular right-angled prisms which can be inscribed in a sphere (two regular identical parallel polygons with n sides linked together by n squares); (2) The regular antiprisms (two regular identical polygons, parallel but one being rotated by an angle of $\dfrac{360°}{2n}$ in relation to the other, linked together by 2n equilateral triangles); they are equally inscribable in a sphere.

The regular Prisms and Antiprisms so defined have all the properties of the Archimedian Polyhedra (in each one the solid angles issuing from the vertices are identical); their specifications can be obtained as follows:

	Number of Vertices v.	Number of Sides s.	Number of Faces f.
Prims	2n	3n	n + 2
Antiprisms	2n	4n	2(n + 1)

Euler's formula is also valid for them.

The most important Archimedian polyhedra are:

(1) The cuboctahedron, having 14 faces (8 equilateral triangles and 6 squares) 24 sides and 12 vertices (Figure 42). It has the important property of having its side, AB, equal to the radius OA of the circumscribed sphere (property analogous to that connecting the hexagon and the circumscribed circle in the plane). If one considers this circumscribed sphere, one can see that the vertices of the cuboctahedron coincide with those of three hexagons obtained by the intersections of three great circles cutting each other reciprocally at 60°. We may thus think that the cuboctahedron is the representant or expansion of the hexagon in three dimensions; in reality the hexagon is represented conjointly by three solid bodies: the cuboctahedron, the hexagonal regular prism (Figure 43)[1] and the Archimedian polyhedron examined hereafter (truncated Octahedron, or tetrakaidecahedron of Kelvin); those two last ones have in three dimensions the property of being able to fill space by repetition, parallel to the analogous property of the hexagon in the plane. The cuboctahedron has two other remarkable properties connected with ideal partitions of space (cf. Chapter V), and plays a predominant part in crystallography (Figure 44 represents a crystal of salt, NaCl, the atoms of Chlorine coinciding with the vertices and centre of a cuboctahedron, the atoms of Sodium with the vertices—and

[1] In contradiction to what one might expect, the radius R of the sphere circumscribed to the hexagonal regular prism is not equal to the side h of the latter; the relation between R and h is $R = \dfrac{h. \sqrt{5}}{2}$, or $h = \dfrac{2R}{\sqrt{5}}$, also $h = \dfrac{2\Phi R}{\Phi^2 + 1}$.

This intrusion of the Golden Section is unexpected.

FIGURE 43

FIGURE 44 FIGURE 45

centres of faces—of the cube out of which the cuboctahedron can
be generated by taking the middle-points of all sides and join-
ing them).[1] The atoms of carbon in its close-packed crystalline

[1] The cuboctahedron can equally be produced by taking the middle-
points of all the sides of an octahedron. Cube and octahedron, being recip-
rocal, have of course the same number of sides (12).

form (diamond), also the atoms of gold, silver, copper and aluminum are at normal temperature packed in cuboctahedral lattices.

The cuboctahedron plays also an important part in architecture, especially in byzantine (and Moslem) architecture, and wherever we meet the problem of setting a dome on a cubical supporting frame. The vertices of the cuboctahedron coincide with the points of contact of six tangent orthogonal circles inscribed on the square faces of the generating cube (Figure 45); if we draw the sphere passing through those twelve points, and if we consider the upper half of this figure, the vertical semicircles AEB, BFC, CGD, DHA, correspond to the semi-circular arches, the spherical triangles EBF, FCG, GDH and HAE to the pendentives which in this solution (the one chosen by the architect of Santa-Sophia) are part of the surface of the above-mentioned sphere (circumscribed to the cuboctahedron). This solution is also illustrated in the upper figure of Plate XIV; the lower figure shows the other solution in which the dome is a complete hemisphere set on the upper circle HEFG.

The Truncated Octahedron (or tetrakaidecahedron of Kelvin —incidentally the cuboctahedron is also a tetrakaidecahedron, having 14 faces—or heptaparallelohedron of Fedorov), with 24 vertices, 36 sides, 14 faces of which 8 are hexagons and 6 squares. As pointed out by Lord Kelvin, this polyhedron is the only one amongst the thirteen Archimedian solids which can fill space by repetition [1] (close-packing without intervals). This polyhedron can be produced by dividing each side of an octahedron in 3 equal parts and joining the points thus obtained (Figure 46). One can also obtain the truncated octahedron by starting from 8 close-packed cubes, dividing into 2 equal parts each of the 4 sides of the small cubes meeting in the centre of each face of the great

[1] We will see that amongst the five platonic solids only the cube has this property.

PLATE XIV
Cuboctahedron and Byzantine Cupolas

cube formed by the juxtaposition of the small ones, and joining to one another the points thus obtained as on Figure 47.

(3) The Triakontagon (or Triakontahedron) having 30 vertices, 60 sides, 32 faces of which 12 are pentagons and 20 triangles. This polyhedron (Figure 48) can be obtained by taking the middles of the sides of either the dodecahedron or the icosahedron; its 30 vertices coincide with the sides of 6 decagons produced by the intersecting of 6 great circles symmetrically placed on a sphere. The triakontagon is indeed the expansion or projection of the decagon in three-dimensional space; we shall not be surprised to see it closely connected with the golden section: the ratio between the radius of the circumscribed sphere and the side of this polyhedron is Φ.

Archimedes studied these thirteen semi-regular polyhedra named after him. The Painter-Geometers of the Renaissance were interested in them, as well as in the five regular platonic solids and the star-polyhedra. In 1492 Pier della Francesca dedicated the treatise *De Quinque Corporibus* to the Duke of Urbino. Luca Pacioli in his *Divina Proportione* examines besides the platonic solids [1] some of the Archimedian ones, in particular the cuboctahedron and Kelvin's polyhedron (*"il corpo de 14, cive 6 quadrate, 8 exagone"*), also the star-polyhedra (Plate XV reproduces two of Leonardo's illustrations for his friend's fascinating book, the upper figure the star-dodecahedron of the second type, the lower figure the *"Stella Octangula"*), so does Dürer in his *Treatise on Proportions*. But the Renaissance author who took most interest in the Archimedian solids was the all-knowing Daniel Barbaro, Patriarch of Aquilea and Venetian diplomatist. In his *Prattica de la Perspettiva* (Venice, 1569) he establishes them all by the method of cutting off angles or sides of generating

[1] According to Pacioli, the icosahedron was taken as an abstract model in planning the temple of Ceres at Cercio near Rome. The little temple of Minerva Medica (known as temple of Vesta) in Rome seems also to have been inspired by the icosahedron or the dodecahedron (see Plate LXI).

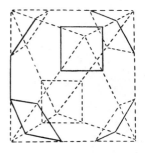

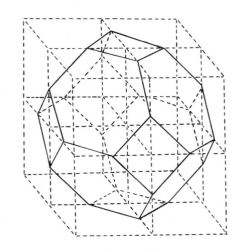

FIGURE 47

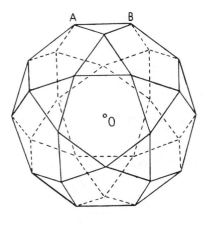

$$\frac{OA}{AB} = \phi$$

FIGURE 48

FIGURE 49

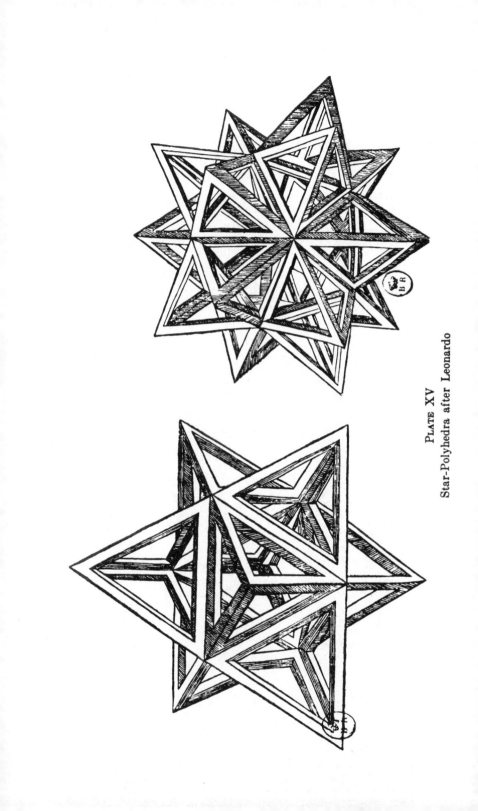

Plate XV

Star-Polyhedra after Leonardo

polyhedra; he develops them on the plane of one of their faces (Dürer's method), composes fancy star-polyhedra by setting regular pyramids on their faces, and takes up again Paolo Ucello's *mazzochios* by inscribing regular polygons in *tori* (rings with circular section) and also studding them with pyramids.

We have already quoted Kepler's partiality for polyhedra and star-polyhedra (1619).

OTHER REMARKABLE VOLUMES

The solid corresponding in space to the rectangle is the right-angled parallelepiped (we will call it hereafter R.A.P.). As the rectangle is completely defined by the lengths of its two adjoining sides (the ratio between them $\frac{a}{b}$ defines the shape and proportion of the rectangle), so is the R.A.P. completely defined by the ratios of two adjoining rectangles, that is by three perpendicular dimensions (or two ratios). We will thus define a R.A.P. by three numbers proportional to these dimensions.[1]

The ratios between these numbers, and the resulting proportions in volumes, surfaces and lines, have obviously a great importance, whether the volumes are those of buildings, rooms, or pieces of furniture.[2] Apart from the cube,[3] the most important R.A.P's, as proportions, are:

[1] The Greeks studied the proportions of different R.A.P.'s (which they considered as *solid* numbers, of the type abc), especially the ones the characteristic numbers of which formed arithmetical, geometrical or harmonic progressions or proportions. Plato studied thoroughly the proportions between volumes, stating even as a theorem that "two middle-terms (proportional means) are necessary to link two solids in a proportion" (for the cubes a³ and b³, the two middle-terms are a²b and ab², because $\frac{a^3}{a^2b} = \frac{ab^2}{b^3}$.)

[2] Palladio writes that the ideal height of a state-room must be the proportional mean between the two other dimensions; he seems to favor a R.A.P. of characteristics 1, $\sqrt{\Phi}$, Φ, the floor and ceiling being Φ rectangles.

[3] The cube is an important element in Byzantine architecture, as support for domes on square or octagonal base. Herodotus wrote that among the Egyptian monuments, the one which most impressed him was the temple of Buto, in the Nile delta, a monolithic cube measuring 40 ells in each dimension.

'(1) The R.A.P. a, aΦ, aΦ or more simply 1, Φ, Φ (Figure 49). This shape is often found in ancient Egypt, generally with "Fibonaccian" approximations $\frac{6}{10}$ and $\frac{10}{16}$ instead of 0.618. The Papyrus of Rameses IV (in the Turin Museum) describing the "Golden Chamber" containing this king's tomb, gives as its dimensions 16 ells (length), 16 ells (width) and 10 ells (height). (See Plate LVIII).

(2) The R.A.P. 1, 1, Φ (Figure 50). The base is a Φ rectangle, the vertical transversal section a square; then the vertical sides (and of course the "ceiling") are also Φ rectangles. It is a shape often found as over-all volume in pieces of Egyptian furniture (stool of Tutankhamen's tomb, et cetera).

(3) The R.A.P.1,1,2(Figure 51) in which the base and vertical rectangles are double-squares, the vertical transversal section a square. This R.A.P. consists of two adjoining cubes, and corresponds of course in space to the double-square on the plane. Its diagonal rectangles have as characteristic ratios $\sqrt{5}$ and $\sqrt{2}$, its great diagonal DB' is $\sqrt{6}$; it was often used as overall volume for Egyptian and Greek temples and for romanesque and gothic churches.

(4) The R.A.P. 1, Φ, Φ², or "Golden Solid" of S. Colman (Figure 52). The three characteristic faces are two Φ rectangles (the smaller side of the "ceiling" Φ rectangle ABCD is the greater side of the vertical Φ rectangle BCC'B') and a Φ² rectangle (ABB'A'). The "great diagonal" DB' is equal to 2BC, that is 2Φ, so that the centre of symmetry of the volume is at the distance Φ of the 8 vertices. This volume has been often used for Egyptian tombs (example, tomb 105 at Gizeh, dimensions 1.ᵐ80, 2.ᵐ95, 4.ᵐ75). The Abbey Church of Maria Laach also shows these proportions; when expressed in rhenan ells (the unit

FIGURE 50

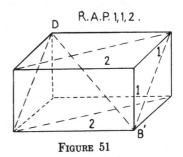

FIGURE 51

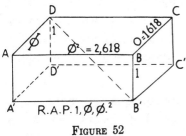

FIGURE 52

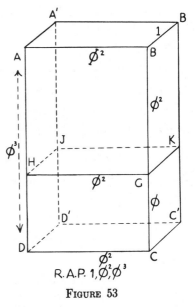

FIGURE 53

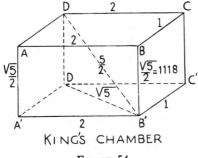

KING'S CHAMBER

FIGURE 54

used at the time of its construction) its three dimensions show the remarkable figures:

261.8... Total length
61.4... Width of the nave
99.2... Length of the nave
100 ... Height of the tower

$$\left(\text{we have } \Phi^2 = 2.618, \ \Phi = \frac{1000}{618}\right).$$

(5) Nearly as important as the "Golden Solid" and found as controlling volume in many pieces of furniture, cupboards, tall-boys of Queen Anne and Chippendale styles, is the R.A.P. 1, Φ^2, Φ^3 (Figure 53). If a horizontal plane is drawn through the vertical rectangle ABCD so as to cut off the square ABGH, the lower volume HGKJCC′D′D thus obtained is a "Golden Solid" 1, Φ, Φ^2.

(6) A R.A.P. of very subtle proportions is the shape of the "King's Chamber" in the Great Pyramid of Cheops, the base of which is a double square, its height being equal to half the diagonal of this double square; then its specifications will be 1, $\frac{\sqrt{5}}{2}$, 2 (Figure 54). The great diagonal DB′ is $\frac{5}{2}$, and the remarkable proportions or characteristic ratios of the diagonal rectangles are:

ACC′A′ **2**

A′B′CD[1] $\frac{4}{3}$

AB′C′D $\frac{\sqrt{21}}{2}$

The (here vertical) rectangle BCC′B′ with characteristic ratio $\frac{\sqrt{5}}{2}$ is often found as over-all frame for human bodies with extended

[1] This diagonal rectangle A′B′CD is formed of two right-angled triangles with smaller sides proportional to 2 and $\frac{3}{2}$, or 4 and 3, that is two triangles of Pythagoras 3–4–5.

(horizontal) arms, and as over-all frame or component of Greek vases (as seen in orthogonal projection). This R.A.P. of the King's Chamber has other properties connected with the Geometry of the Sphere, of the Icosahedron, and of the Great Pyramid itself, as shown by Professor F. J. Dick in an article published in the *American Mathematical Monthly*. Professor Dick's very subtle construction is reproduced in Plate XVI; ABCD is the double-square base of a R.A.P. similar to the King's Chamber; then JF = OA is the height of the King's Chamber, AN is the side of the icosahedron inscribed in a sphere having its centre in O (centre of figure of the R.A.P.) and a radius equal to OA, and the square PQ.RS is the base of a Pyramid similar to the Great Pyramid having its vertex in O and the four corners of its base on the same sphere. The side of this square base, SR or RQ, is equal to the side AN of the icosahedron. The triangle tHt′ represents the meridian triangle [1] of the Great Pyramid, laid down on the plane of the base. The lateral side of the Great Pyramid (joining its vertex to one of the corners of the base) is equal to OA (radius of the circumscribed sphere), and as we have (if Ot′ = a) OA = a $\sqrt{\Phi^2 + 1}$, d is also the side of the star-pentagon inscribed in a circle having a as radius.

Plate XVII shows a variant of Professor Dick's diagram; the relations between sphere, inscribed icosahedron, inscribed Great Pyramid (meridian triangle THK′, base QRSP) with centre at the centre of the sphere, are still the same, but the base of the King's Chamber, ABCD, is on a different scale, its constructions being associated with that of an inner icosahedron.

This diagram (where the meridian Φ rectangle A′NC′M of the icosahedron is rotated so as to lie in the plane of symmetry of the page) has the advantage of leading to another unexpected property of this special projection of the icosahedron; that is, its

[1] As seen in Chapter III, this meridian triangle is composed of two right-angled triangles of Price, such that $\dfrac{Ht′}{Ot′} = \Phi$. This is obtained by the construction on the diagram as t′W = O$\Theta′$ = Ot′ $\times \Phi$.

OH = h Ot = a
Ht´ = c OA = d

PLATE XVI
The King's Chamber, the Great Pyramid and the Icosahedron

PLATE XVII
The King's Chamber, the Great Pyramid and the Icosahedron

correlation with the "symmetry" (in the Vitruvian sense) of the ideal or average (the average of a great number of individuals) human body and face. The theme of the interlinking proportions of the human body as revealed by this projection of the icosahedron (which is also, as we have mentioned before, the projection of the star-dodecahedron generated from a dodecahedron as nucleus) will be examined in Chapter VI; let us only mention here that the point o on the top of the projection of the inner icosahedron is on plate XVI also the projection of the navel [1] (on the "ideal" human figure with extended horizontal arms). Curiously enough, on this same diagram the vertex H of the Pyramid inscribed in the sphere of radius OA' coincides with the projection of the mouth (the total height of the face is equal to oO. If we take on another scale the projection of the great icosahedron as the frame of the human face, LOK is the horizontal of the eyes, mn of the tip of the nose, PS of the mouth). We will see this diagram again in Chapter VI.

We have just seen some of the geometrical properties of the Great Pyramid considered as a solid; it is of course not a tetrahedron, but has four lateral triangular faces sloping to a square base. All these properties (apart from the astronomical and geographical ones which are just as remarkable [2]) are a conse-

[1] Vitruvius, in a sentence comparing the "commodulation" of a well planned-out temple with that of the human body, had already noticed that the navel is the centre of symmetry of the latter.

"*Similiter* (he has just mentioned the accurate planning of interlinking proportions by the ancient painters and sculptors) *vero sacrarum aedium membra ad universam totius magnitudinis summam ex partibus singulis convenientissimum debent habere commensuum responsum. Item corporis centrum medium naturaliter est umbilicus.*"

[2] The meridian plane of the Great Pyramid, containing the axis of the entrance tunnel, faces exactly North (error smaller than $4'35''$ or $\frac{1}{4700}$ of the angular $360°$ sweep of horizon). The meridian of the Pyramid is the one which crosses the maximum surface of land and the minimum of seas; it divides exactly in two equal parts the land on the surface of the globe. The parallel of the Pyramid ($29°58'5''$) is also the one which crosses the greatest surface of land.

quence of the proportions 1, $\sqrt{\Phi}$, Φ, between the smaller side, the longer right-angle side, and the hypotenuse (a, half the side of the square base, h the height, c, the perpendicular drawn from the vertex to one of the sides of the base) of the half meridian triangle of the Pyramid (Figure 55). We must mention here the interesting theory of Jarolimek and Kleppisch. They both noticed (as Petrie had already discovered) that if one calls r the royal

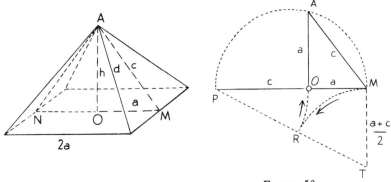

| FIGURE 55 | FIGURE 56 |

ell, standard measure of length used by the ancient Egyptians, equal to O^m 524 (20 inch. 63), one finds:

(1) that all the dimensions of the meridian triangle of the Pyramid are multiples of $4r = 2\ ^m096$, which seems to have been the unit or modulus used in establishing the plans;

we have (Figure 55) $a = 55 \times 4r = 115\ ^m28$
$$c = 89 \times 4r = 186\ ^m53$$
$$h = 70 \times 4r = 146\ ^m72[1]$$

(2) that the coefficients 55 and 89 are consecutive elements of the series of Fibonacci, 1, 1, 2, 3, 5, 8, 13, 21, 34, 55, 89, 144,...

[1] The measurements for a and h are here the recent ones, different from those of Howard-Vyse; but curiously enough $\frac{h}{a}$ is still equal to $\sqrt{\Phi} = 1.273$, and OAM is still a triangle of Price.

asymptotic to the Φ series. This suggested the possibility that the architect of the Great Pyramid, having decided for the profile of his meridian triangle on a theoretical Golden Section basis (Figure 56 gives the rigorous construction of Price's triangle starting from $a + c = PM$), did execute their practical laying out in taking the Fibonaccian approximations:

$$a + c = 144 \times 4r$$
$$a \quad\;\; = \;\; 55 \times 4r$$
$$c \quad\;\; = \;\; 89 \times 4r \quad \left(\frac{89}{55} = 1.61818\ldots, \text{a very} \atop \text{close approximation} \atop \text{of} = 1.618\right).$$

Then, with the same degree of approximation,

$$h = 70 \times 4r. \; \left(\frac{70}{55} = 1.273 = \sqrt{\Phi}\right).$$

The numbers 55, 89 and 70 are also connected by their squares

$$55^2 + 70^2 = 7925$$
$$\text{and } 89^2 \qquad\;\; = 7921.$$

If we apply the same clue to the King's Chamber, we find that the smaller side of the double-square forming the base is 10r and the longer 20r (r being still the Egyptian royal ell).

REGULAR HYPERSOLIDS IN THE FOURTH DIMENSION

In order to round off this brief sketch of the theory of regular shapes, we may here state that in four-dimensional space there exist six regular bodies or hypersolids, bounded by three-dimensional "cells." They are: (1) the Pentahedroid or Hyperpyramid, or C_5 (the index shows the number of three-dimensional cells), corresponding to the Tetrahedron; (2) the Octahedroid or Hypercube, or C_8, corresponding to the Cube; (3) the Hexadecahedroid, or C_{16}, corresponding to the Octahedron; (4) the Icosatetrahedroid, or C_{24}; (5) the Hexacosihedroid, or C_{600}; corresponding to the Icosahedron; (6) the Hecatonicosahedroid, or C_{120}, corresponding to the Dodecahedron. We not only know

all the specifications (numbers and kinds of cells and faces, numbers of sides and vertices) of each of these hyperpolyhedra (for example C_{120} has 120 dodecahedra, as bounding cells, 720 pentagonal faces, 1200 sides, 600 vertices, obviously the realm of the Golden Section in four-dimensional space) but can even construct their projections in three-dimensional and two-dimensional space. The latter have been used by the American architect Claude Bragdon in order to obtain new decorative patterns. (Plate XVIII represents several projections on the plane of 3 of the hypersolids.)

Euler's formula in four-dimensional space becomes $C - F + S - V = 0$ (the letters representing the numbers of cells, faces, sides, vertices). The general formula for a space of any number of dimensions is Schläfli's formula $\Sigma(k = 0, 1, 2, \ldots, n)$ $(-1)^k$. $A_k = 1$.

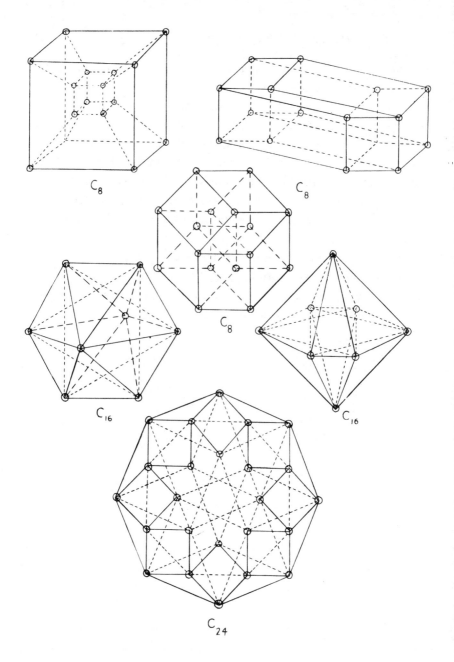

PLATE XVIII
Plane Projections of Three Hypersolids

CHAPTER V

Regular Partitions on the Plane and in Space

IF HAVING CUT BITS of cardboard into equal regular triangles, squares, pentagons, hexagons, octagons, we try by placing identical polygons next to each other to fill a sheet of paper without leaving any intervals, we discover immediately that this continuous mosaic or pavement can be obtained only (amongst the regular polygons) with triangles, squares or hexagons (Plate XIX); the explanation is of course that the vertex-angle of the plane-filling polygon must be a sub-multiple of 360°, and not

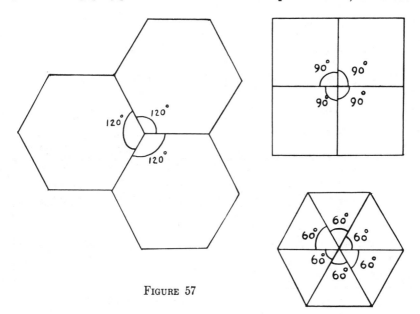

FIGURE 57

bigger than 120° (as at least three polygons must meet at each junction). Only 60°, 90° and 120° satisfy this condition (Figure 57), that is: the plane can be filled (without leaving intervals) only by triangles, squares or hexagons, if a single type of regular polygon is used. We may call these three types regular isomorph partitions or regular equipartitions of the plane.

If we allow regular polygons of several types to meet at each vertex of the lattice, we get 22 more partitions,[1] which we may

[1] These regular and semi-regular partitions of the plane obey the following algebraical conditions: (1) If n is the number of sides of a regular polygon, the inner angle at each vertex is $\alpha = \dfrac{n-2}{n}.180°$; (2) when several regular polygons of the same kind meet at one point without leaving any interval, we must have $2 < n < 7$; (3) if several regular polygons of specifications (numbers of sides) n_1, n_2, n_3, etc. meet at the same point without leaving any interval, we have (it results from (1); n_1, n_2, et cetera may be identical or not):

for three polygons n_1, n_2, n_3, $\left(\dfrac{n_1-2}{n_1} + \dfrac{n_2-2}{n_2} + \dfrac{n_3-2}{n_3}\right).\ 180° = 360°$

or $\dfrac{1}{n_1} + \dfrac{1}{n_2} + \dfrac{1}{n_3} = \dfrac{1}{2}$

for four polygons$\dfrac{1}{n_1} + \dfrac{1}{n_2} + \dfrac{1}{n_3} + \dfrac{1}{n_4} = 1$

for five polygons$\dfrac{1}{n_1} + \dfrac{1}{n_2} + \dfrac{1}{n_3} + \dfrac{1}{n_4} + \dfrac{1}{n_5} = \dfrac{3}{2}$

for six polygons$\dfrac{1}{n_1} + \dfrac{1}{n_2} + \dfrac{1}{n_3} + \dfrac{1}{n_4} + \dfrac{1}{n_5} + \dfrac{1}{n_6} = 2.$

Six solutions, each with three types of polygons (3, 7, 42—3, 8, 24—3, 9, 18—3, 10, 15—4, 5, 20—and 5, 5, 10) are to be rejected, because they give only one point each without possibility of repetition; this leaves the possible combinations:

	n_1	n_2	n_3		n_1	n_2	n_3	n_4		n_1	n_2	n_3	n_4	n_5	n_6
N⁰ 1	3	12	12	N⁰ 5	3	3	4	12	N⁰ 9	3	3	3	4	4	
N⁰ 2	4	6	12	N⁰ 6	3	3	6	6	N⁰ 10	3	3	3	3	6	
N⁰ 3	4	8	8	N⁰ 7	3	4	4	6	N⁰ 11	3	3	3	3	3	3
N⁰ 4	6	6	6	N⁰ 8	4	4	4	4							

Nos. 4, 8, 11 are the three regular isomorph partitions (equipartitions), Nos. 1, 3, 6, 7, 9, 10 give seven regular (identical vertices) polymorph partitions (number 9 gives two), Nos. 2, 5, 6, 7, 12, 13, 14, 15, 16 give the fifteen semi-regular (with different kind of vertices) polymorph partitions.

call "polymorph"; out of these, 7 can be called regular polymorph partitions (having identical vertices in which several kinds of polygons meet), and fifteen can be called semi-regular polymorph partitions (several types of vertices, several types of polygons). The following table gives the specifications of all twenty-five regular and semi-regular plane partitions of space. The horizontal numbers show the numbers of the sides of the polygons meeting at each junction; when there are two lines (in one case even three) of such numbers, they show the two (or three) different types of regular partitions from which they are derived. The vertical rows of angles show the clockwise succession of angles for each type of vertex.

The three regular isomorph partitions (regular equipartitions of the plane) have been shown on Plate XIX; Plate XX shows the regular polymorph partitions 9 and 9-bis.; Plate XXI the regular polymorph partitions 6, 1 and 10, Plate XXII the regular polymorph partitions 3 and 7, Plate XXIII the regular polymorph partition 2, Plate XXIV the semi-regular polymorph partition 13 *quatuor* (with 2 types of vertices), Plate XXV the semi-regular polymorph partition 16, with 4 different types of vertices (the only one with this particularity), Plate XXVI the semi-regular polymorph partition 14-bis., and Plate XXVII the semi-regular polymorph partition N° 12, which combines dodecagon, hexagon, square and triangle.

PARTITIONS OF SPACE

The only one of the five regular polyhedra which allows an equipartition of space is the cube; 8 cubes and 12 lines (fused into 6) meet in every vertex of the lattice thus produced. This lattice is not isotropic (the distances from one point, taken as centre of figure, to the neighbouring ones, are not equal). We can obtain an isotropic [1] point-lattice in space in starting from

[1] Isotropic: homogeneous as regards both linear and solid angular structure.

No. 1 3-12-12 150° 150° 60°

No. 3 4-8-8 135° 135° 90°

No. 5 3-3-4-12 150° 150° 60° 150° 60° 90° 60°

No. 5 bis. 3-3-4-12 150° 60° 60° 90° 90° 60° 90° 60°

No. 6 3-3-6-6 120° 60° 120° 60°

No. 7 3-4-4-6 120° 90° 60° 90°

No. 8 4-4-4-4 90° 90° 90° 90°

No. 9 bis. 3-3-3-4-4 90° 60° 60° 90° 60°

No. 2 4-6-12 150° 120° 90° 150° 90° 120°

No. 4 6-6-6 120° 120° 120°

No. 6 bis. 3-3-6-6 120° 120° 60° 60° 120° 60° 120° 60°

No. 7 bis. 3-4-4-6 120° 120° 60° 60° 120° 90° 90° 60° 120° 60° 90° 90°

No. 9 3-3-3-4-4 90° 90° 90° 90° 120° 90° 90° 60°

No. 10 3-3-3-3-6 120° 60° 60° 60° 60° 120° 60° 90° 90°

N°. 11 3-3-3-3-3-3 60° 60° 60° 60° 60° 60°

N°. 12 4-6-12 150° 150° 120°
 3-4-4-6 90° 120° 90°
 120° 90° 60°
 90°

N°. 13 3-4-6 120° 90° 90°
 3-3-3-4-4 90° 90° 60°
 60° 60° 60°
 90° 60° 60°

N°. 13 bis 3-4-4-6 120° 90° 90°
 3-3-3-4-4 90° 60° 90°
 60° 60° 60°
 90° 60° 60°
 60° 60°

N°. 13 ter 3-4-6 120° 90° 90°
 3-3-3-4-4 90° 90° 60°
 60° 60° 60°
 90° 90° 90°
 60° 60°

N°. 13 quatuor 3-4-4-6 120° 90°
 3-3-3-4-4 90° 60°
 60° 60°
 90° 90°
 60°

N°. 14 3-3-3-4-4 90° 60°
 3-3-3-3-3-3 90° 60°
 60° 60°
 60° 60°
 60° 60°

N°. 14 bis 3-3-3-4-4 90° 90° 60°
 3-3-3-3-3-3 60° 90° 60°
 60° 60° 60°
 90° 60° 60°
 60° 60° 60°
 60° 60°

N°. 14 ter 3-3-3-4-4 90° 90° 60°
 3-3-3-3-3-3 60° 60° 60°
 60° 60° 60°
 90° 60° 60°
 60° 60° 60°

N°. 15 3-3-4-12 150° 150°
 3-3-3-3-3-3 90° 60°
 60° 60°
 60° 90°

N°. 16 3-3-4-12 150° 150° 60°
 3-3-3-4-4 90° 60° 60°
 3-3-3-3-3-3 60° 60° 90°
 60° 90° 60°
 60° 60°

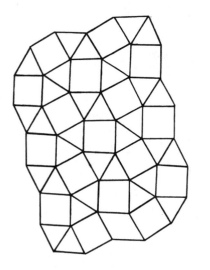

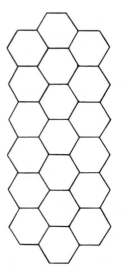

PLATE XIX
Regular Equipartitions of the Plane

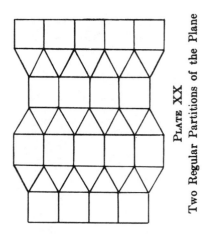

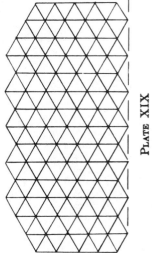

PLATE XX
Two Regular Partitions of the Plane

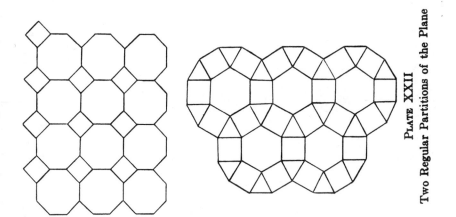

PLATE XXII
Two Regular Partitions of the Plane

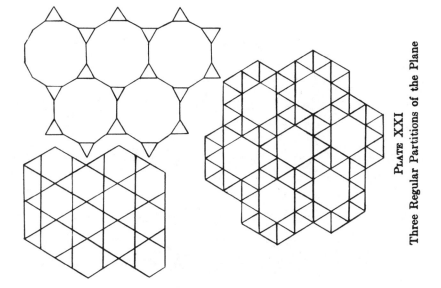

PLATE XXI
Three Regular Partitions of the Plane

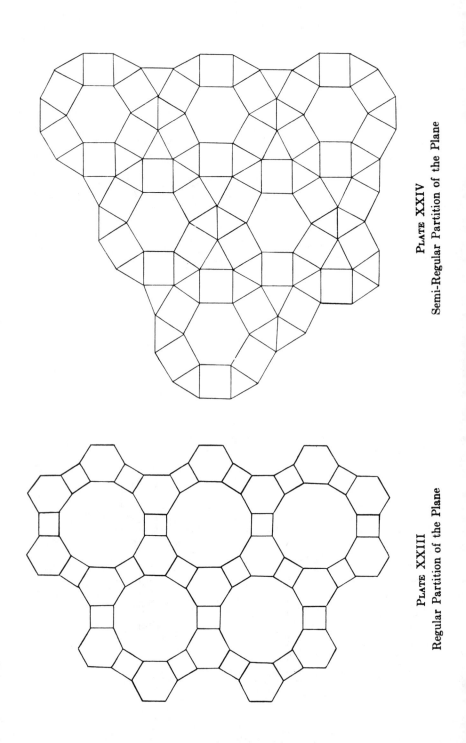

PLATE XXIV
Semi-Regular Partition of the Plane

PLATE XXIII
Regular Partition of the Plane

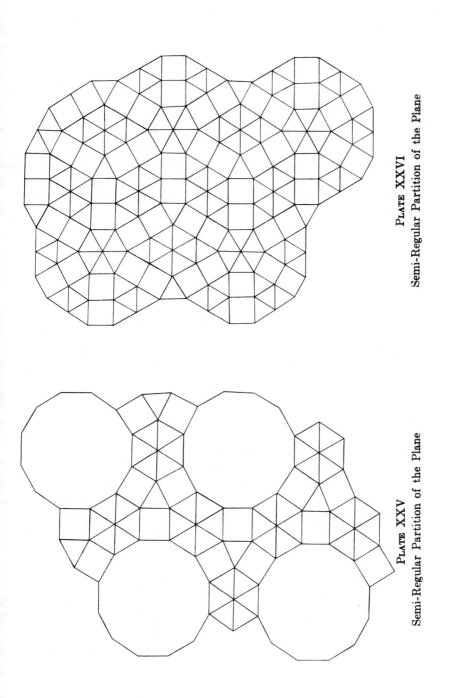

PLATE XXVI
Semi-Regular Partition of the Plane

PLATE XXV
Semi-Regular Partition of the Plane

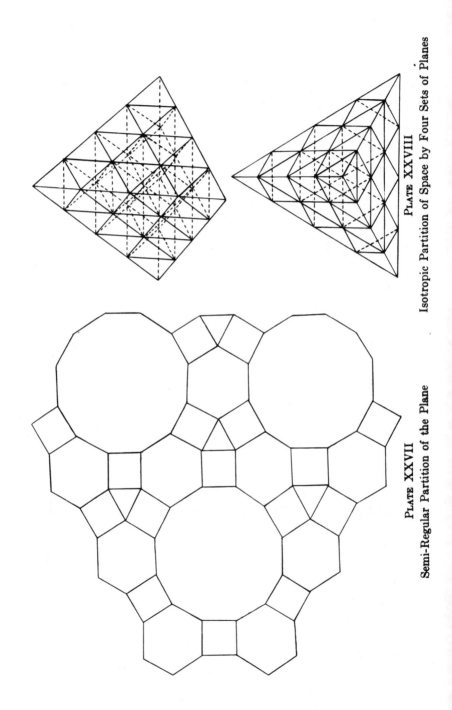

PLATE XXVII
Semi-Regular Partition of the Plane

PLATE XXVIII
Isotropic Partition of Space by Four Sets of Planes

PLATE XXIX
Cuboctahedron and Close-Packing of Spheres

four series of equidistant planes cutting each other under the same angle—that is, parallel to the four faces of a tetrahedron. But oddly enough the partitions thus obtained (Plate XXVIII) do not correspond to a division of space into close-packed tetrahedra (this in euclidian space cannot be realized) but to a division into tetrahedra and octahedra (twice as many tetrahedra as octahedra), or in cuboctahedra and octahedra in equal numbers. The point-lattice is identical to the one obtained in filling space by the most dense possible system of equal tangent spheres, and in taking either all their centres, or their centres and points of contact.

As in the plane we can place outside a circle six tangent circles identical to the first (Figure 58) and repeat the process indefinitely,[1] (the centres of the circles are then part of a triangular or hexagonal isotropic point-lattice), so in space we can have twelve spheres tangent to an identical inner sphere (Figure 59). It is in this perfectly isotropic close-packing of thirteen spheres,[2] indefinitely repeated, that the centres (or else the centres and points of contact) produce the cuboctahedral point-lattice, because in relation to the centre of each sphere the centres of the twelve surrounding tangent spheres (also the twelve points of contact) coincide with the vertices of a cuboctahedron (Figure 59).

[1] In nature the hexagonal lattice is very frequent—for instance, when living cells more or less equally distributed on a plane or curved surface develop by lateral expansion or growth. In space, superficial tension makes living cells (like unicellular organisms) take spherical shape which, apart from an equal repartition of stresses, gives the maximum volume for a given surface (or the minimum surface for a given volume), hence economy of substance. Whenever those cells are closely distributed on the same plane, and have a sufficiently strong expanding force, they take for the same reason hexagonal shapes (corals, colonial madrepora, also the facets on the eye of the fly).

[2] There is another way of packing tangent spheres in a regular way, when their centres are the centres of close-packed cubes, each sphere being tangent to the six faces on the enveloping cube. The equilibrium, the balance of stresses, is of course not as stable as in the other arrangement, as the centres do not form a perfectly isotropic lattice. The cuboctahedral packing of spheres corresponds to the "natural" piling of shot or balls.

FIGURE 58

FIGURE 59

Plate XXIX shows another projection of these thirteen tangent spheres, only the upper layer being completely drawn; they correspond to a projection of the cuboctahedron in which its affinity to the hexagon is clearly seen, as in the upper figure of the plate.

We have seen that among the thirteen Archimedian semi-regular polyhedra, Kelvin's polyhedron (Figures 46 and 47) is the only one which can be close-packed in space without leaving intervals; it is also amongst the regular or semi-regular solids allowing an equipartition of space (the cube and hexagonal regular prism are the only other ones in this category) the one which gives the greatest volume for a given surface; [1] this property is derived from the hexagon (as are for the cuboctahedron the property of producing isotropic point-lattices and of having its side equal to the radius of the circumscribed sphere). Among the regular right-angled prisms (which are really semi-regular polyhedra as they have two different kinds of faces) the hexagonal prism (and its subdivision the triangular prism) also allow the equipartition of space (a property equally inherited from the hexagon, which has thus three representatives in three-dimensional space).

We have already seen that space can be closely filled in a "polymorphic" way (two or more different kinds of regular or semi-regular polyhedra) by a system of tetrahedra and octahedra (twice as many tetrahedra as octahedra) or by a system of octahedra and cuboctahedra in equal numbers. Other systems of close-packing regular and semi-regular polyhedra of two or more kinds might be deduced from a general formula starting from the fact that the solid angles meeting at one point must add to eight solid right-angles (right-angled trihedra). These regular and semi-regular partitions of space play of course an important

[1] So that if one supposes that the spherical cells in a system of spheres close-packed according to the isotropic (cuboctahedral) arrangement possess a faculty of indefinite elastic expansion, the cells will tend to take the shapes of Kelvin's polyhedra.

rôle in crystallography; elementary crystals are close-packed and produce simple or complex space-lattices according to the different elements and different axes of symmetry. The basic configurations are the three principal systems of partition of space: cubic, hexagonal (derived from close-packed hexagonal or tetrahedral prisms) and cuboctahedric, which partakes of the two previous ones.[1] There are in all seven fundamental groups of symmetry, representing 230 possible types of point-lattices.[2] The fundamental law in crystallography is the "law of rational coefficients": the coefficients expressing (in three-dimensional analytical geometry) the relations between the different plane facets of a crystal and the directions of the three principal axes of symmetry are small integer numbers.

The different configurations of crystallized matter correspond to states of stable or relatively stable equilibrium determined by rigorous causality, the chemical reactions of the different elements being themselves explained by a tendency of the electrons to combine with each other according to more stable arrangements. The most general principle governing the states of equilibrium of physico-chemical systems is the "Criterium of Dirichlet": in order that the equilibrium of a closed system should be stable it is sufficient that its potential energy should be (or should pass through) a minimum. A corollary is Curie's Law: a body tends to take the shape presenting the minimum surface energy made possible by the directing forces. In many cases (for crystalline systems as well as for the more complex ones of organic chemistry) the minimum of superficial potential energy corresponds to the solution which for a given volume produces the smallest surface agreeing with the linking forces. (In space the sphere gives

[1] We have seen that common salt (Sodium Chloride) crystallizes according to the cuboctahedric lattice; so does carbon in diamond, and so do in general gold, silver, copper and aluminum. Iron at normal temperature crystallizes in the cubic system (including the centres of the cubes).

[2] A crystallized body shows a number of interlocked point-lattices corresponding to the number of atoms in each molecule.

the most perfect balance of surface energy and the minimum surface stress).

All those principles ruling the stable configurations of physicochemical systems are special cases of the most general law applying to inorganic bodies: the Principle of Least Action or Principle of Hamilton.[1]

The thermodynamical aspect of the Principle of Least Action is the Law of Degradation of Energy, or of the Growth of Entropy (energy is degraded when passing from high tension forms to low tension forms, the lowest being diffused warmth).

Another form of the general principle is Curie's principle: in order that a phenomenon should be produced in a system it is necessary that certain elements of symmetry should be missing (it is "dissymmetry" which is the cause of the phenomenon; in a perfectly homogeneous and isotropic medium, there is no "sufficient reason" for any change).[2]

[1] In order to pass during the interval of time $t_1 - t_0$ from one state to another, a physico-chemical system passes through stages such that the average value of *action* (difference between the Kinetic and the potential energy of the system) within that interval should be as small as possible.

[2] It is also the Principle of Least Action, under its form of "Principle of Stationary Action," which enabled Einstein to establish his General Theory of Relativity, also enabled De Broglie to investigate the inner workings of the atom and establish his Wave Mechanics.

The Geometry of Life

WE HAVE in the preceding chapters sketched the outlines of what may be called the "Science of Space" in the abstract, including the Theory of Proportions, the study of regular and semi-regular polyhedra, and of the interlinking, through the operation (or, to follow Plato's trend of thought, the mediation) of proportions, of those solids and of other remarkable volumes.

This same Science of Space was the basic discipline, the aesthetical frame and guide for the painters and architects of the First Renaissance, and for Dürer (who rode in the autumn of 1506 from Venice to Bologna, residence of Luca Pacioli, in order to be initiated in the mysteries of a "secret perspective").

It is here tentatively suggested that what was good enough for him, for Alberti, Leonardo, Vignola, et cetera, might be good enough for the painters and architects of today. The ignorance of the rudiments of the geometry of solids is especially surprising when noticed in painters of "cubist" ideals and tendencies.[1]

The enumeration and examination of regular and semi-regular solids has led us naturally to consider equipartitions and partitions of space, and to delineate the general laws under which physico-chemical systems may sometimes order themselves into geometrical patterns or "constellations." We have found that the

[1] The most impressive "cubist" manifesto has been formulated by Plato in the *Philebus*:

"But by beauty of shape I want you here to understand not what the multitude generally means by this expression, like the beauty of living beings or of paintings representing them, but something alternatively rectilinear and circular, and the surfaces and solids which one can produce from the rectilinear and the circular, with compass, set-square and rule. Because these things are not, like the others, conditionally beautiful, but are beautiful in themselves."

most general "Law of Nature," at least as applying to inorganic systems, was the Principle of Least Action, or Principle of Hamilton; that its general effect is to produce a state of equilibrium, of minimum potential energy, balanced stresses and equipartition of surface energy, all obtained with the greatest economy (or smallest production) of real (resisting) work.

The statistical form of the principle is: "A system (even a Universe) passes constantly from its least probable to its most probable states," the configuration of maximum probability being at the same time that of the maximum entropy, of the greatest "degradation" of energy (passing from high-tension to low-tension, low-grade energy, to diffused warmth). When the state of final equilibrium produces relatively stable or even rigid arrangements of molecules, as in crystals, we generally obtain geometrical patterns and lattices, resulting from more special aspects of the general principle.[1]

The consideration of isotropic (identical to themselves in every point) systems and point-lattices allowed us to foresee a preference for cubic or hexagonal systems of symmetry; the law of rational indices or coefficients (which is not only an empirical fact but can be deduced from the general theory of groups of symmetry and homogeneous partitions of space) shows us that we have here more than a preference or probability; the cubic, hexagonal, or cuboctahedral symmetries and lattices *must* appear in crystalline inorganic systems to the exclusion of all others, and the pentagon, dodecahedron, icosahedron, do not and *cannot* appear there (one of the subsidiary reasons being that the angles at the vertices of pentagon, dodecahedron and icosahedron are not compatible with regular partitions of space).

[1] We have seen that the law of the minimum surface potential energy introduces for a given volume the solution giving the smallest possible surface agreeing with the linking forces. Another consequence is the tendency to obtain an homogeneous or symmetrical disposition of molecular and atomic elements, hence plane faces as in crystals (and in regular arrangements of piles of shot or cannon-balls), and the "law of rational indices."

The directed, asymmetric, "pulsating" forces manifested in growing living organisms act, or can act, quite differently from the physico-chemical reactions obeying the "Principle of Least Action,"[1] so that the "Geometry of Life" will introduce shapes and volumes not met with in rigorously inorganic systems. One of the most striking examples of the predominance of hexagonal symmetry in those (inorganic) systems when conditions are favourable to a homogeneous repartition of stresses is shown by the microscopic examination of snow-flakes; these give a practically infinite number of hexagonal (more rarely, triangular) patterns, sometimes with a strikingly beautiful but hard perfection (Figure 60 gives an example out of the many thousands of different snow-crystals photographed by W. Bentley and others).

On the other hand the pentagon and the dodecahedron (its representative or expansion in three-dimensional space) whilst *never* appearing in inorganic crystalline systems,[2] play a predominant rôle in the shapes of living organisms, and in the diagrams of living growth; this for the double reason that:

(1) The Golden Section, the Φ series or progression (and its asymptotic subsidiary the Fibonacci series) have the property of producing by simple addition (accretion of identical parts) a succession of numbers in geometrical progression, or a succession of similar shapes (the two results are intimately connected), what

[1] This Principle is in fact a mathematical test of discrimination between inorganic and organic systems. It is not that the physico-chemical laws are really in abeyance within a closed system containing life, but that life in such a system can act as an "external force"; the system, although apparently closed, does not behave as a closed system. The tendency of plants to absorb carbon dioxide and to give up oxygen is a most "improbable" reaction; so is also the continuous photosynthesis by which plants, with low-grade elements (water and carbon dioxide) and low-tension energy, build up stocks of substances of high-grade chemical potential (dextrose, et cetera).

[2] It is the regular dodecahedron which never appears there; irregular dodecahedra, with non-identical faces, do (but very seldom) appear in iron-pyrites, as the different angles may so adjust themselves to each other as to produce a stable equilibrium and an isolated irregular crystal.

Sir D'Arcy Thompson calls "Gnomonic Growth"; [1] this type of homothetic growth by intussusception or imbibition (from inside outwards) is the one associated with living organisms, whereas in crystals the growth is by "agglutination," simple addition from outside of identical elements, each particle getting at the place most easily reached, the final distribution of energy in the system being such as to cause no further motion (this incidentally corresponds to plane facets or faces). And the Golden Section and the

[1] In the Greek theory of figurate numbers, a *gnomon* was a number which added to a figurate number (plane or solid) produced the next figurate number in that series (that is, a "similar" number); the Greek gnomons corresponded thus to our finite differences, but had always a geometrical aspect. Thus the series of triangular numbers, 1,3,6,10,15,21,... $\frac{n(n+1)}{1.2}$, has as corresponding series of gnomons the series of natural integers 1, 2, 3,..., n, and corresponds also to a series of growing similar triangles.

related series are, as we have seen, intimately associated with the pentagon and pentagonal symmetry.

(2) Whereas this pentagonal symmetry cannot be (for purely arithmetical reasons in angular distribution) associated with equipartitions of space or homogeneous point-lattices, it fits in perfectly with the asymmetric and vectorial (directed) pulsations of living growth, especially the ones creating similar shapes,[1] (gnomonic growth). As Professor Jaeger stated for the first time in his "Lectures on the Principle of Symmetry," a certain preference for pentagonal symmetry, a symmetry connected with the Golden Section and unknown in inanimate systems, seems to exist in the animal reign as well as in botany (we have just seen the reasons for this preference). Professor Jaeger notices that the shapes of the five regular solids are found in radiolarian skeletons (the icosahedron in *Circogonia Icosahedra*, the dodecahedron in *Circorhegma Dodecahedra*), whereas the regular dodecahedron and icosahedron are never found in mineral crystallizations.

We have already mentioned the presence of the Φ rectangle and of the Golden Section in the human body; before giving more details about this, we must point out an algebraical curve intimately connected with homothetic ("gnomonic") growth, the logarithmic spiral. Its definition is: a plane curve produced by a point on a straight line which (the line) rotates uniformly around a pole situated on it, this point moving on the line (vector radius) with a speed proportional to its distance from the pole (Figure 61). The logarithmic spiral is the only plane curve in which two arcs are always "similar" to each other, varying in dimensions but not in shape (in the same spiral), and this property is ex-

[1] Another difference between inorganic (purely physico-chemical) and organic reactions is that whereas in the first case the Principle of Least Action tends to produce an economy of energy (of production of useful energy, but a maximum spending of accumulated, useful, energy), in the second case (living systems) there seems to be a tendency towards economy of substance (D'Arcy Thompson, *op. cit.*). There is a curious analogy here with gothic architecture, where the balancing of stresses on pillars and buttresses allows of a minimum weight in walls and roofing.

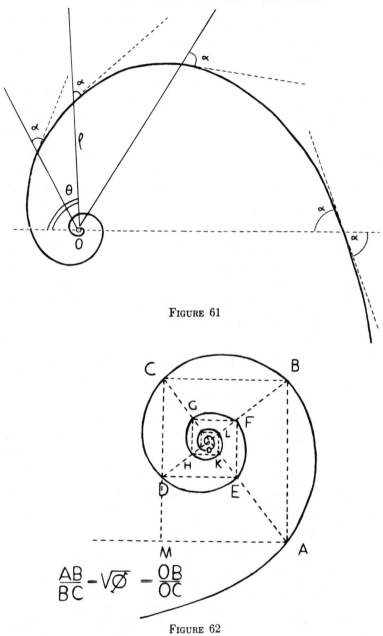

FIGURE 61

$$\frac{AB}{BC} = \sqrt{\phi} = \frac{OB}{OC}$$

FIGURE 62

tended to the surfaces determined by the vector radii limiting the arcs.[1] Inversely, any plane curve starting from a pole and such that the vectorial area of any angular sector be a "gnomon" for the whole of the preceding shape is a logarithmic spiral. This property of gnomonic growth and the rôle of the logarithmic spiral in living growth have been specially studied by Sir D'Arcy Thompson in his outstanding treatise on "Growth and Form" (C.U.P.); the property of gnomonic growth applies also to the curved surfaces and volumes bounded or defined by logarithmic spirals, and inversely: if a geometric structure is composed of successive homothetic (similar) parts, similarly situated, we can always trace through the corresponding points a series of logarithmic spirals. All this applies specially to the growth of shells [2] and horns (antelopes, wild goat and sheep, et cetera).

Every logarithmic spiral is directly connected to a characteristic geometric series or progression determined by the intersections of any vector radius by the consecutive spires; then the successive lengths of the segments form a geometrical series [3] and so do the segments between the spires (LF, FB, et cetera); the ratio of any of these progressions is the same for any given logarithmic spiral. But every logarithmic spiral is also related to the shape of a characteristic rectangle determined by the intersection with the curve of three radii separated by right angles (as on the

[1] The equation of this curve in polar coordinates can be deduced from the definition; it is $\varrho = a^\vartheta$ (equivalent to $\vartheta = K \log \varrho$). The radius grows in geometrical progression, whilst the angle grows in arithmetical progression, so that the angles are (apart from a constant factor) the logarithms of the corresponding radii. The vector radius in every logarithmic spiral makes also a constant angle α with the curve (Figure 61). The straight line and the circle are extreme limiting cases of the logarithmic spiral, with α respectively $0°$ and $90°$. The curve is so rich in remarkable algebraical and geometrical properties that Bernouille named it *"Spira Mirabilis."*

[2] The magnificent *Haliotis Splendens* or Abalone Shell of California (upper figure, Plate XXX) is a perfect example of gnomonic growth, as regards lines, surfaces, volumes.

[3] Like the segments OL, OF, OB, et cetera, or the segments OK, OE, OA, et cetera, in Figure 62.

lower right figure in Plate XXXI and on Figure 62) and the characteristic ratio of the rectangle (between its longer and its shorter side) is also sufficient to specify the corresponding spiral (it is also the ratio between two consecutive perpendicular radii, $\frac{OB}{OC}$, or $\frac{OA}{OB}$, in Figure 62).

Plate XXXI shows three abstract pentagonal designs (therefore in the Golden Section proportion theme) of which the upper ones suggest floral shapes; the lower right figure is a logarithmic spiral having the Φ rectangle as characteristic or directing rectangle and $\Phi = 1.618$ as characteristic ratio or modulus (this spiral characterizes the shape of the small Abalone Shell, *Haliotis Parvus*). But the ratio of the geometric progression determined by the intersections of radii and consecutive spires is Φ^4. Figure 62 shows the logarithmic spiral having the $\sqrt{\Phi}$ directing rectangle, and therefore $\sqrt{\Phi} = 1.273$ as characteristic ratio or number; the ratio of the geometric progression determined by the intersections of radii and spires is Φ^2. This rule is general: if r should be the characteristic ratio or number of any logarithmic spiral (that is, the characteristic ratio of its directing rectangle), then the ratio of the geometric progression determined by the spires on any radius is r^4. One can call r the quadrantal pulsation, r^4 the radial pulsation of the spiral. The spiral of Figure 62 (with $\sqrt{\Phi}$ as characteristic ratio or quadrantal pulsation) is associated to the shape of the beautiful shell *Dolium Perdix*. This spiral and the one having Φ as characteristic ratio can be taken as typical curves of "harmonious growth." In the shells *Murex, Fusus Antiquus, Scalaria Pretiosa, Solarium trochleare,* many fossil Ammonites, and in the volutes of many Ionic capitals, the specific spiral has $\sqrt[4]{\Phi}$ as characteristic rectangle or ratio, or quadrantal pulsation, and therefore Φ as radial pulsation.

Plate XXXII shows the approximative logarithmic spiral connected with a pseudo-gnomonic-cellular growth with Fibonaccian accretion (series 1, 2, 3, 5, 8, 13, 21, 34, 55, 89, . . .); it is

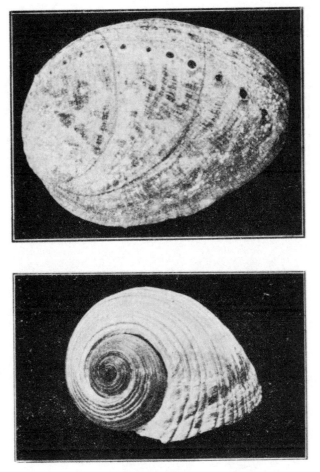

PLATE XXX
Logarithmic Spiral and Shell-Growth

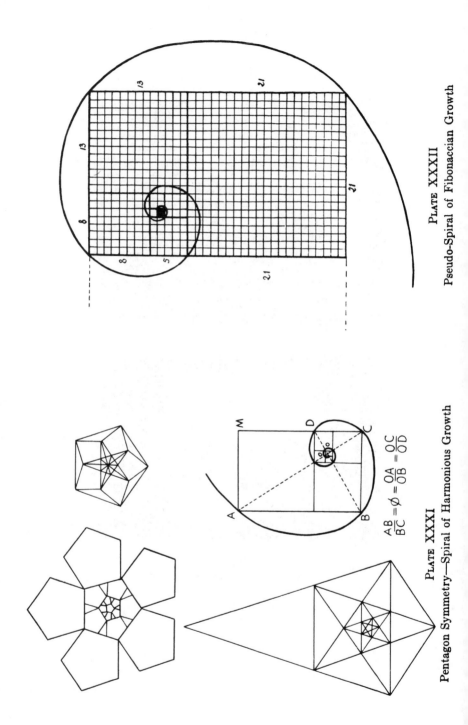

PLATE XXXII

Pseudo-Spiral of Fibonaccian Growth

$$\frac{AB}{BC} = \phi = \frac{OA}{OB} = \frac{OC}{OD}$$

PLATE XXXI

Pentagon Symmetry—Spiral of Harmonious Growth

often met in biology and is asymptotic to the logarithmic spiral with characteristic ratio and quadrantal pulsation Φ. We have seen that a similar, Fibonaccian, approximation (the progression 55, 89, 144) was probably used in the execution of the Great Pyramid.

On Plate XXXIII is seen a typical example of pentagonal symmetry in flowers; this symmetry is also met in many marine organisms, specially starfishes and sea-urchins, as in Plate XXXIV (the whole system of covering plates of the sea-urchin is based on pentagonal design; Plate XXXIV shows in its lower right figure the extraordinary masticating gadget of the sea-urchin, called "Aristotle's Lantern").

Plate XXXV gives two examples of X-rayed shells, showing clearly the directing spiral of *Nautilus Pompilius* and the gnomonic growth of *Triton Tritonis*.

Let us return to the human body; as mentioned before, the average human body (and within the body, the face) shows an extraordinarily symphonic "commodulation" of proportions either in the Golden Section theme, or in that of the "consonant" $\sqrt{5}$ proportion. J. Hambidge has analysed hundreds of skeletons and published the striking results of his measurements in his magazine *Diagonal* (Yale University Press). Although the individual measurements vary, and although even the ways in which the proportions are linked may take many forms (variations of *key* or mode), each normal skeleton reveals what is a perfect "symphonic" design or harmonic theme. We must here admit with Hambidge that the skeletons show the details and over-all designs of these themes more rigorously than the living human body where skin, muscular tissues, hair, et cetera, introduce fluctuations less easily translated into precise measurements. Whereas in the living body the navel is the visible centre of symmetry, pole, or focus of the system of proportions (as already noticed by Vitruvius) in the skeleton this centre is (in frontal

projection) the intersection of the vertical axis with the horizontal line tangent to the upper bones of the pelvis.[1]

The ideal Golden Section Symphony appears in the average values of measurements taken of hundreds of bodies, or else in "ideal" specimens; I reproduce in plates XXXVI, XXXVII, XXXVIII, XXXIX, and XL the perfect Golden Section theme of proportions appearing in the face of Helen Wills (the Olympic tennis champion), in the profile of Isabella d'Este, and in the body of a Viennese athlete.

The readers of the previous chapters will recognise on Plates XXXVII and XL the icosahedron (or the star-dodecahedron) which already appeared in the diagrams (Plates XVI and XVII) combining the proportions of the Great Pyramid and of the King's Chamber.

An interesting point is that in this particular "ideal" theme, the fundamental diagram of the face is the same as the one of the whole body; the link between the two is that the height of the face is equal to the vertical distance between the middle of the body (intersection of the legs in "ideal" specimens) and the navel. The vertical distance between the top of the head and the navel (the *minor* of the two segments in the Φ proportion determined by the navel) is equal to the distance between the tip of the medium finger (the arm hanging vertically) and the floor or horizontal level supporting the whole.[2]

[1] A most thorough analysis of the proportions of human skeleton and living human body is given by Mr. E. Beothy (sculptor and architect) in his very useful book *La Série d'Or* (Chanth, *ed.*).

[2] The Φ proportion appears in many other projections or measurements of the human body. I have already mentioned that the three bones of the middle fingers form universally a Φ progression (the longer being equal to the sum of the two other ones).

Amongst Miss Veronica Lake's measurements given in an American magazine, I notice 34″ for the chest contour, and 21″ for the waist, both Fibonaccian numbers, having as ratio 1.619.

In the average or *ideal* face, we find also the Φ ratio between the height of the face (up to the roots of the hair) and the vertical distance "line of eye-brows–lower tip of the chin," and between the vertical distance "lower part of the nose–lower tip of the chin" and the distance "meeting line of the lips–lower tip of the chin."

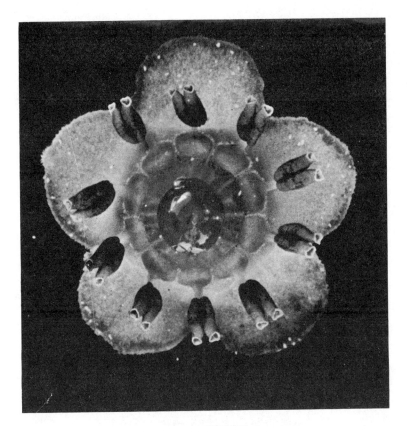

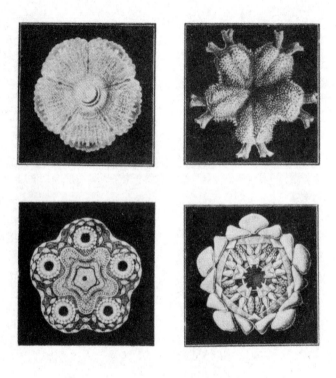

PLATE XXXIV
Pentagonal Symmetry in Marine Animals
(Photograph, Bibliographisches Institut, Leipzig)

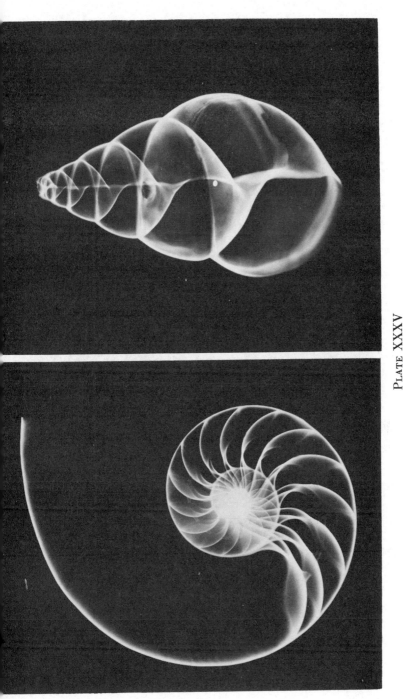

PLATE XXXV

Shell, Logarithmic Spiral and Gnomonic Growth

(Photographs: Kodak Limited)

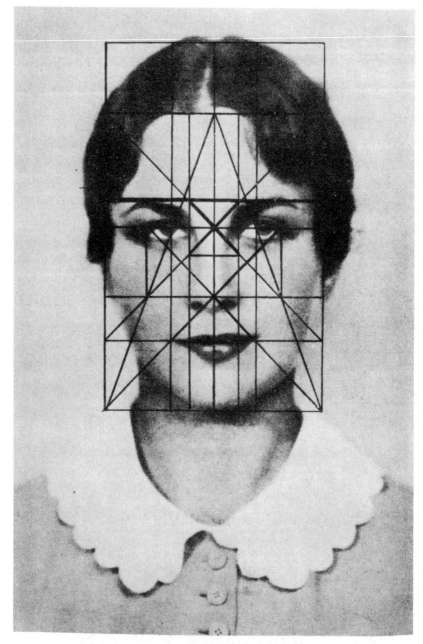

PLATE XXXVI
Miss Helen Wills, Harmonic Analysis

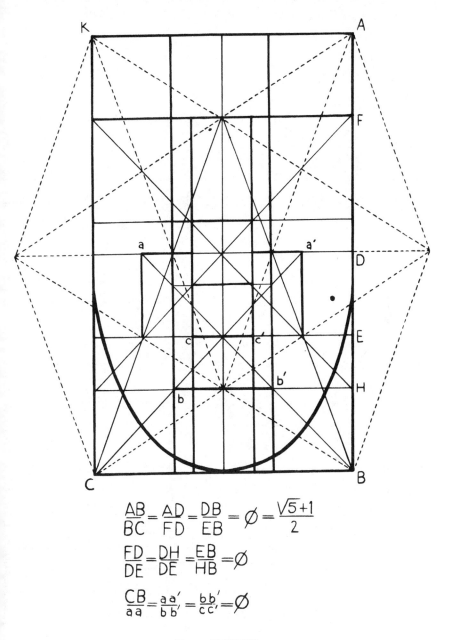

$$\frac{AB}{BC} = \frac{AD}{FD} = \frac{DB}{EB} = \emptyset = \frac{\sqrt{5}+1}{2}$$

$$\frac{FD}{DE} = \frac{DH}{DE} = \frac{EB}{HB} = \emptyset$$

$$\frac{CB}{aa} = \frac{aa'}{bb'} = \frac{bb'}{cc'} = \emptyset$$

PLATE XXXVII
Miss Helen Wills, Diagram of Proportions in Face

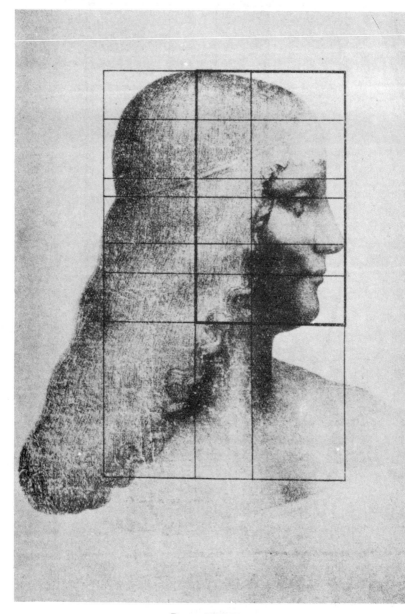

PLATE XXXVIII
Isabella d'Este, Harmonic Analysis
(Photograph, Alinari)

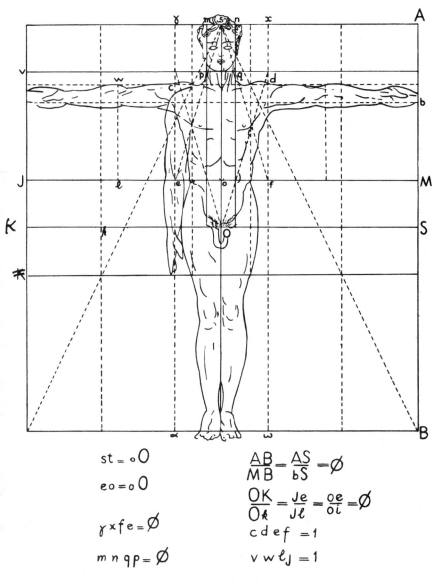

$$st = {}_oO$$

$$eo = {}_oO$$

$$\gamma x f e = \emptyset$$

$$m n q p = \emptyset$$

$$\frac{AB}{MB} = \frac{AS}{bS} = \emptyset$$

$$\frac{OK}{O\hbar} = \frac{Je}{Jl} = \frac{oe}{oi} = \emptyset$$

$$c d e f = 1$$

$$v w l_J = 1$$

PLATE **XXXIX**
Athlete's Body, Harmonic Analysis

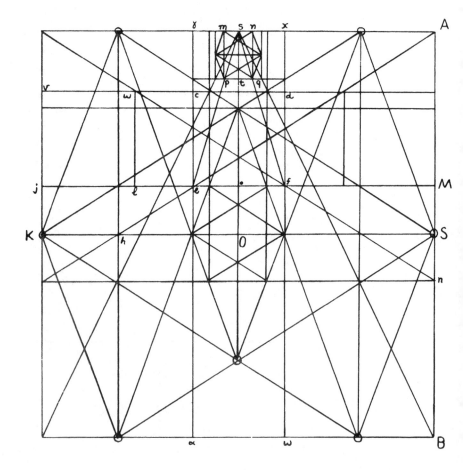

PLATE XL
Diagram of Preceding Analysis (Φ Theme)

It is also interesting to study the fluctuations of the ratio $\frac{h}{n}$ (total height to navel height) during the continuous growth of one particular body; here is a table giving the different values of that ratio (as also of the ratio $\frac{n}{m}$, where m represents the vertical distance between the top of the head and the navel) as observed by Zeysing on a particular boy from his birth to the age of 21 (he published his results in 1855):

Vertical Height h in metres:	Age in years:	$\frac{h}{n}$	$\frac{n}{m}$
0.485	0	2	1
	1	1.90	1.11
0.863	2	1.84	1.17
	3	1.79	1.26
	4	1.75	1.34
	5	1.70	1.42
	6	1.68	1.46
	7	1.67	1.50
	8	1.65	1.54
	9	1.64	1.56
	10	1.64	1.57
	11	1.63	1.58
	12	1.63	1.59
	13	1.625	1.60
	. .		
	17	1.59	1.70
	. .		
1.731	21	1.625	1.60[1]

Zeysing observes that in this special case the ratio $\frac{n}{m}$, after having reached once its definite future value (1.60) about the thirteenth year, overreaches it in a strong oscillation which, about the seventeenth year, gives to the adolescent male body ultra-feminine

[1] We see that in this case the popular belief that when two years old a child has half his future adult height is justified within an approximation of five millimetres. If we write $p = \frac{n}{m}$, we have $\frac{h}{n} = \frac{p+1}{p}$. It is interesting also to note that in the new-born infant the navel divides the body into two equal parts.

proportions, returning afterwards to the male ratio 1.60 when adult growth has been achieved.[1]

If the human body gives the most striking and obvious illustrations of the presence of the Golden Section in living growths and shapes, other examples can be found all through the animal world (including insects), and the resulting diagrams of proportions, however diversely arranged, can be deciphered by the same key.

The analysis of the profile projection of the photograph of a perfect thoroughbred (Plate XLII) shows an interesting combination of squares, Φ, $\sqrt{\Phi}$, and $\Phi\sqrt{\Phi}$ rectangles; the resulting over-all frame is unexpectedly a square.

Having finished this brief presentation of what we have called "The Geometry of Life," and shown the part played therein by Pacioli's *Divine Proportion* and the correlated pentagonal symmetry, we will now try to present the conclusions of recent research concerning the transmission of Greek and Gothic plans and canons of proportion, considered also under the angle of the "Science of Space" sketched in the first five chapters.

[1] Zeysing found that this value $1.60 = \frac{8}{5}$ for $\frac{n}{m}$ is an average value for male proportions, and that $\frac{5}{3} = 1.666$ is an average value for feminine proportions; he also correlated those values respectively to the major and minor triads and scales.

The smallness of the head on the "ideal" body of Plates XXXIX and XL is of course exceptional; a more normal set of good proportions is shown in Plate XLI, where in an over-all rectangle of characteristic ratio $\frac{\sqrt{5}}{2}$, the head is $\frac{1}{8}$ of the total height, and the navel has a vertical ordinate of $\frac{5}{8}$ of the whole body.

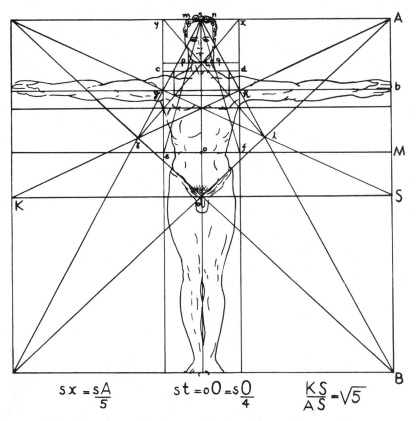

$$sx = \frac{sA}{5} \qquad st = oO = \frac{sO}{4} \qquad \frac{KS}{AS} = \sqrt{5}$$

PLATE XLI

Male Body in $\sqrt{5}$ Theme, with Diagram

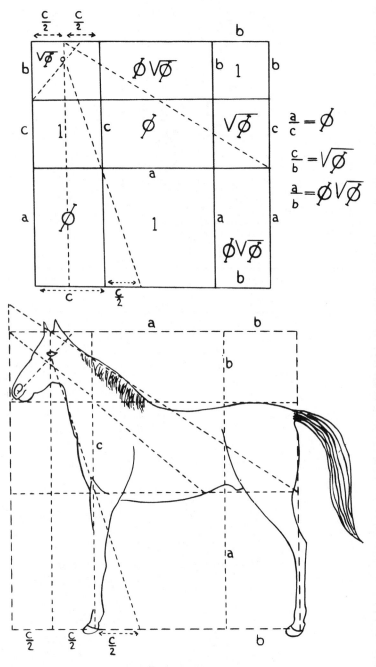

$$\frac{a}{c} = \phi$$

$$\frac{c}{b} = \sqrt{\phi}$$

$$\frac{a}{b} = \phi\sqrt{\phi}$$

PLATE XLII
Harmonic Analysis of Horse in Profile

The Transmission of Geometrical Symbols and Plans

HAVING DISCOVERED that there is a "Geometry of Life" correlated to what we have called the Theory or Science of Space (and showing characteristic differences from the Geometry of ordered inorganic systems like crystals), we shall now proceed to find out if there is also a "Geometry of Art," and the connections, if any, between it and the Geometry of Life. The answer to the first question, if we consider the case of Architecture, is obviously in the affirmative, and it is in this realm that our research will start; we will later see that the other "visual" arts, Painting, Sculpture, specially Decorative Art (any craft in fact where design is useful or necessary) have to take the "Science of Space" into consideration. We can even state that Geometry, and especially the concept of Proportion, thoroughly worked out by the followers of Pythagoras and Plato on the lines presented in Chapter I, are the foundation of the whole development of European or Western Architecture, leading through the Vitruvian concepts of analogy and "symmetry" to a "eurhythmic," symphonic attitude to Art in general.

This conception was intimately related to the Pythagorean axiom that "Everything is arranged according to Number," [1] and to the vision of the Universe as a harmoniously ordered Whole;

[1] *Hieros Logos* of Pythagoras, quoted by Iamblichus. In his *Epinomis*, Plato supports the Pythagorean point of view: "Numbers are the highest degree of knowledge" and "Number is Knowledge itself." The whole argument of the *Timaeus*, the text of Plato's magnificent Seventh Letter, his friendship with Archytas of Tarentum, confirm the supposition that Plato had adopted, then developed, the core of the Pythagorean doctrine.

the word *Cosmos* was, according to tradition, credited to Pythagoras, and meant originally "Order," and this order is perceived as harmony, as consonance between ourselves and the Universe. This idea was developed as the correspondence between the Macrocosmos (the World) and the Microcosmos, or Man, with sometimes the Temple as link, as "proportional mean" between the two.

This point of view was reinforced by the importance given by the Pythagoreans to the theory of Music, and the Platonic theory of Proportions is directly issued from that of musical intervals (considered as ratios between the lengths of the strings of the tetrachord).[1]

Number and its translation or illustration, geometrical form, played thus a dominant part in the *Weltanschauung* of the most important and influential school of Greek thought.[2]

For the Pythagoreans and Plato indeed, Number, the "ideal" or "divine" number (as distinguished from the ordinary, arithmetical counting or measuring number—this distinction has been reintroduced by the modern school of Mathematical Logic, or Logistics, with Bertrand Russell's and Whitehead's concept of number as a "Class of Classes") is one of the archetypes, paradigma, eternal patterns guiding the "Great Ordering One"; in fact the different integers were not two, three, four, five, ten, et cetera, but the dyad, triad, tetrad, pentad, decad, having their

[1] Cf. in the *Timaeus* the establishment by Plato of the "Number of the World-Soul," or Cosmic Scale of 36 notes. Plato starts from the two geometric progressions 1,2,4,8 and 1,3,9,27, combined into one series 1,2,3,4,9,8,27, then "fills" twice all the intervals, first by arithmetic, then by harmonic means ($b = \dfrac{a+c}{2}$ and $b = \dfrac{2\,ac}{a+c}$ respectively).

[2] That Plato was the interpreter of the still esoteric Pythagorean creed is abundantly proved, not only by many passages in the *Timaeus* and *Theaetetus*, but by his beautiful Seventh Letter to the heirs of Dion of Syracuse. I repeat here the quotation out of the *Timaeus* set in front of my Introduction: "And it was then that all these kinds of things thus established received their shapes from the *Ordering One*, through the action of Ideas and Numbers" (*Timaeus*)

special character, one might say personality, in the "Society of Numbers." This leads naturally to a Number Mysticism which had a direct offspring (born in the rich intellectual soil of the Alexandrine Diaspora) in the Hebrew Kabbala, and which was transmitted through numerous more or less underground channels (Medieval Magic, Rosicrucian Esoterism, Operative and Speculative Masonic Lodges).

The most important "personalities" among the archetypal numbers (setting aside the One or Monad out of which by "fluxion" all the others could be produced) were for the Pythagoreans the Five, or Pentad, and the Ten, or Decad.

Five was the number of Love (uniting Two, the first even, female, number, and Three, the first odd, male, number);[1] it was also the symbol of Health (Hygeia) and Harmony.[2] With the Pentad or Five was associated its geometrical symbol, the Pentagram or Pentalpha (five interlinked A's). And a passage of Lucian ("On Slips in Greeting") informs us that the pentagram was the secret sign of brotherhood between the Pythagoreans.[3] The importance of this symbol and of the constructions related to it, all based on the Golden Section, and kept jealously as the most important mathematical secret of the Fraternity, is underlined by a reference in Iamblichus (*Life of Pythagoras*):

"Hippasus who was a Pythagorean but, owing to his being the first to publish and write down the construction of the sphere from 12 pentagons (the construction of the dodecahedron), perished by shipwreck for his impiety, but received credit for the discovery, whereas this really belonged to HIM (Pythagoras)."

Hippocrates of Chios is reported to have been expelled from

[1] The students of the Chinese *Pa-Kua* or Eight Magic Trigrams, will recognise an identical conception, curiously justified by the modern theory of Chromosomes and Genes.

[2] If Five was the Number of Love, Seven was the Virgin Number. We have seen that the circle cannot be divided into seven parts by a rigorous construction. A neo-Pythagorean manuscript of the French "Bibliothèque Nationale" states: "ὁ πέντε γάμος. ὁ ἑπτὰ παρθένος."

[3] This is confirmed in the *Scholium 609* to Aristophanes' *Clouds*.

the Fraternity for having divulged the construction of the pentagon.

The importance attached to the pentagram is confirmed by Lucian in an episode in which, in the night before a decisive battle, Alexander appears, in a dream, to Antiochus, showing him a pentagram.[1]

After what we have seen about the rôle of pentagonal symmetry and of the associated Golden Section in the Morphology of Life and living Growth, the choice of this symbol seems to have been guided by an extraordinary intuition. We have already mentioned that in the *Timaeus*, Plato chooses the dodecahedron, projection in three dimensions of the pentagon, as guiding scheme for the harmony of the Cosmos. Here, too, he seems to have followed a Pythagorean inspiration; we find the following hint in Aetius (*Placita*): "Pythagoras, seeing that there are 5 solid figures . . . said that the Sphere of the Universe arose from the dodecahedron." [2]

Pacioli (*Divina Proportione*) states that Plato's choice is due to the presence of the Golden Section (quoting Campanus of Novara he reminds us that this proportion links together in a rational way the five regular bodies by an irrational-geometrical-symphony). The Pentagram became later, especially in medieval magic lore, the special symbol of Man, the Microcosmos, as corresponding by "analogy" to the Universe, or Macrocosmos. The Principle of Analogy, which was in the nineteenth century formulated by Thiersch as the leading guiding principle of Western Art,[3] is already found in Pythagorism as a general law:

[1] The same anecdote is related by A. Kircher in the chapter "De Magicis Amuletis" of his *Arithmologia*, the enemy (the Galates), being defeated after Antiochus had carried into battle a *vexillum* with the pentagram, following the advice of his professional dream-interpreters.

[2] A Scholium on Euclid's Fourth book. including the problem: "to construct a regular pentagon through mean and extreme ratio (Golden Section)," says: "The whole book is the discovery of the Pythagoreans."

[3] "We have found, in considering the most remarkable architectural productions of all periods, that in each of these *one fundamental shape is*

"You will know, as far as it is allowed to a mortal, that Nature is from all points of view similar to itself." (*Hieros Logos* or Sacred Speech, collected by the direct disciples of the Master of Samos).

The numerical symbol of the Macrocosmos or Universe was the Decad, or Ten; [1] the geometrical shape corresponding to it being the Decagon. We have seen that the decagon and pentagon have the same "theme" of symmetry (ruled of course by the Golden Section). The esoteric concept of correspondence or analogy between Macrocosmos (Ten) and Microcosmos (Five) was condensed by Hermetists, Kabbalists, Magicians, Rosicrucians, in the sentence:

ID QUOD INFERIUS
SICUT QUOD SUPERIUS

borrowed from the hermetic *Emerald Table.*

The Pythagorean oath by which the members of the Fraternity [2] bound themselves not to betray their mathematical and

repeated so that the parts by their adjustment and disposition reproduce similar figures. Harmony results only from the repetition of the principal figure throughout the sub-divisions of the whole." (*Die Proportion in der Architektur.*)

[1] Let us here quote Nicomachus of Gerasa, the most explicit exponent of Pythagorean Number-Mystic:

"But as the Whole was an illimited multitude . . . an Order was necessary . . . and it was in the Decad that a natural balance between the Whole and its elements was found to pre-exist . . . That is why the All-Ordering God (literally: "the God arranging with art") acting in accordance with his Reason, made use of the Decad as a canon for the Whole . . . and this is why the things from Earth to Heaven have for the whole as well as for their parts their ratios of concord based upon the Decad and are ordered accordingly." Also: "Because it (the Decad) was used as a measure for the Whole, as a set-square and a rule in the hand of the One who regulates all things."

We see here the source of the Vitruvian concepts of analogy, *symmetry* (concord) and eurhythmy, and the justification of Thiersch's conclusion.

Vitruvius also extolled the perfection of the number Ten; we will see farther down the correlation between Decad and Tetraktys, this latter being another of the Pythagorean mathematical secrets or passwords.

[2] The Pythagorean Brotherhood. established by the Samian philosopher (circa 580 to 500 B.C.) in Sicily and Calabria, consisted of three degrees: the

other secrets was taken in the name of the Tetraktys; this was the symbol

$$
\begin{array}{c}
\bullet \\
\bullet \quad \bullet \\
\bullet \quad \bullet \quad \bullet \\
\bullet \quad \bullet \quad \bullet \quad \bullet
\end{array}
$$

representing at the same timé the sum of the first four integers $(1 + 2 + 3 + 4 = 10$, that is the Decad) and the fourth "triangular" number (in the series with "gnomonic" growth 1, 3, 6. 10, 15,..., $\dfrac{n(n + 1)}{2}$, where the successive gnomons or differences are the integers of the natural series 1, 2, 3, 4..., n).

Tetraktys and Decad represent the same "archetypal" number,[1] but in addition the Tetraktys, owing to its "figurate" con-

novices or "politics" (exoteric stage), the "nomothets" (first degree of initiation), active philosophers who directed the social and political work of the Society by instructions given to the novices (simple executive and "liaison" agents), and lastly, the "Mathematicians," who had been through the complete initiation, including of course the "Laws of Number." Silence, music, certain incenses, physical and moral purifications (rigid cleanliness, pure linen clothes, daily self-examinations), a mild asceticism, played their part in the discipline of this community (their possessions were actually put in common) which, through the *Therapeutae* of Alexandrine Egypt, became a model for the contemplative monastic orders as well as for the militant ones (Jesuits, *Rules of St. Ignatius*) of the Christian Church, and for the most famous of modern secret societies.

Pythagorean teaching had such a success, that the Fraternity took over political power in Magna Graecia including Sicily (Crotoniate League); the Master died about 500 B.C., but the Pythagorean supremacy in Sicily and Calabria lasted till *circa* 450 B.C. About this date popular uprisings successively detached the vassal cities from the Crotoniate League, and the leading members of the sect, besieged by the mob in Metapontum, perished in a gigantic fire (with the exception of Philolaos and Lysis). Later Archytas, pupil of Philolaos and friend of Plato (whom according to Diogenes Laërtius he initiated to the Pythagorean secret teaching) succeeded in re-establishing a successful Pythagorean State in Tarentum.

[1] In Lucian's *Auction of Souls*, Pythagoras says to Agorastes: "Do you see? What you think is Ten, a perfect triangle and our oath." The form of the Pythagorean oath has been conserved for us by Iamblichus: "No, I swear by HIM who has given us the Tetraktys, in which are found the source and root of eternal Nature."

stitution, was an expression of the principal intervals of the tetrachord lyra $\left(\dfrac{2}{1}\right.$ or $\dfrac{4}{2}$, the octave, $\dfrac{3}{2}$ the fifth, $\dfrac{4}{3}$ the fourth$\left.\right)$.

Vitruvius, as mentioned above, underlines the virtues of the number Ten, and also the perfection of the Six; we have seen that Six (*Tiphereth*, the sixth Sephirah, number of Justice and Balance in the Kabbala), the geometrical symbol of which is the pseudo-hexagram or Shield of David, is associated to the hard, "perfect" symmetry of crystals. This association of 10 and 6 as important harmonizing numbers was already used by the ancient Egyptians (especially the characteristic ratio $\dfrac{10}{6} = \dfrac{5}{3}$, Fibonaccian approximation of Φ, for rectangles or volumes), and was later taken up by the architects of the first Renaissance.

The Pentagram itself was transmitted through the centuries by a triple underground filiation: as frame of the secret planning diagrams of architects and Master Masons, handed over from father to son, or adopted son (the same oath of secrecy imposed upon the Pythagorean initiates, was exacted from architects and physicians), as one of the esoteric recognition symbols or signs of certain secret societies, finally as actual element of magic ritual (pentacle).

The practical secrets of the craft of building were transmitted by the corporations of Stone Masons, from the antique "Collegia Opificum" existing already in Roman Republican times, through their successors in the Roman Western and Eastern Empires, to the Carolingian monastic architectural workshops (mostly Benedictine), and to the secular Medieval Guilds of Builders and Masons federated in the "Gothic" period on the continent in the *Bauhütte*, with supreme headquarters in the *lodge* attached to Strassburg Cathedral.

In England the oldest masonic documents (*Ordinationes* of York, 1352 and 1409) mention King Athelstan (925–940) as having established the first Guilds of Masons in the British

Islands. It is interesting to note that the "Cooke Manuscript" in the British Museum (copy dating from circa 1430 of a fourteenth century text) quotes Pythagoras and Hermes as having revealed the secrets of Geometry to the human race; the same manuscript in its statutory part insists on the obligations of the Mason of not betraying the secrets of his craft.[1]

We cannot insist here on the continuous chain, transmitting rites, passwords, symbols, which stretches from the Pythagorean Brotherhood and the Greek Mysteries (Eleusis) to these Operative Masons Lodges, then to Speculative Masonry;[2] we will only remark that while the Pentagram travelled as a magic symbol and tool via Occultist and Rosicrucian circles (we find it in Agrippa of Nettesheim's *De Occulta Philosophia*,[3] 1530, in Henry Kunrath's *Amphitheatre de l'Eternelle Sapience,* 1609, finally as defensive pentacle used by Faust against Mephistopheles in Goethe's drama);[4] it also travelled in its other (politico-

[1] In another, somewhat later, Masonic manuscript, we find the admonition: "You shall keepe secret ye obscure and intricate pts, of ye science, not disclosing them to any but such as study and use the same" (MSS n = 2, Great Lodge of London).

[2] The reception of honorary, "accepted," members by the operative English and Scottish Lodges is already mentioned in 1600 (John Boswell of Auchinleck received in the lodge "Mary's Chapel" of Edinburgh as "non-operative brother"); in 1663 the Earl of St. Albans is elected honorary Grand Master of the "Old Lodge of St. Paul," with Sir Christopher Wren as "Surveyor." And it is only in 1717 that "Speculative" Free-Masonry was established independently with the "Great Lodge of England."

[3] The link between Pythagorism and Medieval and Renaissance Occultism is evident in the following extract of Agrippa's *Kabbala*:

"Boetius has said: 'Everything which since the beginning of things was produced by Nature seems to be formed according to numerical relations, issued from the wisdom of the Creator.' Numbers are the nearest and simplest relations with the ideas of Divine Wisdom . . . The power of Numbers in living nature does not reside in their names, nor in the numbers as counting elements, but in the numbers of perceiving knowledge, formal and natural . . . The one who succeeds in linking usual and natural numbers to divine numbers will operate miracles through Numbers."

[4] (Faust to Mephisto:) *"Das Pentagramma macht dir Pein?"* In England, the Ashmolean Library possesses a fourteenth century magic manuscript in which a pentagram having in its centre the letter G is shown as a symbol

esoteric) trajectory from the Pythagorean Society to modern Free-Masonry, where the "Flaming Star" is none other than our Pentagram, with the letter G in its middle, Latin transcription of the hebrew *Yod*, itself the number Ten or Decad.

We shall not be surprised to see in the next chapter that, according to the converging results of recent researches about Canons of Proportions and plans used by Gothic Master Builders, the fundamental Gothic Diagram, the Key-Diagram transmitted from Master to Master (the third degree of initiation in the craft) was based on pentagram and decagon, placed within the circle of orientation of the church or cathedral.

Anticipating the next chapter, I reproduce in Plate XLIII this fundamental Gothic Master Diagram, out of which, as illustrated by Prof. Moessel (*Die Proportion in der Antike und Mittelalter*, C. H. Beck ed., Munich, and subsequent works), all standard plans of Gothic churches can be derived.[1]

In the operative Masons Guilds the Companion (second degree of initiation) received at the end of his probation period a personal "mason's mark" or seal which remained for life his sign or password. He had to draw and "prove" it when questioned on his peregrinations to other lodges. In opposition to the "Fundamental" Design, known only to the achieved Master Builders, these masons' marks, which were not secret, except for the way of "proving" them, that is, placing them in their circle, do *never* show the pentagram, pentagon or decagon, but obviously obey very carefully evolved geometrical schemes. About the "placing" (*Stellen*) of the sign according to the rules of what the documents

allowing one to obtain "the supreme knowledge." Two amulets having belonged to Dr. John Dee, the famous Elizabethan Master Magician, have each on one side a pentagram within a circle. A "magic" rock-crystal dodecahedron of the same period belongs to the London Museum of Medicine and Magic.

[1] Top figure Plate XLIII. On the lower diagram is shown the connection between this diagram and the Φ rectangle ABCD having as smaller side the side of the pentagon, AB = EF, and as greater side the side of the pentagram, BC = bc inscribed in the directing circle.

of the *Bauhütte* call *"Den fürnebmsten und gerechten Steinmetz-grund"* (The very noble and right fundamental law of the Stone-mason), we have to guide us only two mysterious quatrains in the *Bauhütte* ritual of which I give one:

> *"Ein Punkt der in dem Zirkel geht,*
> *Der im Quadrat und Dreyangel steht,*
> *Kennst du den Punkt, so ist es gut,*
> *Kennst du ihm nit, so ist's umbsonst!"*

> (A point in the Circle,
> And which sits in the Square and in the Triangle,
> Do you know the point? then all is right,
> Don't you know it? Then all is vain!)

It has been reserved to a Viennese architect, Franz Rziha,[1] to discover the mathematical key to these mysterious and pleasant masons' marks of which I reproduce (Plates XLIV and XLV) 10 examples from Rziha's work (he examined 9000 all over Europe, and published 1000), with their keys; they range from Byzantine (top left, Plate XLIV) to Romanesque and Gothic marks (they are often found as signatures on keystones; sometimes, as under the chancel of St. Stephen in Vienna, they appear with the effigy of the Master Architect, sometimes also in shields on funeral plaques). The thick lines represent the seal or sign itself, the thin lines represent the ground-lattice, which allows an infinite number of combinations. There are four types of lattices (Square, Triangle, Quadrilobed Rose, Three-lobed Rose) corresponding to signs conferred respectively by the lodges of Strassburg, Cologne, Vienna and Bern, later Prague also for the last one.

In the following chapter we will examine the conclusions which the scholars working in this field have reached concerning the actual cooperation of proportions and "symmetry" in Greek and Gothic plans.

[1] In his monumental work *Studien über Steinmetz-Zeichen.*

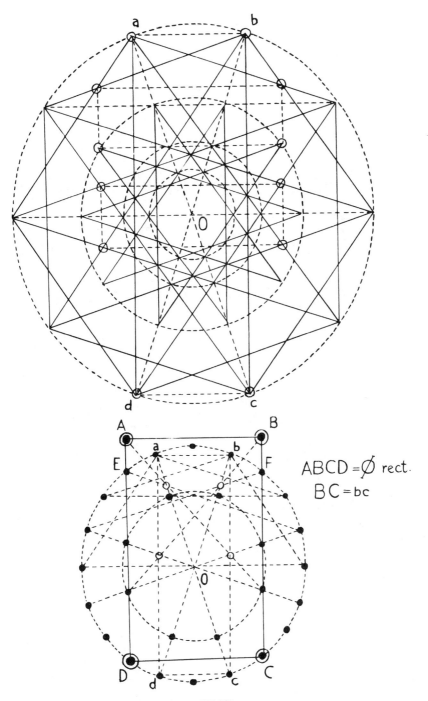

ABCD = \emptyset rect.
BC = bc

PLATE XLIII
The Gothic Master Diagram

PLATE XLIV
Masons' Marks

PLATE XLV
Gothic Masons' Marks

Greek and Gothic Canons of Proportion

ALL THROUGH the nineteenth century architects and archeologists have tried to find out explanations and keys for the beautiful proportions of Greek and Gothic monuments; to find, that is, whether their builders had explicit rules and canons of proportion and design, or whether the perfection of these monuments was just due to a mixture of luck and good taste.

We won't examine here the out-of-date and ponderous theories of Viollet-le-Duc and Dehio, but will only note that about 1850 Zeysing already had observed the obvious presence of the Golden Section in the frontal view of the Parthenon $\left(\dfrac{AC}{AD} = \dfrac{DC}{AC}\right.$ $= \Phi$ on Plate LVII farther down).

Modern research (in the last thirty years) has elaborated three principal theories concerning Greek and Gothic canons of proportion, respectively expounded by the American J. Hambidge,[1] the Norwegian F. M. Lund [2] and the German Professor Moessel.[3] The three theories are converging, agree about one main point, and when combined into one synthesis may be said to give the most probable solution and key to the problem under consideration; after what we have seen about the transmission of the Pythagorean Pentagram and the importance of the Decad, we shall not be surprised to discover that in all probability

[1] *Dynamic Symmetry*, also the review *Diagonal* published by the Yale University Press, and Dr. Caskey's *Geometry of the Greek Vase*.

[2] *Ad Quadratum*, in English (Batsford) and French (A. Morancé) editions. Also *Ad Quadratum II*, in Norwegian.

[3] *Die Proportion in Antike und Mittelalter* (C. H. Beck ed., Munich) and other works.

Pacioli's and Zeysing's intuitions were right, and that the secret of Greek "symmetry" and later of Gothic "harmonic" composition resides not only in the use of *analogia* (geometric proportion), but especially in the predominance, amongst the different possible analogies, of the analogia *par excellence*,[1] the Golden Section.

The clue to the manipulation of proportion in agreement with the Greek concept of symmetry (Vitruvius mentioned the concept, but cautiously refrained from explaining the technique) was found by Mr. Hambidge in Plato's *Theaetetus*, and this in the sentence concerning numbers which are δυνάμει σύμμετροί; meaning irrational (non-commensurable) numbers like $\sqrt{2}$, $\sqrt{3}$, $\sqrt{5}$, such that the squares (or other surfaces) constructed on them produce sequences linked by commensurable proportions ("commensurable in the square" being the exact translation of Plato's expression). The importance of the use of these irrational proportions (irrational in the first dimension, but rational, commensurable, consonant *in the square* [2]), and the accuracy of Hambidge's interpretation, are proved by the sentence of Vitruvius advising the use of "geometrical" proportions (that is, irrational, as compared to the arithmetical, rational or aliquot ratios like $\frac{1}{2}$, $\frac{2}{3}$, $\frac{3}{4}$, etc.[3]) in delicate problems of symmetry, and confirmed by Pacioli's very explicit "*che la proporzione si molto più ampia in la quantità continua che in la discreta*" (*Divina Proportione*, lib. II, cap. XX), the discrete or "static" or "simple"

[1] Proclus (410–483 A.D.) writes: "Eudoxus of Cnidos . . . an associate of Plato's school, . . . to the 3 proportions added another three . . . and increased the number of theorems about *the section* (περὶ τὴν τομὴν) which had their origin with Plato" (*On Euclid*).

Bretschneider identifies -ἡ τομὴ with the Golden Section (which in German is also called *the* continuous proportion, *die stetige Proportion*).

[2] Two rectangles, the linear dimensions of which would be in the ratio \sqrt{a}, would have their surfaces in the ratio a.

[3] "The delicate questions concerning symmetry are resolved by geometrical ratios and methods" (*Difficilesque symmetriarum quaestiones geometricis rationibus et methodis inveniuntur*).

symmetries being $\frac{1}{2}, \frac{2}{3}, \frac{3}{4}$ and their likes, and the "continuous" or "dynamic" ones being $\sqrt{2}, \sqrt{3}, \sqrt{5}$, et cetera.

In order to elaborate and illustrate this notion of dynamic symmetry, J. Hambidge showed that the simplest measurable and comparable surfaces, the rectangles (corresponding incidentally to the "plane" figurate numbers of the Greeks), can be classified into two main categories: (a) the *Static* rectangles, having as characteristic ratios "arithmetic" rational fractions like $\frac{1}{2}, \frac{2}{3}, \frac{3}{3}, \frac{3}{4}$, (the "discrete" proportions of Pacioli), and (b) the *Dynamic* rectangles, which have as characteristic ratios "geometric" (irrational) fractions or numbers like $\sqrt{2}, \sqrt{3}, \sqrt{5}$, $\Phi = \frac{\sqrt{5}+1}{2}, \Phi^2, \sqrt{\Phi}$, et cetera.

Hambidge pointed out three facts: (1) The "static" rectangles are not helpful for producing "harmonic" subdivisions and interplays of surfaces. (2) The dynamic rectangles however can produce the most varied and satisfactory harmonic (consonant, related by symmetry) subdivisions and combinations, and this by the very simple process already mentioned in Chapter II, of drawing inside the chosen rectangle a diagonal and the perpendicular to it from one of the two remaining vertices (thus dividing the surface into a reciprocal rectangle and its gnomon, as in Figure 8) and then drawing any network of parallels and perpendiculars to sides and diagonals. This process produces automatically surfaces correlated by the characteristic proportion of the initial rectangle [1] and also avoids (automatically again)

[1] Of course a dynamic rectangle of modulus or characteristic ratio $m = \sqrt{n}$ (n being an integer) can always be divided into n smaller rectangles similar to itself by dividing the long sides into n equal segments and joining the corresponding points; the modulus of each of the small rectangles will be $\frac{\sqrt{n}}{n} = \frac{1}{\sqrt{n}}$, inverse of, but similar to, \sqrt{n}. It is a useful convention to take as characteristic ratio of a rectangle the ratio between the horizontal and the vertical side; then a characteristic ratio $m > 1$ means that the

the mixing of antagonistic themes like $\sqrt{2}$ and $\sqrt{3}$ or $\sqrt{5}$. $\sqrt{5}$ **and** Φ on the contrary are not antagonistic but consonant, also with $\sqrt{\Phi}$, Φ^2, et cetera.

Plate XLVI shows a collection of "static" $\left(\dfrac{3}{2}, \dfrac{4}{3}\right)$ and dynamic $(\sqrt{2}, \sqrt{3}, \sqrt{4} = 2, \sqrt{5})$ rectangles.[1]

Plates XLVII, XLVIII and XLIX show harmonic subdivisions, according to "dynamic symmetry," of the rectangles $\sqrt{2}$, $\sqrt{3}$ and $\sqrt{5}$ respectively (the lower figures on Plate XLVIII give the analysis and explanation of the "Gothic" diagram of Plate LXV, elevation of the dome of Milan).

Plate L shows harmonic subdivisions of the Φ rectangle, "attacked" in its own or the $\sqrt{5}$ theme.

J. Hambidge and Dr. Caskey, curator of Greek antiquities of the Boston Museum, found that most of the Greek vases of the great periods (like the ones on Plates LI, LII and LIII), Greek ritual implements (sacrificial pans like the one on Plate LIV, bronze mirrors like the one on Plate LV) could have their design and proportions analyzed through a "harmonic" combination of dynamic rectangles. But although, in Mr. Hambidge's classification, the ratios $\sqrt{2}$ and $\sqrt{3}$ are "dynamic" themes, they are found much more rarely [2] than the ratios $\sqrt{5}$ and Φ (and the square "treated" by $\sqrt{5}$ or Φ). The reason being that the harmonic modulations allowed by the former ($\sqrt{2}$ and $\sqrt{3}$) are much more

rectangle is set horizontally; if m $<$ 1, the rectangle is vertical. When m is expressed in decimal fractions, and the vertical sides are equal and their length taken as unity, the modulus of the greater rectangle formed by the juxtaposed smaller ones is equal to the sum of their moduli.

[1] Let us repeat that the square ($\sqrt{1} = 1$) and the double-square ($\sqrt{4} = 2$) can be used indifferently as static or dynamic rectangles; the square lends itself to an indefinite number of harmonic decompositions (Plate LVI) in the Φ or $\sqrt{5}$ themes (it has a universal symmetry and can be "attacked" in any theme); the double-square of course, having as diagonal $\sqrt{5}$, is directly related to the $\sqrt{5}$ and Φ rectangles. But the square is even nearer to the Φ rectangle, being its "gnomon."

[2] We have seen that these symmetries ($\sqrt{2}$ and $\sqrt{3}$) are specially connected with crystal lattices.

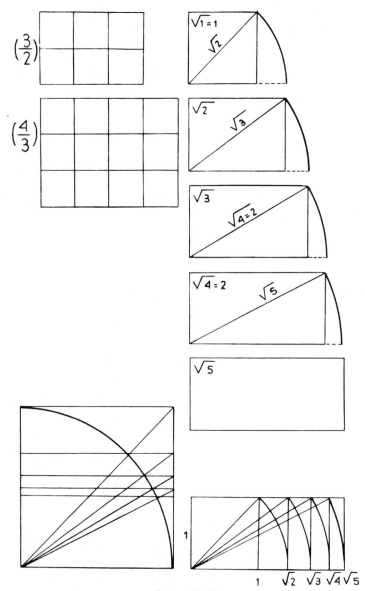

PLATE XLVI
Static and Dynamic Rectangles

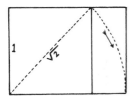

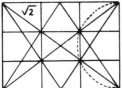
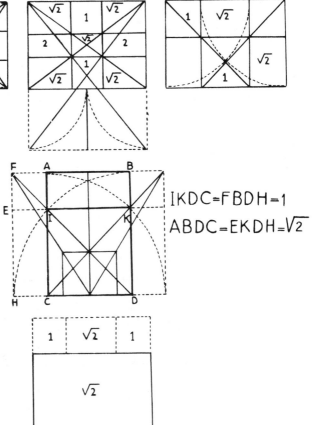

$$IKDC = FBDH = 1$$
$$ABDC = EKDH = \sqrt{2}$$

PLATE XLVII
The $\sqrt{2}$ Rectangle, Harmonic Decompositions

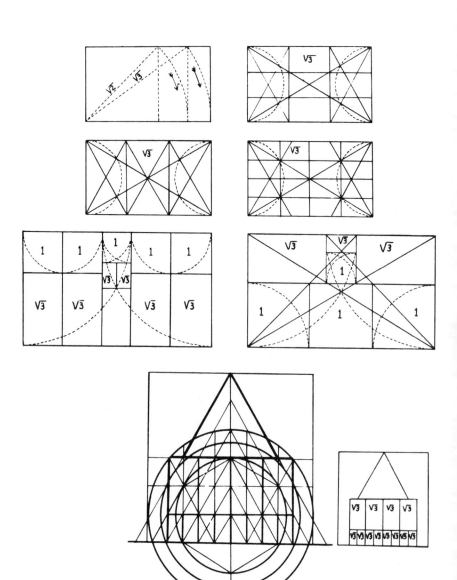

PLATE XLVIII
The √3 Rectangle, Harmonic Decompositions

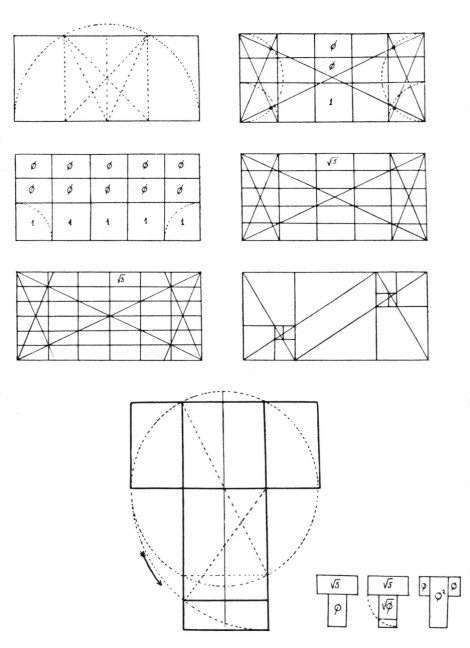

PLATE XLIX
The √5 Rectangle, Harmonic Decompositions

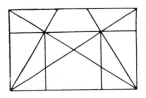
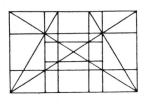
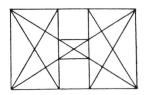

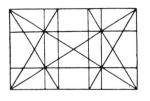

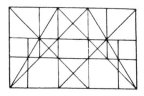

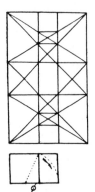
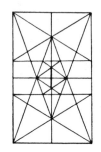
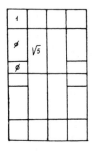
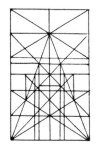

PLATE L

The Φ Rectangle, Harmonic Decompositions

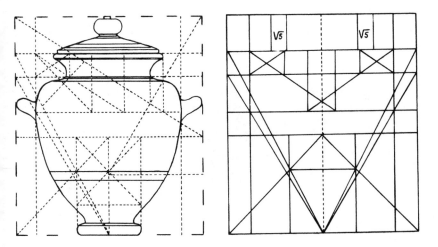

PLATE LI
Greek Vase (Stamnos), Harmonic Analysis
(from *Geometry of the Greek Vase*, by Dr. Caskey)

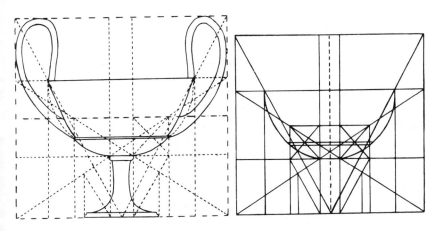

PLATE LII
Greek Vase (Kantharos), Harmonic Analysis
(from *Geometry of the Greek Vase*, by Dr. Caskey)

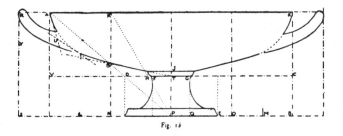

Fig. 16

PLATE LIII
Greek Vase (Kylix), Harmonic Analysis
(from *The Diagonal*, Yale University Press)

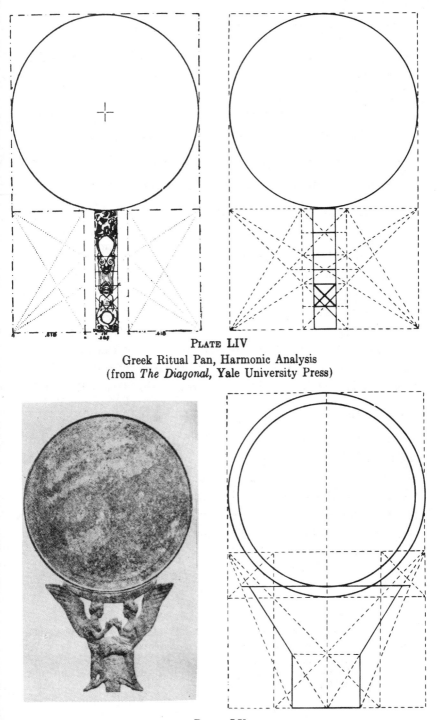

PLATE LIV
Greek Ritual Pan, Harmonic Analysis
(from *The Diagonal*, Yale University Press)

PLATE LV
Greek Bronze Mirror, Harmonic Analysis
(from *The Diagonal*, Yale University Press)

limited than those produced by the themes $\sqrt{5}$ and Φ which, being related, can be combined in an infinite number of ways (also with the square and double-square).

These same combinations of $\sqrt{5}$ and Φ rectangles were also found in the hundreds of human skeletons examined by Mr. Hambidge, the rectangle $\dfrac{2\Phi - 1}{2} = \dfrac{\sqrt{5}}{2}$ (two horizontal $\sqrt{5}$ rectangles superposed) being paramount, specially as overall frame, the connected rectangles $\dfrac{5\Phi - 6}{2} = 1.045$, $\dfrac{\Phi + 1}{2} = 1.309$, $\dfrac{2\Phi - 1}{\Phi} = \dfrac{\sqrt{5}}{\Phi}$ $= 1.382$, $\dfrac{4}{\Phi + 1} = 1.528$, $\dfrac{2\Phi}{2\Phi - 1} = \dfrac{2\Phi}{\sqrt{5}} = 1.4472$[1] appearing in the separate anatomical subdivisions; the same rectangles appear in the harmonic subdivisions of Greek vases.[2] We shall not be surprised to find that when taking up the plans of Greek temples, Hambidge discovered here also the rectangles $\sqrt{5}$ and Φ (Plate LVII shows Hambidge's analysis of the front of the Parthenon; the horizontal plan for the same—with the front to scale—is shown on Figure 63. Zeysing had already noticed that Φ was the fundamental ratio for this façade, $\dfrac{AC}{AD} = \dfrac{ED}{AE} = \Phi$).

We cannot enter here into all the details of Hambidge's illustration of the Greek "dynamic symmetry" as sketched above; we can only state that it gives a plausible key, and also a new method of harmonic composition, widely used now (as shown in the next chapter) by architects, painters, silversmiths, all over the world. In Plate LVIII I give an interesting application of this method to the tomb of Rameses IV, the plan of which is

[1] Also $\dfrac{5\Phi}{2} = 4.0451$, $\dfrac{2\Phi + 1}{\Phi + 2} = 1.1708$, $\dfrac{\Phi + 2}{2} = 1.809$, $\dfrac{3\Phi - 1}{\Phi + 2} = 1.0652$, $\dfrac{5\Phi - 4}{2} = 2.045$, et cetera.

[2] Out of the 120 Greek vases in the Boston Museum which can be subjected to a "dynamic" analysis, eighteen are based on the $\sqrt{2}$ theme (six having as overall frame the $\sqrt{2}$ rectangle, 1.4142, itself), six on the $\sqrt{3}$ theme (three having the rectangle $\sqrt{3}$ as frame); all the other ones on themes connected with Φ or $\sqrt{5}$.

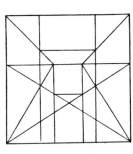
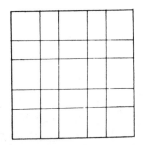
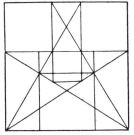
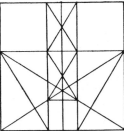
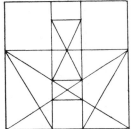
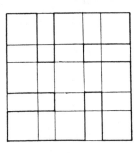
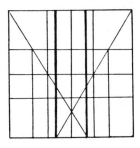
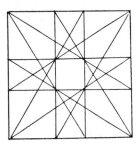
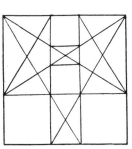
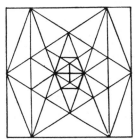
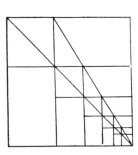

PLATE LVI

The Square, Harmonic Decompositions in the Φ Theme

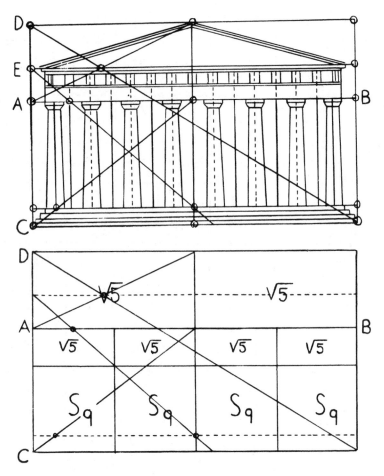

PLATE LVII
The Parthenon, Harmonic Analysis (Hambidge)

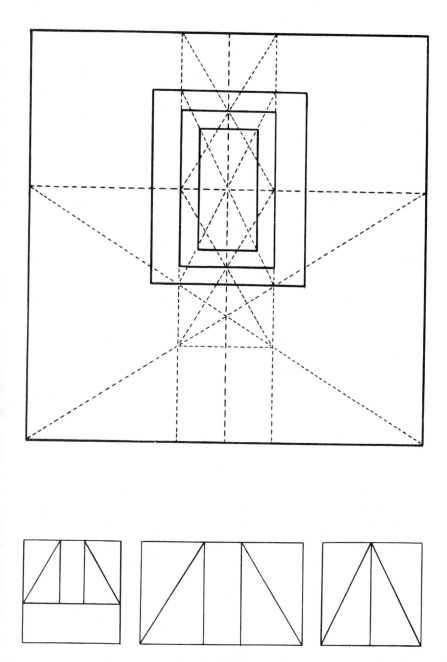

PLATE LVIII
Tomb of Rameses IV, Harmonic Analysis

given to scale in the "Rameses Papyrus" of the Turin Museum; the connection between the three inner rectangles is remarkable, as the smaller one is double square, the intermediate one a Φ rectangle, the enveloping one consisting of two Φ rectangles equal to the intermediate one but perpendicular to it. (The smaller figures at the bottom of the plate show diagrams of pieces of Egyptian furniture.)

But Hambidge's theory, interesting as it is, does not apply to all cases, especially not to Gothic plans, where, as we shall see, a circle is generally the controlling figure. The next system, which tried especially to discover the key of Gothic canons of proportion, is that of F. M. Lund. He found, independently of Hambidge, the same and other hints for the importance of the Golden Section in the Greek and Roman architectural traditions (on the sarcophagus of a Roman architect, reproduced in the *Inconographie Chrétienne* of Didron, is clearly engraved, next to a square, a rule divided in four parts forming a rigorous descending Φ progression; on a carved stone in the Naples Museum is engraved the "Sublime" Isosceles Triangle of the Pentagram, subdivided into the smaller similar triangle and its "gnomon," et cetera); and he tried to explain the plans of Gothic churches and cathedrals (Beauvais, Cologne, Rheims, Notre-Dame, et cetera) by grafting directly onto the rectangular naves pentagons or pentagrams, the centres of which coincide with "focal" points like the centre of figure of the apse, or the altar. His star-diagrams are beautiful approximations (in some cases quite rigorous); I reproduce in Figure 64 one of his diagrams showing a vertical section through a Gothic cathedral of the Cologne type, in which the width of the nave and that of the pillars are connected by interlinking circles and pentagrams.

But it was reserved to Professor Moessel (a Münich architect) to build up, independently of the two afore-quoted pioneers, a completely satisfactory theory and synthesis, and to point out the most probable way in which, starting as early as Egyptian times

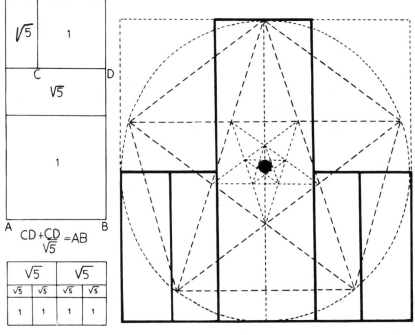

FIGURE 63 FIGURE 64

the plans of the important monuments of every great period or style of architecture were executed according to a very subtle and rational "dynamic symmetry" in which the special properties of the Golden Section were used to obtain the most flexible and varied "eurhythmy."

Having first decided that the problem of Proportion dominated all others in the field of architecture, Professor Moessel spent part of his life in measuring or checking up the dimensions (lengths, surfaces, volumes) of all the Egyptian, Greek, Romanesque and Gothic buildings of which we possess accurate plans. He did not start from any *a priori* theory; but from the comparison of these hundreds of diagrams emerged gradually impressive analogies, similarities, even identities; amongst the thousands of numerical ratios thus expressed, certain numbers were always

recurring, also their powers, and ordered progressions of these powers.

The geometrical shapes could all be reduced, for the horizontal plans as well as for vertical façades or sections, to the inscription within a circle, or several concentric circles, of one or several regular polygons. On the horizontal plane this directing circle was sometimes divided into 4, 8 or 16 equal parts, more frequently by the more subtle division into 10 or 5 parts. This controlling circle seemed to be the direct transposition on the plan of the *circle of orientation* of the building traced first on the ground itself, supposition in agreement with the religious importance attributed to the orientation of temples by Egyptians, Greeks and Romans. Vitruvius describes very clearly the way in which the *line* North-South was placed into the circle of orientation by marking the direction of minimum shadow-length of a vertical pole erected at the centre of the circle (true noon and true South); the tracing of a perpendicular direction, in fact of any right-angle, was obtained, as we have seen (Chapter III), by using a continuous rope divided by knots into $3 + 4 + 5 = 12$ equal parts.[1]

The predominant division of the controlling circle into 5 or 10, or 20 parts (which introduced automatically the theme of the Golden Section) proves that the Greek architects were in possession of the Pythagorean secret of the construction of a pentagon inscribed into a given circle; the Egyptians appear to have used a practical, Fibonaccian, approximation, like the one noticed by Kleppisch and Jarolimek in the half-meridian triangle of

[1] The method thus made use of the theorem of Pythagoras as concerning the particular case $3^2 + 4^2 = 5^2$. The Greeks, as seen from a passage of Democritus of Abdera (450–360 B.C., the first philosopher who seems to have used the expressions Macrocosmos and Microcosmos), borrowed this method from the Egyptian "arpedonapts" or ritual land-surveyors; Pythagoras generalized this special case into the theorem applying to all right-angled triangles. Pacioli calls this theorem: "the discovery of the proportions of the right angle," and specifies that the Pythagoreans called the right angle "angle of equity."

the Great Pyramid (where 55, 70, 89 give the sides, in the Φ ratio, of an approximate triangle of Price; we have $55^2 + 70^2 = 7925$, $89^2 = 7921$, and $\frac{89}{55} = 1.618$, very close approximation to Φ).

Professor Moessel could thus classify the controlling diagrams of nearly all the buildings analyzed by him according to a small number of specific types based on what he calls the *"Kreisteilung,"* or polar subdivision of the directing circle, this for elevations as well as for the horizontal plans, the elements and wholes of both projections being set for each case on the same diagram, and linked by chains of proportions which, in the case of Gothic plans especially, have as *"Leitmotiv"* the well-known themes of the Golden Section group. Plate LIX gives the two specific diagrams controlling the majority of standard Gothic churches or cathedrals; they can both be "set" into the fundamental or Master Diagram (Plate XLIII) given in Chapter VII.

Plate LX shows, under the very simple plan and elevation of an Egyptian temple (where the circle of orientation is divided into 10 parts) a striking confirmation of Professor Moessel's *"Kreisteilung"* theory as given by the façade of the rock tomb of Mira (the figure is taken from Perrot and Chippiez, the circle and pentagon placed by Professor Moessel [1]). We see that Professor Moessel's solutions combine (without any previous knowledge of their theories) the starry diagrams of Lund with Hambidge's dynamic rectangles, and are also in harmony with the cryptic allusions in the *Bauhütte* documents to the circle and the pole.

On Plates LXI, LXII and LXIII are shown analyses by D. Wiener of the scale plans of three Roman buildings: [2] the little temple of Minerva Medica (so-called temple of Vesta), the Pantheon, and San-Stefano Rotondo; they illustrate this inter-

[1] *Die Proportion in Antike und Mittelalter.*

[2] The *"Kreisteilung"* theory is also confirmed by Vitruvius' mention of the classic planning of Greek theatres—3 squares inscribed in the controlling circle—and Roman theatres—4 equilateral triangles in the circle.

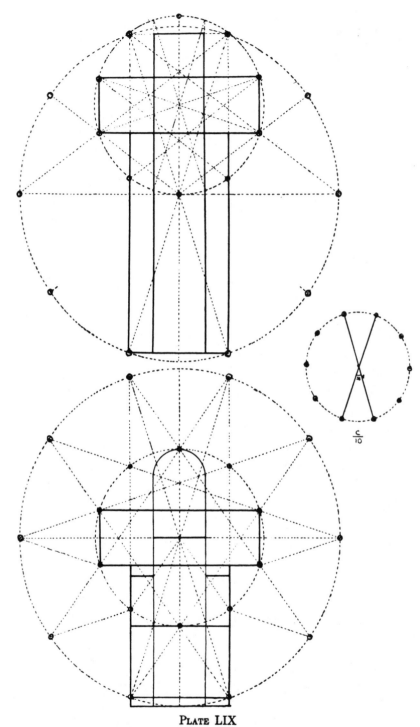

$\frac{c}{10}$

PLATE LIX
Two Gothic Standard Plans (Moessel)

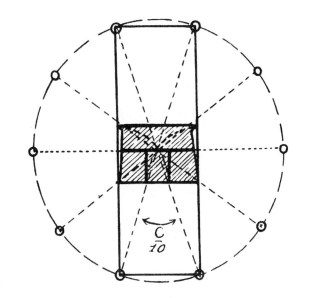

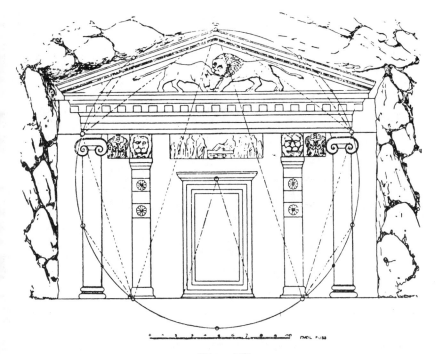

PLATE LX
Egyptian Temple Plan—Rock Tomb at Mira (Moessel)

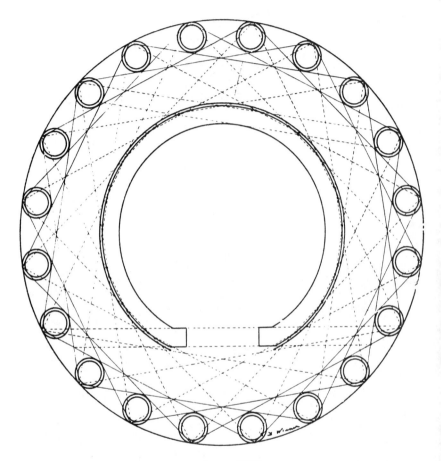

PLATE LXI
Temple of Minerva Medica, Harmonic Analysis (Wiener)

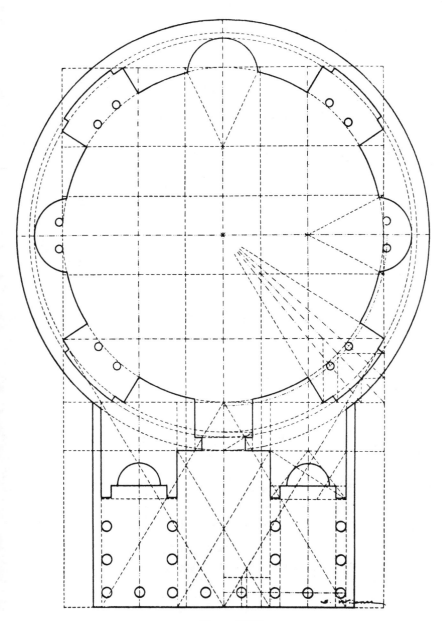

PLATE LXII
Pantheon of Rome, Harmonic Analysis (Wiener)

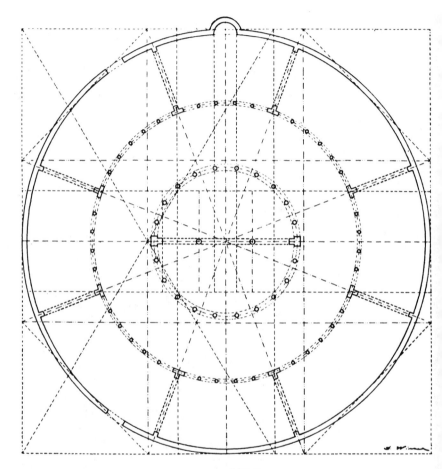

PLATE LXIII
San-Stefano Rotondo, Harmonic Analysis (Wiener)

play of *"Kreisteilung"* and dynamic rectangles (the temple of Minerva Medica is divided into 20 segments by 4 pentagons); the simple "dynamic" subdivisions of San-Stefano and Pantheon are illustrated on Plate LXIV. Plate LXV shows without any addition one of the rare Gothic plans in actual existence; it is the elevation of the Dome of Milan published in 1521 (in his Como edition of Vitruvius) by Caesar Caesariano, Master Architect in charge of the Dome. Not only are the directing circle and its function clearly shown, but in the Latin sentence on top appears the centre of the circle, also the words *symmetria* and *eurhythmia* (the plan is here guided by a $\sqrt{3}$ symmetry, as shown on the condensed diagrams at the bottom of Plate XLVIII [1]).

With the first Renaissance, the heretofore jealously concealed technique of symmetry ceased to be secret; the "Golden Section" or "Divine Proportion" itself was glorified in Pacioli's book, and the "Science of Space" was openly taken up and expounded (Piero della Francesca, Alberti, Dürer), whilst the revival of Neo-Platonism (Platonic "Academias" in Florence [2] and Rome) contributed to popularize the Platonic, symphonic, conception of Proportion, Rhythm, and Beauty.

We have no space here to examine the rôle of harmonic composition on similar lines manifested in the works of the Renaissance painters familiarized with the ideas of Pacioli and Alberti. The tests of Hambidge and Moessel have equally been applied here with success; I shall only reproduce in Plate LXVI an analysis by Dr. Funk-Hellet of a Leda by Leonardo (two superimposed horizontal Φ rectangles). But an unexpected result of the coming into the open of this long-hidden technique of Dynamic Sym-

[1] Professor Moessel has observed that: "the specific subdivisions of the circle and the numerical ratios which are their characteristics appear in the plane projections of the regular solids inscribed in the sphere, tetrahedron, octahedron, cube, dodecahedron and icosahedron." I have illustrated this important fact in Plates XVI, XVII, XXXVI, and XL (Great Pyramid, human face, human body).

[2] The Florentine Platonic Academy was started in 1459 by Cosimo de' Medici under Marsilio Ficino's direction.

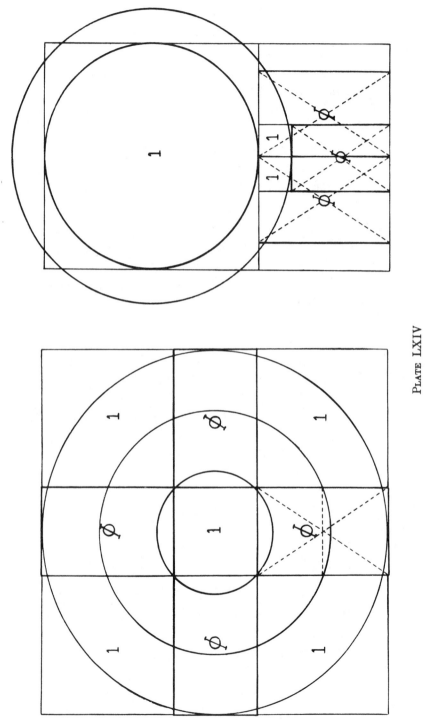

PLATE LXIV

Diagrams for Plates LXII and LXIII

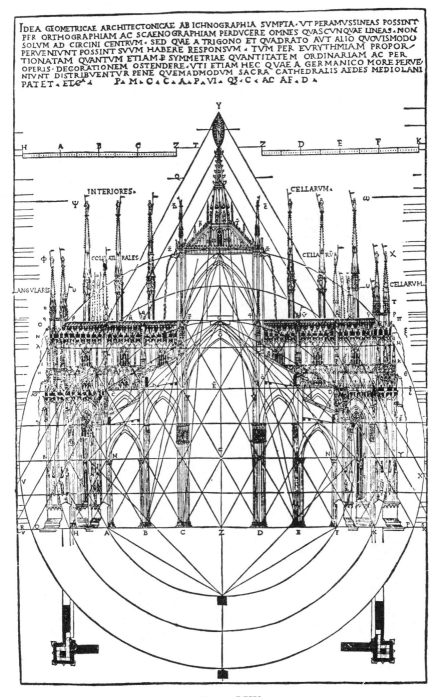

Plate LXV

Dome of Milan, Elevation and Section
(Caesar Caesariano, 1521)

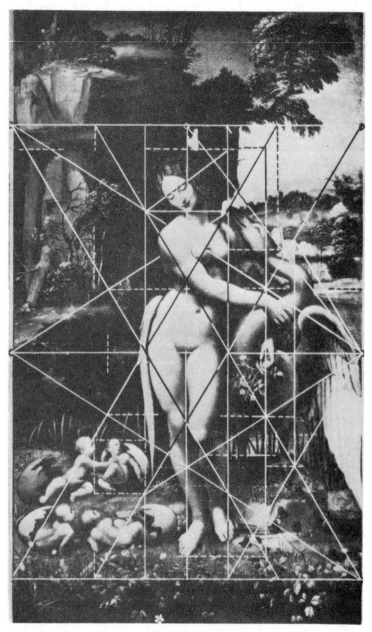

PLATE LXVI
Harmonic Analysis of a Renaissance Painting
(Funck-Hellet)

metry was that after hardly a hundred and fifty years its teachings became mechanized into a sterile fixation on the "Orders," and a complete misunderstanding of Vitruvius based on the erroneous use of static, arithmetic, *moduli.* The meaning of the word "symmetry" itself was forgotten and replaced by the modern one.

It was in France that this academic fossilization developed its worst symptoms. The rôle of Geometry, the very concept of ordered composition, were attacked, and a manifesto of the *a-geometric* school was launched by Perrault in the following outburst:

"The reasons which make us admire the beautiful works of art have no other foundation than chance and the workers' caprice, as these have not looked for reasons to settle the shape of things, the precision of which is of no importance."

But Palladio, Christopher Wren,[1] the Adams brothers and Gabriel thought otherwise, and so did the very scientific Baroque architects of Italy, Spain and southern Germany, who incorporated the ellipse and the logarithmic spiral into the designs of their "metaphysical theatres."

Incidentally the *"Kreisteilung"* theory, the important rôle of the circle and the pole in the *"Heimlichkeiten"* or secret symbolism of the *Bauhütte,* in masons' marks, et cetera, bring also to mind the part played by the circle in the Greek mysteries. Although our information about them is very scant, we know (cf. Victor Magnien's book on the subject) that at Eleusis the third degree of initiation (or *holoclere* initiation) was also called "The Mystery of the Circle," and that a circular figure drawn on the ground was an element of the ritual.

We need only recall the immense rose, circle filled by the white army of the blessed, in which, at the end of the "Divine Comedy," Dante sees Beatrice take her exalted place and send

[1] The Sheldonian Theatre in Oxford shows a rigorous vertical modulation in the Golden Section proportion. So does Gabriel's Hotel de Crillon.

him her last smile; also the circular diagrams, uniting Macro-
cosmos and Microcosmos, of the Twelfth Century mystics Saint
Hildegard [1] and Herrade of Landsberg; but, to come to our times,
we find mentioned, in Dr. Jung's studies of the graphic symbols
to which the subconscious mind is most responsive, the quasi-
magical relaxing action of certain circular diagrams ("the magi-
cally working symbol is required, containing that primitive anal-
ogy which speaks to the unconscious in its very own language
. . . and whose goal is to unite the singularity of contemporary
consciousness with life's most ancient past"). Jung calls them
"Mandala-Symbols," because of their analogy with the Thibetan
circular *mandalas*. The Buddhist Shingon sect in Japan uses
similar circular abstract patterns as spiritual "resonators," in
order to advance the progress of meditation.

Dr. Jung reproduces several of these circular symbols in his
commentary to "the Secret of the Golden Flower"; the funda-
mental diagrams of Professor Moessel (Plates XLIII and LIX),
the Great Pyramid diagrams (Plates XVI and XVII), in spite
of their precise geometrical meaning (or perhaps because of it),
would not seem out of place in this collection.

To come back to our subject, we can sum up this chapter in
stating that in all great periods of Western Art the knowledge
and use of Symmetry in its antique meaning have been the main-
spring of "symphonic" composition, and that among the pro-
portions which have in conformity with Thiersch's Principle of
Analogy produced the recurrency and consonance of similar
shapes ("the reassuring impression given by that which remains
similar to itself in the diversity of evolution," like the recurrence
of the tonic key in melody) the Golden Section seems to have
been paramount.

We have seen that this was equally true in biology; there
is a Geometry of Art as there is a Geometry of Life, and, as the
Greeks had guessed, they happen to be the same.

[1] *Scivias et Liver divinorum operum simplicis hominis.*

Symphonic Composition

WE HAVE MENTIONED that from about the end of the seventeenth century the knowledge and use of "Dynamic Symmetry," of Vitruvian "symmetry" in general, were gradually forgotten, and that with the brilliant exception of Baroque Architecture and of a few masters like Robert Adams and Gabriel, a mechanical, static, conception of design and ornament had dominated Western Architecture and Decorative Art.

With the recent rediscovery by Zeysing, Hambidge and Moessel of the "lost keys," the importance of planned composition, of the knowledge of the "Theory of Space," including the study of Proportions, has been realized again; if the enemies of geometrical planning still try to hold to some of their positions, they have had on most of their front to give way to what we may call the Neo-Pythagorean surge.

The truth is that, whether or not an architect or a painter uses "Dynamic Symmetry" or another method of coherent "commodulation," we can safely state that it is anyhow better for him to know the workings of the first; exactly as between two composers of *atonal* music, it will be the one who has studied tonal harmony who will, if both are equally gifted, produce the more satisfactory compositions.

Incidentally, students of harmony will perceive that there is a more than superficial similarity between the rôle of the tonic, or of the (tonic) major triad, in music, and the rôle of the characteristic ratio, or leading proportion theme, in a "harmonic" spatial composition.

The Cubist School of painting was itself a natural reaction

to an obvious lack of geometrical feeling and knowledge, but, unlike Dürer (I reproduce in Plate LXVII two "cubist" studies, the top one by Dürer, the lower one by his pupil E. Schön), most of the modern cubists were blissfully ignorant of the geometry of the regular solids and of the corresponding interplay of proportions.

From time to time the Golden Section was temporarily rediscovered by isolated artists or aesthetic "chapels," Seurat being a very interesting case in point. That Seurat's (1859–1891) now famous canvases (*"Dimanche d'été à la Grande Jatte," "Parade," "Le Cirque,"* et cetera) owe their quasi-hypnotic charm and power to a rigorous geometrical technique of composition (he called it "divisionism") rather than to his *"pointillist"* treatment of pigments, is generally admitted; I owe to Mr. André Lhote the confirmation of the fact that the use of the Golden Section was Seurat's master trump or trick.

Plates LXVIII, LXIX, and LXX show three of Seurat's well-known paintings (*Le Pont de Courbevoie, Parade* and *Le Cirque*) with an indication of their main "harmonic" subdivisions. The proportions of the frame, of the over-all rectangle, are of course left to chance; Seurat did not know Hambidge's "Law of the non-mixing of themes" (already formulated by Alberti), and attacked every canvas by the Golden Section. It is just by accident that the over-all rectangle in *Le Pont de Courbevoie* shows approximately two vertical juxtaposed Φ rectangles, that in *Le Cirque* it should be a very near approximation of $\sqrt{\Phi} = 1.273$ (here 1,268); but the subdivisions (both horizontal and vertical) in those three compositions, as in many works of Seurat, are quite rigorously in the Golden Section theme, as shown on the diagrams of Plate LXXI. Plate LXXII shows the probably subconscious but successful use of the Golden Section in a typical Guardi painting.

As stated in Chapter VIII, the publication of the theories of Hambidge and Moessel brought forward not only two very inter-

PLATE LXVII
Cubist Studies (Dürer and Schön)

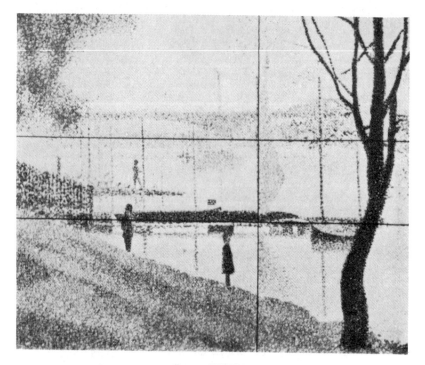

PLATE LXVIII
Le Pont de Courbevoie (Seurat), Harmonic Division
(Photograph, Medici Society)

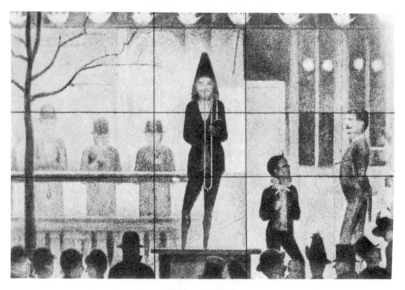

PLATE LXIX
Parade (Seurat), Harmonic Division
(Photograph, G. Crès, Paris)

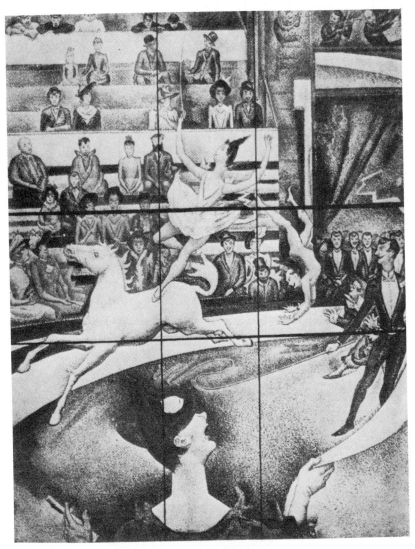

PLATE LXX

Le Cirque (Seurat), Harmonic Division
(Photograph, G. Crès, Paris)

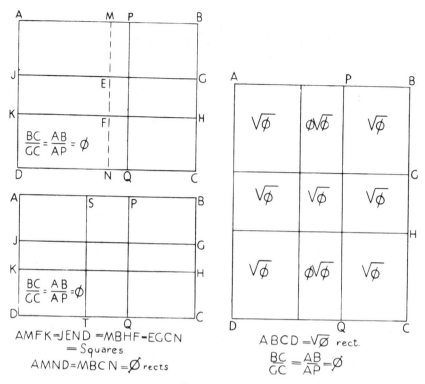

$$\frac{BC}{GC} = \frac{AB}{AP} = \phi$$

$$\frac{BC}{GC} = \frac{AB}{AP} = \phi$$

AMFK = JEND = MBHF = EGCN
= Squares
AMND = MBCN = ϕ rects

ABCD = $\sqrt{\phi}$ rect.

$$\frac{BC}{GC} = \frac{AB}{AP} = \phi$$

PLATE LXXI
Diagrams for Three Preceding Plates (Seurat)

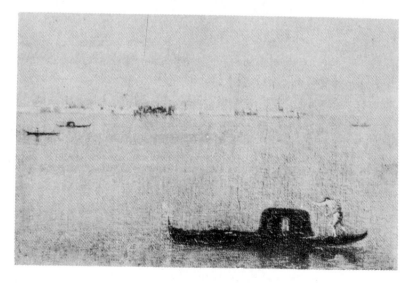

PLATE LXXII
Guardi, Lagoon of Venice
(Photograph, Medici Society)

esting archeological hypotheses concerning past canons of proportion, but also quite independently (that is: whether these diagrams were or were not those actually used by Greek and Gothic artists) a very valuable technique, or rather two techniques (they can be used separately or together) of "harmonic" composition. The lesson was not lost upon American and European architects and artists; if in America J. Hambidge's Dynamic Symmetry and his rectangles are favoured by architects like Claude Bragdon, by designers like Albert Southwick, who planned many pieces of silverware for Tiffany & Co. of New York, and by the teachers of the New York City School of Arts, in France both systems were successfully used. While young architects there too were mostly partial to Hambidge's rectangles, the eminent Paris silversmith and sculptor Puyforcat has been using both these and Moessel's circular diagrams for his gold and silver ware and his ecclesiastical chalices (also for some of his statues like the one of Descartes for the "Maison de France" in The Hague, Plate LXXIII); Plate LXXIV shows one of his cups with regulating Φ rectangle.

As example of the work of a modern painter using rigorous dynamic symmetry in the composition of his canvases, I reproduce in Plate LXXV the crystal-like lilies of D. Wiener, in Plate LXXVI their regulating diagram.

Plate LXXVII shows a Golden Rectangle with all its harmonic lines and focal points, used as regulating lattice by D. Wiener, to whom I am also indebted for the stimulating studies of Roman plans on Plates LXI, LXII and LXIII, and the photographs of star-polyhedra in Chapter III.

In architecture, the growing part played by the engineer, especially in industrial buildings, was another reason for the reintroduction of geometry in planning; to this was added, at the psychological moment, the purifying, blasting influence of Le Corbusier. I will here take the liberty of quoting a page out of an article of mine in the review "Horizon" (*Frozen Music,* September 1943):

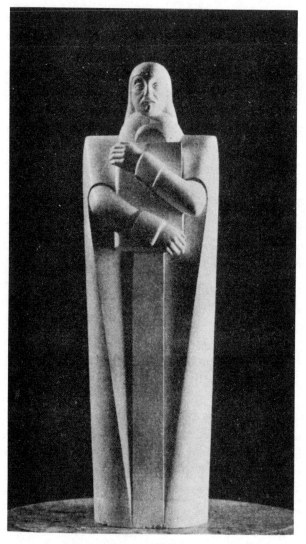

PLATE LXXIII
Statue of Descartes (J. Puiforcat)

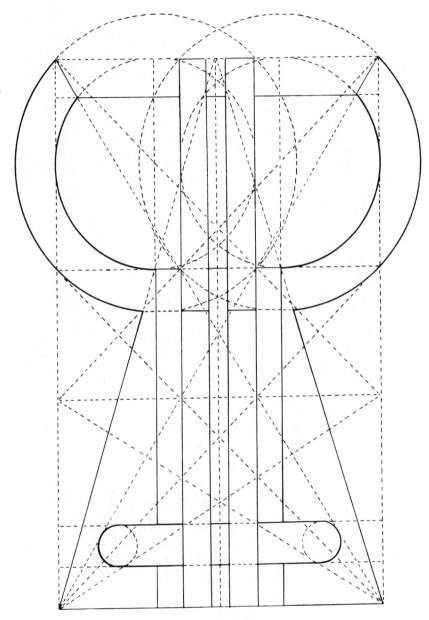

PLATE LXXIV
Regulating Diagram of Cup (J. Puiforcat)

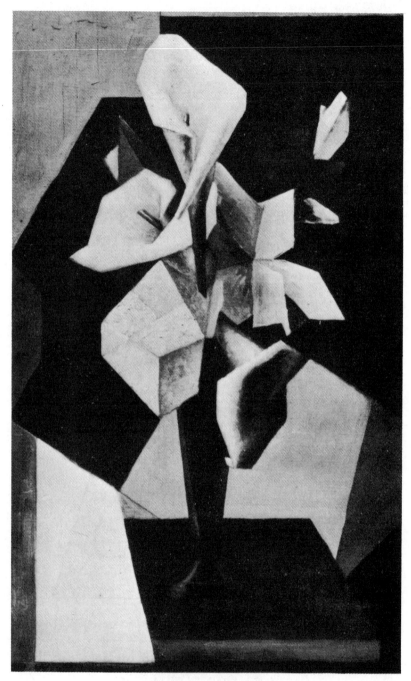

PLATE LXXV
Lilies (D. Wiener)

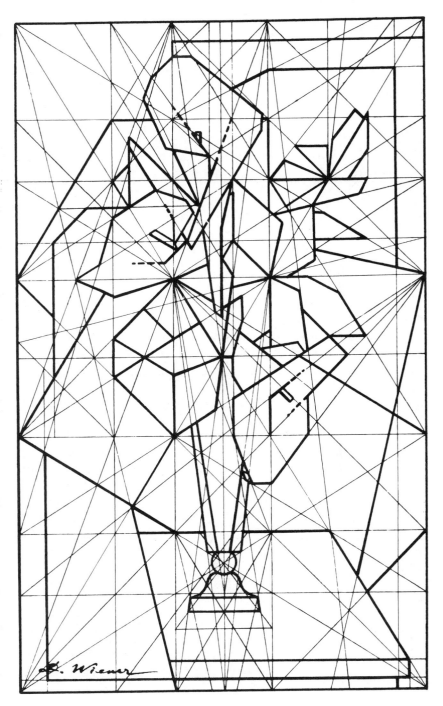

PLATE LXXVI
Diagram for Lilies (D. Wiener)

PLATE LXXVII
The Φ Rectangle (D. Wiener)

"Whilst the mathematical laws governing living shapes and living growth were thus shown to fit in curiously with the theories and patterns of Greek and Gothic Aesthetics, discovered by the archeological line of investigation, still a third school of thought and research contributed to the revival of mathematical Aesthetics. This was a consequence of the reaction against the sterility of nineteenth-century architecture with (on the Continent especially) its blind copying and mixing of Renaissance or Louis XVI *clichés,* reaction which found its strongest expression in Le Corbusier's lashing statements.[1] The battle-cry of this new 'functionalist' school is Le Corbusier's untranslatable: 'la maison est une machine à habiter,' the argument, Sullivan's 'Form follows Function,' the justification and programme, Sir Walter Armstrong's 'Beauty is Fitness expressed.' "

The result of the *functionalist* attitude was to bring back to architecture not only the "Theory of Space," the science of pure volume, but also the science of stresses; engineer and architect joined hands,[2] growth in animals and plants was shown to fit in with that of human constructions; shyly at first, artists began to admit that in some productions of this collaboration, American silos and factories, could be found the abstract beauty of Byzan-

[1] *Vers une Architecture,* etcetera. *"L'architecture n'a rien à voir avec les styles."*—*"Les architectes de ce temps, perdus dans les "pochés" stériles de leurs plans, les rinceaux, les pilastres ou les faîtages de plomb, n'ont pas acquis la conception des volumes primaires. On ne leur a jamais appris cela à l'Ecole des Beaux-Arts."*

"Les architectes ont aujourd'hui peur de la géométrie des surfaces. L'architecture est le jeu savant, correct et magnifique des volumes assemblés sous la lumière."

[2] To quote again Le Corbusier: *"L'ingénieur, inspiré par la loi d'économie et conduit par le calcul, nous met en accord avec les lois de l'Univers." "Assujettis aux strictes obligations d'un programme impératif, les ingénieurs emploient les génératrices et les accusatrices des formes. Ils créent des faits plastiques limpides et impressionants"* (*Vers une Architecture*).

tine or Romanesque volumes, that the Golden Gate Bridges could give the same aesthetic impression of superbly balanced stresses as a Gothic cathedral.,

The architect must, of course, retain the supreme control, impart to his creation the organic unity [1] without which it cannot be considered as a work of art. Le Corbusier himself found that the functionalist conditions allow the architect a certain freedom in the disposition of his structural elements, and rediscovered the eternal value of proportion, of the interplay of proportions, within an organic design. He rediscovered also the usefulness of the golden section as a "regulating theme," as shown in his plan for the projected "Mundaneum" (World Centre of Studies and Artistic and Scientific Co-ordination in Geneva) and for his villa at Garches.

Plate LXXVIII reproduces the plan of Le Corbusier and Jeanneret for the "Mundaneum"; it is a Φ rectangle treated in the Hambidge manner.

Amongst the architects working and teaching in conformity with the principles of "Dynamic Symmetry," I will also quote Mr. Ch. Häuptli, Professor of Architecture at the Bienne (Biel) Polytechnic School, in Switzerland. Plate LXXIX reproduces a façade in "Golden Section" proportions by one of his pupils.

Plate LXXX shows the "regulating diagram" of the façade of Tiffany's Paris branch; it was designed by Mr. A. Southwick according to dynamic symmetry, and is formed of four vertical Φ^2 rectangles. All the details (including the lettering) of this façade, as also of the showroom inside, are "modulated" according to the Φ theme.

The afore-sketched rediscovery of Neo-Pythagorean Aesthetics did coincide with a startling resurrection of scientific Pythagoreanism (to quote Bertrand Russell: "Perhaps the oddest thing about Modern Science is its return to Pythagoreanism.")

[1] "Art is the power of creating organisms, out of stone, clay, colours, tones, words." (Schumacher, *Handbuch der Architektur*.)

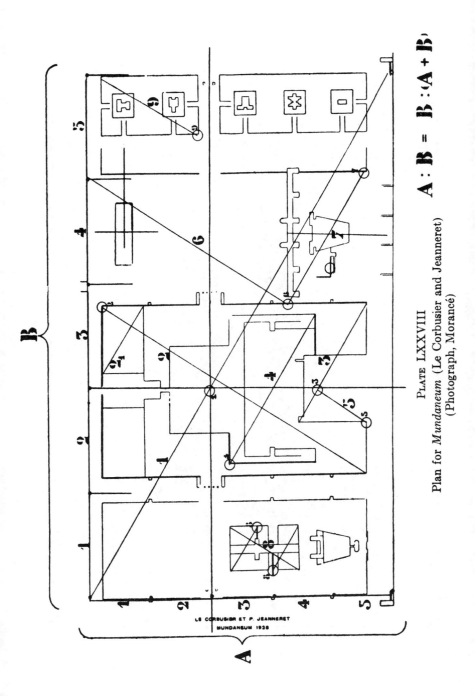

$$A : B = B : (A + B)$$

PLATE LXXVIII

Plan for *Mundaneum* (Le Corbusier and Jeanneret)
(Photograph, Morancé)

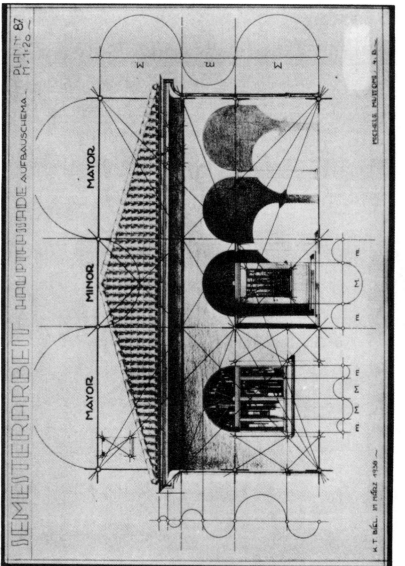

PLATE LXXIX

Façade in Φ Proportion by a Pupil of C. Häuptli

PLATE LXXX
Diagram of Façade of Tiffany & Co., Paris
(A. Southwick)

Plato and the Neo-Pythagoreans had clearly stated that structure and number are the only things which count in our perception— or rather, reconstruction—of the external world. And modern science, with its quest for "invariants" and group-structure, has arrived at the same conclusion, via Einstein, Eddington and Jeans.[1]

In the remarkable book published by Dr. Martin Johnson with the suggestive title: *Art and Scientific Thought*, I find the following lucid presentation of the affinity between the point of view of the scientist and that of the artist:

". . . . The work of scientist and artist alike is the presentation of Form, Pattern, Structure, in material or in mental images. For the work of either to fulfil its end it must be communicable: the hearer, reader or beholder of the work of art must in the end find coherence and feeling from the images aroused in his own mind, and the verifier of the scientific theory must be able to reproduce in his own mathematics and experiments the measurable facts communicated."

Coherence of course is here the important word, but whilst in art coherence has a more elastic meaning than in logic or science, it is in the visual arts produced by "symmetry," deriving from a key proportion, in music by the harmonic perspective derived from the tonic and the related triads. Incidentally, Dr. Martin Johnson devotes an essay to the singular case of Leonardo da Vinci, uniting the vision of the artist with the experimental curiosity (these are sometimes fused) and the causal rigour of the scientist.

In the case of art, visual or temporal, modulation is the way to organize the created work of art harmoniously, in conformity with the Principle of Analogy quoted in Chapter VII, so as to

[1] "Thought, taken in its most general meaning to contain Art, Philosophy, Religion, Science, taken themselves in their most general acceptation, is the quest of invariance in a fluctuating world." (C. J. Keyser). And Eddington: "All that Physics discloses to us in the external world is a structure in conformity with the Theory of Groups (Group-Structure)."

suggest "the reassuring impression given by that which remains similar to itself in the diversity of evolution."

The Principle of Analogy was indeed the main instrument in this quest for permanent structure, for the main "Invariants," an instrument common to Art and Science; *analogia* itself, the geometric proportion (A is to B as C is to D), was the capital tool of Euclidian Mathematics. And the master minds in our Western Civilization have been, since Plato, the ones who have perceived the analogies, the permanent similarities, between things, structures, images. If analogy is found at the base of Dynamic Symmetry, Eurhythmy and modulation, in the arts of space as well as in musical harmony, it also dominates literature, metaphor being only a condensed and unexpected analogy; to quote Aristotle:

"But the greatest thing of all is to be a master of the metaphor. It is the only thing which cannot be taught by others; and it is also a sign of original genius, because a good metaphor implies the intuitive perception of similarity in dissimilar things."

This "intuitive perception of similarity" was the source of Shakespeare's metaphors, of Francis Bacon's and Leonardo's [1] insight into the Laws of Nature.

Structure, Pattern, on one side, Metaphor on the other, may lead to Symbol, explicit or veiled, as we have seen in noticing the connection (the "analogies" in fact) between regulating diagrams and Mandalas, acting on the conscious or the subconscious plane, or on both.

[1] The writer of Shakespeare's plays, verily the "King of Metaphor," and Francis Bacon may be identical; the arguments of the Baconian theory are extremely interesting.

About Leonardo's analogical vision I will quote here a remarkable sentence out of his note-books, also commented upon by Dr. Martin Johnson:

"O marvellous Necessity, who with supreme reason constrainest all effects to be the direct result of their causes, and by a supreme and irrevocable law every natural action obeys thee by the straightest possible process."

We find here not only the Principle of Causality, but, connected to it, the first formulation of the Principle of Least Action, which, as we have seen in Chapter V, is the Master Law dominating all processes in inorganic systems.

Concerning the question whether, at least in the realms of architecture and decorative art, planning should be conscious or subconscious, we have made clear our conviction that the "symphonic," organized planning which, through all the great periods of European Art, was its characteristic feature, was without any doubt conscious.

Inspiration, even passion, is indeed necessary for creative art, but the knowledge of the Science of Space, of the Theory of Proportions, far from narrowing the creative power of the artist, opens for him an infinite variety of choices within the realm of symphonic composition.

As Claude Bragdon said:

"A work of architecture may be significant, organic, dramatic, but it will fail to be a work of art unless it be also *schematic*. It means (this word) a systematic disposition of parts according to some co-ordinating principle."

Or, to express this point of view in the very terms in which the Gothic Master Builder Jean Vignot put it in 1392 before the City Fathers of Milan when asked for his expert advice about the continuation of the work on the famous marble Dome:

"Ars Sine Scientia Nihil"

A CATALOG OF SELECTED
DOVER BOOKS
IN ALL FIELDS OF INTEREST

A CATALOG OF SELECTED DOVER
BOOKS IN ALL FIELDS OF INTEREST

CONCERNING THE SPIRITUAL IN ART, Wassily Kandinsky. Pioneering work by father of abstract art. Thoughts on color theory, nature of art. Analysis of earlier masters. 12 illustrations. 80pp. of text. 5⅜ x 8½. 23411-8

ANIMALS: 1,419 Copyright-Free Illustrations of Mammals, Birds, Fish, Insects, etc., Jim Harter (ed.). Clear wood engravings present, in extremely lifelike poses, over 1,000 species of animals. One of the most extensive pictorial sourcebooks of its kind. Captions. Index. 284pp. 9 x 12. 23766-4

CELTIC ART: The Methods of Construction, George Bain. Simple geometric techniques for making Celtic interlacements, spirals, Kells-type initials, animals, humans, etc. Over 500 illustrations. 160pp. 9 x 12. (Available in U.S. only.) 22923-8

AN ATLAS OF ANATOMY FOR ARTISTS, Fritz Schider. Most thorough reference work on art anatomy in the world. Hundreds of illustrations, including selections from works by Vesalius, Leonardo, Goya, Ingres, Michelangelo, others. 593 illustrations. 192pp. 7⅛ x 10¼. 20241-0

CELTIC HAND STROKE-BY-STROKE (Irish Half-Uncial from "The Book of Kells"): An Arthur Baker Calligraphy Manual, Arthur Baker. Complete guide to creating each letter of the alphabet in distinctive Celtic manner. Covers hand position, strokes, pens, inks, paper, more. Illustrated. 48pp. 8¼ x 11. 24336-2

EASY ORIGAMI, John Montroll. Charming collection of 32 projects (hat, cup, pelican, piano, swan, many more) specially designed for the novice origami hobbyist. Clearly illustrated easy-to-follow instructions insure that even beginning papercrafters will achieve successful results. 48pp. 8¼ x 11. 27298-2

THE COMPLETE BOOK OF BIRDHOUSE CONSTRUCTION FOR WOODWORKERS, Scott D. Campbell. Detailed instructions, illustrations, tables. Also data on bird habitat and instinct patterns. Bibliography. 3 tables. 63 illustrations in 15 figures. 48pp. 5¼ x 8½. 24407-5

BLOOMINGDALE'S ILLUSTRATED 1886 CATALOG: Fashions, Dry Goods and Housewares, Bloomingdale Brothers. Famed merchants' extremely rare catalog depicting about 1,700 products: clothing, housewares, firearms, dry goods, jewelry, more. Invaluable for dating, identifying vintage items. Also, copyright-free graphics for artists, designers. Co-published with Henry Ford Museum & Greenfield Village. 160pp. 8¼ x 11. 25780-0

HISTORIC COSTUME IN PICTURES, Braun & Schneider. Over 1,450 costumed figures in clearly detailed engravings–from dawn of civilization to end of 19th century. Captions. Many folk costumes. 256pp. 8⅜ x 11¾. 23150-X

STICKLEY CRAFTSMAN FURNITURE CATALOGS, Gustav Stickley and L. & J. G. Stickley. Beautiful, functional furniture in two authentic catalogs from 1910. 594 illustrations, including 277 photos, show settles, rockers, armchairs, reclining chairs, bookcases, desks, tables. 183pp. 6½ x 9¼. 23838-5

AMERICAN LOCOMOTIVES IN HISTORIC PHOTOGRAPHS: 1858 to 1949, Ron Ziel (ed.). A rare collection of 126 meticulously detailed official photographs, called "builder portraits," of American locomotives that majestically chronicle the rise of steam locomotive power in America. Introduction. Detailed captions. xi+ 129pp. 9 x 12. 27393-8

AMERICA'S LIGHTHOUSES: An Illustrated History, Francis Ross Holland, Jr. Delightfully written, profusely illustrated fact-filled survey of over 200 American lighthouses since 1716. History, anecdotes, technological advances, more. 240pp. 8 x 10¾. 25576-X

TOWARDS A NEW ARCHITECTURE, Le Corbusier. Pioneering manifesto by founder of "International School." Technical and aesthetic theories, views of industry, economics, relation of form to function, "mass-production split" and much more. Profusely illustrated. 320pp. 6⅛ x 9¼. (Available in U.S. only.) 25023-7

HOW THE OTHER HALF LIVES, Jacob Riis. Famous journalistic record, exposing poverty and degradation of New York slums around 1900, by major social reformer. 100 striking and influential photographs. 233pp. 10 x 7⅞. 22012-5

FRUIT KEY AND TWIG KEY TO TREES AND SHRUBS, William M. Harlow. One of the handiest and most widely used identification aids. Fruit key covers 120 deciduous and evergreen species; twig key 160 deciduous species. Easily used. Over 300 photographs. 126pp. 5⅜ x 8½. 20511-8

COMMON BIRD SONGS, Dr. Donald J. Borror. Songs of 60 most common U.S. birds: robins, sparrows, cardinals, bluejays, finches, more–arranged in order of increasing complexity. Up to 9 variations of songs of each species.
Cassette and manual 99911-4

ORCHIDS AS HOUSE PLANTS, Rebecca Tyson Northen. Grow cattleyas and many other kinds of orchids–in a window, in a case, or under artificial light. 63 illustrations. 148pp. 5⅜ x 8½. 23261-1

MONSTER MAZES, Dave Phillips. Masterful mazes at four levels of difficulty. Avoid deadly perils and evil creatures to find magical treasures. Solutions for all 32 exciting illustrated puzzles. 48pp. 8¼ x 11. 26005-4

MOZART'S DON GIOVANNI (DOVER OPERA LIBRETTO SERIES), Wolfgang Amadeus Mozart. Introduced and translated by Ellen H. Bleiler. Standard Italian libretto, with complete English translation. Convenient and thoroughly portable–an ideal companion for reading along with a recording or the performance itself. Introduction. List of characters. Plot summary. 121pp. 5¼ x 8½. 24944-1

TECHNICAL MANUAL AND DICTIONARY OF CLASSICAL BALLET, Gail Grant. Defines, explains, comments on steps, movements, poses and concepts. 15-page pictorial section. Basic book for student, viewer. 127pp. 5⅜ x 8½. 21843-0

THE CLARINET AND CLARINET PLAYING, David Pino. Lively, comprehensive work features suggestions about technique, musicianship, and musical interpretation, as well as guidelines for teaching, making your own reeds, and preparing for public performance. Includes an intriguing look at clarinet history. "A godsend," *The Clarinet,* Journal of the International Clarinet Society. Appendixes. 7 illus. 320pp. 5⅜ x 8½. 40270-3

HOLLYWOOD GLAMOR PORTRAITS, John Kobal (ed.). 145 photos from 1926-49. Harlow, Gable, Bogart, Bacall; 94 stars in all. Full background on photographers, technical aspects. 160pp. 8⅜ x 11¼. 23352-9

THE ANNOTATED CASEY AT THE BAT: A Collection of Ballads about the Mighty Casey/Third, Revised Edition, Martin Gardner (ed.). Amusing sequels and parodies of one of America's best-loved poems: Casey's Revenge, Why Casey Whiffed, Casey's Sister at the Bat, others. 256pp. 5⅜ x 8½. 28598-7

THE RAVEN AND OTHER FAVORITE POEMS, Edgar Allan Poe. Over 40 of the author's most memorable poems: "The Bells," "Ulalume," "Israfel," "To Helen," "The Conqueror Worm," "Eldorado," "Annabel Lee," many more. Alphabetic lists of titles and first lines. 64pp. 5³⁄₁₆ x 8¼. 26685-0

PERSONAL MEMOIRS OF U. S. GRANT, Ulysses Simpson Grant. Intelligent, deeply moving firsthand account of Civil War campaigns, considered by many the finest military memoirs ever written. Includes letters, historic photographs, maps and more. 528pp. 6⅛ x 9¼. 28587-1

ANCIENT EGYPTIAN MATERIALS AND INDUSTRIES, A. Lucas and J. Harris. Fascinating, comprehensive, thoroughly documented text describes this ancient civilization's vast resources and the processes that incorporated them in daily life, including the use of animal products, building materials, cosmetics, perfumes and incense, fibers, glazed ware, glass and its manufacture, materials used in the mummification process, and much more. 544pp. 6¹⁄₈ x 9¼. (Available in U.S. only.) 40446-3

RUSSIAN STORIES/RUSSKIE RASSKAZY: A Dual-Language Book, edited by Gleb Struve. Twelve tales by such masters as Chekhov, Tolstoy, Dostoevsky, Pushkin, others. Excellent word-for-word English translations on facing pages, plus teaching and study aids, Russian/English vocabulary, biographical/critical introductions, more. 416pp. 5⅜ x 8½. 26244-8

PHILADELPHIA THEN AND NOW: 60 Sites Photographed in the Past and Present, Kenneth Finkel and Susan Oyama. Rare photographs of City Hall, Logan Square, Independence Hall, Betsy Ross House, other landmarks juxtaposed with contemporary views. Captures changing face of historic city. Introduction. Captions. 128pp. 8¼ x 11. 25790-8

AIA ARCHITECTURAL GUIDE TO NASSAU AND SUFFOLK COUNTIES, LONG ISLAND, The American Institute of Architects, Long Island Chapter, and the Society for the Preservation of Long Island Antiquities. Comprehensive, well-researched and generously illustrated volume brings to life over three centuries of Long Island's great architectural heritage. More than 240 photographs with authoritative, extensively detailed captions. 176pp. 8¼ x 11. 26946-9

NORTH AMERICAN INDIAN LIFE: Customs and Traditions of 23 Tribes, Elsie Clews Parsons (ed.). 27 fictionalized essays by noted anthropologists examine religion, customs, government, additional facets of life among the Winnebago, Crow, Zuni, Eskimo, other tribes. 480pp. 6⅛ x 9¼. 27377-6

FRANK LLOYD WRIGHT'S DANA HOUSE, Donald Hoffmann. Pictorial essay of residential masterpiece with over 160 interior and exterior photos, plans, elevations, sketches and studies. 128pp. 9¼ x 10¾. 29120-0

THE MALE AND FEMALE FIGURE IN MOTION: 60 Classic Photographic Sequences, Eadweard Muybridge. 60 true-action photographs of men and women walking, running, climbing, bending, turning, etc., reproduced from rare 19th-century masterpiece. vi + 121pp. 9 x 12. 24745-7

1001 QUESTIONS ANSWERED ABOUT THE SEASHORE, N. J. Berrill and Jacquelyn Berrill. Queries answered about dolphins, sea snails, sponges, starfish, fishes, shore birds, many others. Covers appearance, breeding, growth, feeding, much more. 305pp. 5¼ x 8¼. 23366-9

ATTRACTING BIRDS TO YOUR YARD, William J. Weber. Easy-to-follow guide offers advice on how to attract the greatest diversity of birds: birdhouses, feeders, water and waterers, much more. 96pp. 5³⁄₁₆ x 8¼. 28927-3

MEDICINAL AND OTHER USES OF NORTH AMERICAN PLANTS: A Historical Survey with Special Reference to the Eastern Indian Tribes, Charlotte Erichsen-Brown. Chronological historical citations document 500 years of usage of plants, trees, shrubs native to eastern Canada, northeastern U.S. Also complete identifying information. 343 illustrations. 544pp. 6½ x 9¼. 25951-X

STORYBOOK MAZES, Dave Phillips. 23 stories and mazes on two-page spreads: Wizard of Oz, Treasure Island, Robin Hood, etc. Solutions. 64pp. 8¼ x 11. 23628-5

AMERICAN NEGRO SONGS: 230 Folk Songs and Spirituals, Religious and Secular, John W. Work. This authoritative study traces the African influences of songs sung and played by black Americans at work, in church, and as entertainment. The author discusses the lyric significance of such songs as "Swing Low, Sweet Chariot," "John Henry," and others and offers the words and music for 230 songs. Bibliography. Index of Song Titles. 272pp. 6½ x 9¼. 40271-1

MOVIE-STAR PORTRAITS OF THE FORTIES, John Kobal (ed.). 163 glamor, studio photos of 106 stars of the 1940s: Rita Hayworth, Ava Gardner, Marlon Brando, Clark Gable, many more. 176pp. 8⅜ x 11¼. 23546-7

BENCHLEY LOST AND FOUND, Robert Benchley. Finest humor from early 30s, about pet peeves, child psychologists, post office and others. Mostly unavailable elsewhere. 73 illustrations by Peter Arno and others. 183pp. 5⅜ x 8½. 22410-4

YEKL and THE IMPORTED BRIDEGROOM AND OTHER STORIES OF YIDDISH NEW YORK, Abraham Cahan. Film Hester Street based on *Yekl* (1896). Novel, other stories among first about Jewish immigrants on N.Y.'s East Side. 240pp. 5⅜ x 8½. 22427-9

SELECTED POEMS, Walt Whitman. Generous sampling from *Leaves of Grass*. Twenty-four poems include "I Hear America Singing," "Song of the Open Road," "I Sing the Body Electric," "When Lilacs Last in the Dooryard Bloom'd," "O Captain! My Captain!"—all reprinted from an authoritative edition. Lists of titles and first lines. 128pp. 5³⁄₁₆ x 8¼. 26878-0

THE BEST TALES OF HOFFMANN, E. T. A. Hoffmann. 10 of Hoffmann's most important stories: "Nutcracker and the King of Mice," "The Golden Flowerpot," etc. 458pp. 5⅜ x 8½. 21793-0

FROM FETISH TO GOD IN ANCIENT EGYPT, E. A. Wallis Budge. Rich detailed survey of Egyptian conception of "God" and gods, magic, cult of animals, Osiris, more. Also, superb English translations of hymns and legends. 240 illustrations. 545pp. 5⅜ x 8½. 25803-3

FRENCH STORIES/CONTES FRANÇAIS: A Dual-Language Book, Wallace Fowlie. Ten stories by French masters, Voltaire to Camus: "Micromegas" by Voltaire; "The Atheist's Mass" by Balzac; "Minuet" by de Maupassant; "The Guest" by Camus, six more. Excellent English translations on facing pages. Also French-English vocabulary list, exercises, more. 352pp. 5⅜ x 8½. 26443-2

CHICAGO AT THE TURN OF THE CENTURY IN PHOTOGRAPHS: 122 Historic Views from the Collections of the Chicago Historical Society, Larry A. Viskochil. Rare large-format prints offer detailed views of City Hall, State Street, the Loop, Hull House, Union Station, many other landmarks, circa 1904-1913. Introduction. Captions. Maps. 144pp. 9⅜ x 12¼. 24656-6

OLD BROOKLYN IN EARLY PHOTOGRAPHS, 1865-1929, William Lee Younger. Luna Park, Gravesend race track, construction of Grand Army Plaza, moving of Hotel Brighton, etc. 157 previously unpublished photographs. 165pp. 8⅜ x 11¾. 23587-4

THE MYTHS OF THE NORTH AMERICAN INDIANS, Lewis Spence. Rich anthology of the myths and legends of the Algonquins, Iroquois, Pawnees and Sioux, prefaced by an extensive historical and ethnological commentary. 36 illustrations. 480pp. 5⅜ x 8½. 25967-6

AN ENCYCLOPEDIA OF BATTLES: Accounts of Over 1,560 Battles from 1479 B.C. to the Present, David Eggenberger. Essential details of every major battle in recorded history from the first battle of Megiddo in 1479 B.C. to Grenada in 1984. List of Battle Maps. New Appendix covering the years 1967-1984. Index. 99 illustrations. 544pp. 6½ x 9¼. 24913-1

SAILING ALONE AROUND THE WORLD, Captain Joshua Slocum. First man to sail around the world, alone, in small boat. One of great feats of seamanship told in delightful manner. 67 illustrations. 294pp. 5⅜ x 8½. 20326-3

ANARCHISM AND OTHER ESSAYS, Emma Goldman. Powerful, penetrating, prophetic essays on direct action, role of minorities, prison reform, puritan hypocrisy, violence, etc. 271pp. 5⅜ x 8½. 22484-8

MYTHS OF THE HINDUS AND BUDDHISTS, Ananda K. Coomaraswamy and Sister Nivedita. Great stories of the epics; deeds of Krishna, Shiva, taken from puranas, Vedas, folk tales; etc. 32 illustrations. 400pp. 5⅜ x 8½. 21759-0

THE TRAUMA OF BIRTH, Otto Rank. Rank's controversial thesis that anxiety neurosis is caused by profound psychological trauma which occurs at birth. 256pp. 5⅜ x 8½. 27974-X

A THEOLOGICO-POLITICAL TREATISE, Benedict Spinoza. Also contains unfinished Political Treatise. Great classic on religious liberty, theory of government on common consent. R. Elwes translation. Total of 421pp. 5⅜ x 8½. 20249-6

MY BONDAGE AND MY FREEDOM, Frederick Douglass. Born a slave, Douglass became outspoken force in antislavery movement. The best of Douglass' autobiographies. Graphic description of slave life. 464pp. 5⅜ x 8½.　　22457-0

FOLLOWING THE EQUATOR: A Journey Around the World, Mark Twain. Fascinating humorous account of 1897 voyage to Hawaii, Australia, India, New Zealand, etc. Ironic, bemused reports on peoples, customs, climate, flora and fauna, politics, much more. 197 illustrations. 720pp. 5⅜ x 8½.　　26113-1

THE PEOPLE CALLED SHAKERS, Edward D. Andrews. Definitive study of Shakers: origins, beliefs, practices, dances, social organization, furniture and crafts, etc. 33 illustrations. 351pp. 5⅜ x 8½.　　21081-2

THE MYTHS OF GREECE AND ROME, H. A. Guerber. A classic of mythology, generously illustrated, long prized for its simple, graphic, accurate retelling of the principal myths of Greece and Rome, and for its commentary on their origins and significance. With 64 illustrations by Michelangelo, Raphael, Titian, Rubens, Canova, Bernini and others. 480pp. 5⅜ x 8½.　　27584-1

PSYCHOLOGY OF MUSIC, Carl E. Seashore. Classic work discusses music as a medium from psychological viewpoint. Clear treatment of physical acoustics, auditory apparatus, sound perception, development of musical skills, nature of musical feeling, host of other topics. 88 figures. 408pp. 5⅜ x 8½.　　21851-1

THE PHILOSOPHY OF HISTORY, Georg W. Hegel. Great classic of Western thought develops concept that history is not chance but rational process, the evolution of freedom. 457pp. 5⅜ x 8½.　　20112-0

THE BOOK OF TEA, Kakuzo Okakura. Minor classic of the Orient: entertaining, charming explanation, interpretation of traditional Japanese culture in terms of tea ceremony. 94pp. 5⅜ x 8½.　　20070-1

LIFE IN ANCIENT EGYPT, Adolf Erman. Fullest, most thorough, detailed older account with much not in more recent books, domestic life, religion, magic, medicine, commerce, much more. Many illustrations reproduce tomb paintings, carvings, hieroglyphs, etc. 597pp. 5⅜ x 8½.　　22632-8

SUNDIALS, Their Theory and Construction, Albert Waugh. Far and away the best, most thorough coverage of ideas, mathematics concerned, types, construction, adjusting anywhere. Simple, nontechnical treatment allows even children to build several of these dials. Over 100 illustrations. 230pp. 5⅜ x 8½.　　22947-5

THEORETICAL HYDRODYNAMICS, L. M. Milne-Thomson. Classic exposition of the mathematical theory of fluid motion, applicable to both hydrodynamics and aerodynamics. Over 600 exercises. 768pp. 6⅛ x 9¼.　　68970-0

SONGS OF EXPERIENCE: Facsimile Reproduction with 26 Plates in Full Color, William Blake. 26 full-color plates from a rare 1826 edition. Includes "The Tyger," "London," "Holy Thursday," and other poems. Printed text of poems. 48pp. 5¼ x 7.　　24636-1

OLD-TIME VIGNETTES IN FULL COLOR, Carol Belanger Grafton (ed.). Over 390 charming, often sentimental illustrations, selected from archives of Victorian graphics—pretty women posing, children playing, food, flowers, kittens and puppies, smiling cherubs, birds and butterflies, much more. All copyright-free. 48pp. 9¼ x 12¼.　　27269-9

PERSPECTIVE FOR ARTISTS, Rex Vicat Cole. Depth, perspective of sky and sea, shadows, much more, not usually covered. 391 diagrams, 81 reproductions of drawings and paintings. 279pp. 5⅜ x 8½. 22487-2

DRAWING THE LIVING FIGURE, Joseph Sheppard. Innovative approach to artistic anatomy focuses on specifics of surface anatomy, rather than muscles and bones. Over 170 drawings of live models in front, back and side views, and in widely varying poses. Accompanying diagrams. 177 illustrations. Introduction. Index. 144pp. 8⅜ x11¼. 26723-7

GOTHIC AND OLD ENGLISH ALPHABETS: 100 Complete Fonts, Dan X. Solo. Add power, elegance to posters, signs, other graphics with 100 stunning copyright-free alphabets: Blackstone, Dolbey, Germania, 97 more—including many lower-case, numerals, punctuation marks. 104pp. 8⅛ x 11. 24695-7

HOW TO DO BEADWORK, Mary White. Fundamental book on craft from simple projects to five-bead chains and woven works. 106 illustrations. 142pp. 5⅜ x 8. 20697-1

THE BOOK OF WOOD CARVING, Charles Marshall Sayers. Finest book for beginners discusses fundamentals and offers 34 designs. "Absolutely first rate . . . well thought out and well executed."–E. J. Tangerman. 118pp. 7¾ x 10⅝. 23654-4

ILLUSTRATED CATALOG OF CIVIL WAR MILITARY GOODS: Union Army Weapons, Insignia, Uniform Accessories, and Other Equipment, Schuyler, Hartley, and Graham. Rare, profusely illustrated 1846 catalog includes Union Army uniform and dress regulations, arms and ammunition, coats, insignia, flags, swords, rifles, etc. 226 illustrations. 160pp. 9 x 12. 24939-5

WOMEN'S FASHIONS OF THE EARLY 1900s: An Unabridged Republication of "New York Fashions, 1909," National Cloak & Suit Co. Rare catalog of mail-order fashions documents women's and children's clothing styles shortly after the turn of the century. Captions offer full descriptions, prices. Invaluable resource for fashion, costume historians. Approximately 725 illustrations. 128pp. 8⅜ x 11¼. 27276-1

THE 1912 AND 1915 GUSTAV STICKLEY FURNITURE CATALOGS, Gustav Stickley. With over 200 detailed illustrations and descriptions, these two catalogs are essential reading and reference materials and identification guides for Stickley furniture. Captions cite materials, dimensions and prices. 112pp. 6½ x 9¼. 26676-1

EARLY AMERICAN LOCOMOTIVES, John H. White, Jr. Finest locomotive engravings from early 19th century: historical (1804–74), main-line (after 1870), special, foreign, etc. 147 plates. 142pp. 11⅜ x 8¼. 22772-3

THE TALL SHIPS OF TODAY IN PHOTOGRAPHS, Frank O. Braynard. Lavishly illustrated tribute to nearly 100 majestic contemporary sailing vessels: Amerigo Vespucci, Clearwater, Constitution, Eagle, Mayflower, Sea Cloud, Victory, many more. Authoritative captions provide statistics, background on each ship. 190 black-and-white photographs and illustrations. Introduction. 128pp. 8⅞ x 11¾. 27163-3

LITTLE BOOK OF EARLY AMERICAN CRAFTS AND TRADES, Peter Stockham (ed.). 1807 children's book explains crafts and trades: baker, hatter, cooper, potter, and many others. 23 copperplate illustrations. 140pp. 4⅝ x 6. 23336-7

VICTORIAN FASHIONS AND COSTUMES FROM HARPER'S BAZAR, 1867–1898, Stella Blum (ed.). Day costumes, evening wear, sports clothes, shoes, hats, other accessories in over 1,000 detailed engravings. 320pp. 9⅜ x 12¼. 22990-4

GUSTAV STICKLEY, THE CRAFTSMAN, Mary Ann Smith. Superb study surveys broad scope of Stickley's achievement, especially in architecture. Design philosophy, rise and fall of the Craftsman empire, descriptions and floor plans for many Craftsman houses, more. 86 black-and-white halftones. 31 line illustrations. Introduction 208pp. 6½ x 9¼. 27210-9

THE LONG ISLAND RAIL ROAD IN EARLY PHOTOGRAPHS, Ron Ziel. Over 220 rare photos, informative text document origin (1844) and development of rail service on Long Island. Vintage views of early trains, locomotives, stations, passengers, crews, much more. Captions. 8⅞ x 11¾. 26301-0

VOYAGE OF THE LIBERDADE, Joshua Slocum. Great 19th-century mariner's thrilling, first-hand account of the wreck of his ship off South America, the 35-foot boat he built from the wreckage, and its remarkable voyage home. 128pp. 5⅜ x 8½.
40022-0

TEN BOOKS ON ARCHITECTURE, Vitruvius. The most important book ever written on architecture. Early Roman aesthetics, technology, classical orders, site selection, all other aspects. Morgan translation. 331pp. 5⅜ x 8½. 20645-9

THE HUMAN FIGURE IN MOTION, Eadweard Muybridge. More than 4,500 stopped-action photos, in action series, showing undraped men, women, children jumping, lying down, throwing, sitting, wrestling, carrying, etc. 390pp. 7⅞ x 10⅝.
20204-6 Clothbd.

TREES OF THE EASTERN AND CENTRAL UNITED STATES AND CANADA, William M. Harlow. Best one-volume guide to 140 trees. Full descriptions, woodlore, range, etc. Over 600 illustrations. Handy size. 288pp. 4½ x 6⅜. 20395-6

SONGS OF WESTERN BIRDS, Dr. Donald J. Borror. Complete song and call repertoire of 60 western species, including flycatchers, juncoes, cactus wrens, many more–includes fully illustrated booklet. Cassette and manual 99913-0

GROWING AND USING HERBS AND SPICES, Milo Miloradovich. Versatile handbook provides all the information needed for cultivation and use of all the herbs and spices available in North America. 4 illustrations. Index. Glossary. 236pp. 5⅜ x 8½.
25058-X

BIG BOOK OF MAZES AND LABYRINTHS, Walter Shepherd. 50 mazes and labyrinths in all–classical, solid, ripple, and more–in one great volume. Perfect inexpensive puzzler for clever youngsters. Full solutions. 112pp. 8⅛ x 11. 22951-3

PIANO TUNING, J. Cree Fischer. Clearest, best book for beginner, amateur. Simple repairs, raising dropped notes, tuning by easy method of flattened fifths. No previous skills needed. 4 illustrations. 201pp. 5⅜ x 8½. 23267-0

HINTS TO SINGERS, Lillian Nordica. Selecting the right teacher, developing confidence, overcoming stage fright, and many other important skills receive thoughtful discussion in this indispensible guide, written by a world-famous diva of four decades' experience. 96pp. 5⅜ x 8½. 40094-8

THE COMPLETE NONSENSE OF EDWARD LEAR, Edward Lear. All nonsense limericks, zany alphabets, Owl and Pussycat, songs, nonsense botany, etc., illustrated by Lear. Total of 320pp. 5⅜ x 8½. (Available in U.S. only.) 20167-8

VICTORIAN PARLOUR POETRY: An Annotated Anthology, Michael R. Turner. 117 gems by Longfellow, Tennyson, Browning, many lesser-known poets. "The Village Blacksmith," "Curfew Must Not Ring Tonight," "Only a Baby Small," dozens more, often difficult to find elsewhere. Index of poets, titles, first lines. xxiii + 325pp. 5⅜ x 8¼. 27044-0

DUBLINERS, James Joyce. Fifteen stories offer vivid, tightly focused observations of the lives of Dublin's poorer classes. At least one, "The Dead," is considered a masterpiece. Reprinted complete and unabridged from standard edition. 160pp. 5³⁄₁₆ x 8¼. 26870-5

GREAT WEIRD TALES: 14 Stories by Lovecraft, Blackwood, Machen and Others, S. T. Joshi (ed.). 14 spellbinding tales, including "The Sin Eater," by Fiona McLeod, "The Eye Above the Mantel," by Frank Belknap Long, as well as renowned works by R. H. Barlow, Lord Dunsany, Arthur Machen, W. C. Morrow and eight other masters of the genre. 256pp. 5⅜ x 8½. (Available in U.S. only.) 40436-6

THE BOOK OF THE SACRED MAGIC OF ABRAMELIN THE MAGE, translated by S. MacGregor Mathers. Medieval manuscript of ceremonial magic. Basic document in Aleister Crowley, Golden Dawn groups. 268pp. 5⅜ x 8½. 23211-5

NEW RUSSIAN-ENGLISH AND ENGLISH-RUSSIAN DICTIONARY, M. A. O'Brien. This is a remarkably handy Russian dictionary, containing a surprising amount of information, including over 70,000 entries. 366pp. 4½ x 6⅛. 20208-9

HISTORIC HOMES OF THE AMERICAN PRESIDENTS, Second, Revised Edition, Irvin Haas. A traveler's guide to American Presidential homes, most open to the public, depicting and describing homes occupied by every American President from George Washington to George Bush. With visiting hours, admission charges, travel routes. 175 photographs. Index. 160pp. 8¼ x 11. 26751-2

NEW YORK IN THE FORTIES, Andreas Feininger. 162 brilliant photographs by the well-known photographer, formerly with *Life* magazine. Commuters, shoppers, Times Square at night, much else from city at its peak. Captions by John von Hartz. 181pp. 9¼ x 10¾. 23585-8

INDIAN SIGN LANGUAGE, William Tomkins. Over 525 signs developed by Sioux and other tribes. Written instructions and diagrams. Also 290 pictographs. 111pp. 6⅛ x 9¼. 22029-X

ANATOMY: A Complete Guide for Artists, Joseph Sheppard. A master of figure drawing shows artists how to render human anatomy convincingly. Over 460 illustrations. 224pp. 8⅜ x 11¼. 27279-6

MEDIEVAL CALLIGRAPHY: Its History and Technique, Marc Drogin. Spirited history, comprehensive instruction manual covers 13 styles (ca. 4th century through 15th). Excellent photographs; directions for duplicating medieval techniques with modern tools. 224pp. 8⅜ x 11¼. 26142-5

DRIED FLOWERS: How to Prepare Them, Sarah Whitlock and Martha Rankin. Complete instructions on how to use silica gel, meal and borax, perlite aggregate, sand and borax, glycerine and water to create attractive permanent flower arrangements. 12 illustrations. 32pp. 5⅜ x 8½. 21802-3

EASY-TO-MAKE BIRD FEEDERS FOR WOODWORKERS, Scott D. Campbell. Detailed, simple-to-use guide for designing, constructing, caring for and using feeders. Text, illustrations for 12 classic and contemporary designs. 96pp. 5⅜ x 8½. 25847-5

SCOTTISH WONDER TALES FROM MYTH AND LEGEND, Donald A. Mackenzie. 16 lively tales tell of giants rumbling down mountainsides, of a magic wand that turns stone pillars into warriors, of gods and goddesses, evil hags, powerful forces and more. 240pp. 5⅜ x 8½. 29677-6

THE HISTORY OF UNDERCLOTHES, C. Willett Cunnington and Phyllis Cunnington. Fascinating, well-documented survey covering six centuries of English undergarments, enhanced with over 100 illustrations: 12th-century laced-up bodice, footed long drawers (1795), 19th-century bustles, 19th-century corsets for men, Victorian "bust improvers," much more. 272pp. 5⅜ x 8¼. 27124-2

ARTS AND CRAFTS FURNITURE: The Complete Brooks Catalog of 1912, Brooks Manufacturing Co. Photos and detailed descriptions of more than 150 now very collectible furniture designs from the Arts and Crafts movement depict davenports, settees, buffets, desks, tables, chairs, bedsteads, dressers and more, all built of solid, quarter-sawed oak. Invaluable for students and enthusiasts of antiques, Americana and the decorative arts. 80pp. 6½ x 9¼. 27471-3

WILBUR AND ORVILLE: A Biography of the Wright Brothers, Fred Howard. Definitive, crisply written study tells the full story of the brothers' lives and work. A vividly written biography, unparalleled in scope and color, that also captures the spirit of an extraordinary era. 560pp. 6⅛ x 9¼. 40297-5

THE ARTS OF THE SAILOR: Knotting, Splicing and Ropework, Hervey Garrett Smith. Indispensable shipboard reference covers tools, basic knots and useful hitches; handsewing and canvas work, more. Over 100 illustrations. Delightful reading for sea lovers. 256pp. 5⅜ x 8½. 26440-8

FRANK LLOYD WRIGHT'S FALLINGWATER: The House and Its History, Second, Revised Edition, Donald Hoffmann. A total revision—both in text and illustrations—of the standard document on Fallingwater, the boldest, most personal architectural statement of Wright's mature years, updated with valuable new material from the recently opened Frank Lloyd Wright Archives. "Fascinating"–*The New York Times*. 116 illustrations. 128pp. 9¼ x 10¾. 27430-6

PHOTOGRAPHIC SKETCHBOOK OF THE CIVIL WAR, Alexander Gardner. 100 photos taken on field during the Civil War. Famous shots of Manassas Harper's Ferry, Lincoln, Richmond, slave pens, etc. 244pp. 10⅝ x 8¼. 22731-6

FIVE ACRES AND INDEPENDENCE, Maurice G. Kains. Great back-to-the-land classic explains basics of self-sufficient farming. The one book to get. 95 illustrations. 397pp. 5⅜ x 8½. 20974-1

SONGS OF EASTERN BIRDS, Dr. Donald J. Borror. Songs and calls of 60 species most common to eastern U.S.: warblers, woodpeckers, flycatchers, thrushes, larks, many more in high-quality recording. Cassette and manual 99912-2

A MODERN HERBAL, Margaret Grieve. Much the fullest, most exact, most useful compilation of herbal material. Gigantic alphabetical encyclopedia, from aconite to zedoary, gives botanical information, medical properties, folklore, economic uses, much else. Indispensable to serious reader. 161 illustrations. 888pp. 6½ x 9¼. 2-vol. set. (Available in U.S. only.) Vol. I: 22798-7
Vol. II: 22799-5

HIDDEN TREASURE MAZE BOOK, Dave Phillips. Solve 34 challenging mazes accompanied by heroic tales of adventure. Evil dragons, people-eating plants, blood-thirsty giants, many more dangerous adversaries lurk at every twist and turn. 34 mazes, stories, solutions. 48pp. 8¼ x 11. 24566-7

LETTERS OF W. A. MOZART, Wolfgang A. Mozart. Remarkable letters show bawdy wit, humor, imagination, musical insights, contemporary musical world; includes some letters from Leopold Mozart. 276pp. 5⅜ x 8½. 22859-2

BASIC PRINCIPLES OF CLASSICAL BALLET, Agrippina Vaganova. Great Russian theoretician, teacher explains methods for teaching classical ballet. 118 illustrations. 175pp. 5⅜ x 8½. 22036-2

THE JUMPING FROG, Mark Twain. Revenge edition. The original story of The Celebrated Jumping Frog of Calaveras County, a hapless French translation, and Twain's hilarious "retranslation" from the French. 12 illustrations. 66pp. 5⅜ x 8½.
22686-7

BEST REMEMBERED POEMS, Martin Gardner (ed.). The 126 poems in this superb collection of 19th- and 20th-century British and American verse range from Shelley's "To a Skylark" to the impassioned "Renascence" of Edna St. Vincent Millay and to Edward Lear's whimsical "The Owl and the Pussycat." 224pp. 5⅜ x 8½.
27165-X

COMPLETE SONNETS, William Shakespeare. Over 150 exquisite poems deal with love, friendship, the tyranny of time, beauty's evanescence, death and other themes in language of remarkable power, precision and beauty. Glossary of archaic terms. 80pp. 5³⁄₁₆ x 8¼. 26686-9

THE BATTLES THAT CHANGED HISTORY, Fletcher Pratt. Eminent historian profiles 16 crucial conflicts, ancient to modern, that changed the course of civilization. 352pp. 5⅜ x 8½. 41129-X

THE WIT AND HUMOR OF OSCAR WILDE, Alvin Redman (ed.). More than 1,000 ripostes, paradoxes, wisecracks: Work is the curse of the drinking classes; I can resist everything except temptation; etc. 258pp. 5⅜ x 8½. 20602-5

SHAKESPEARE LEXICON AND QUOTATION DICTIONARY, Alexander Schmidt. Full definitions, locations, shades of meaning in every word in plays and poems. More than 50,000 exact quotations. 1,485pp. 6½ x 9¼. 2-vol. set.
Vol. 1: 22726-X
Vol. 2: 22727-8

SELECTED POEMS, Emily Dickinson. Over 100 best-known, best-loved poems by one of America's foremost poets, reprinted from authoritative early editions. No comparable edition at this price. Index of first lines. 64pp. 5³⁄₁₆ x 8¼. 26466-1

THE INSIDIOUS DR. FU-MANCHU, Sax Rohmer. The first of the popular mystery series introduces a pair of English detectives to their archnemesis, the diabolical Dr. Fu-Manchu. Flavorful atmosphere, fast-paced action, and colorful characters enliven this classic of the genre. 208pp. 5³⁄₁₆ x 8¼. 29898-1

THE MALLEUS MALEFICARUM OF KRAMER AND SPRENGER, translated by Montague Summers. Full text of most important witchhunter's "bible," used by both Catholics and Protestants. 278pp. 6⅝ x 10. 22802-9

SPANISH STORIES/CUENTOS ESPAÑOLES: A Dual-Language Book, Angel Flores (ed.). Unique format offers 13 great stories in Spanish by Cervantes, Borges, others. Faithful English translations on facing pages. 352pp. 5⅜ x 8½. 25399-6

GARDEN CITY, LONG ISLAND, IN EARLY PHOTOGRAPHS, 1869–1919, Mildred H. Smith. Handsome treasury of 118 vintage pictures, accompanied by carefully researched captions, document the Garden City Hotel fire (1899), the Vanderbilt Cup Race (1908), the first airmail flight departing from the Nassau Boulevard Aerodrome (1911), and much more. 96pp. 8⅞ x 11¾. 40669-5

OLD QUEENS, N.Y., IN EARLY PHOTOGRAPHS, Vincent F. Seyfried and William Asadorian. Over 160 rare photographs of Maspeth, Jamaica, Jackson Heights, and other areas. Vintage views of DeWitt Clinton mansion, 1939 World's Fair and more. Captions. 192pp. 8⅞ x 11. 26358-4

CAPTURED BY THE INDIANS: 15 Firsthand Accounts, 1750-1870, Frederick Drimmer. Astounding true historical accounts of grisly torture, bloody conflicts, relentless pursuits, miraculous escapes and more, by people who lived to tell the tale. 384pp. 5⅜ x 8½. 24901-8

THE WORLD'S GREAT SPEECHES (Fourth Enlarged Edition), Lewis Copeland, Lawrence W. Lamm, and Stephen J. McKenna. Nearly 300 speeches provide public speakers with a wealth of updated quotes and inspiration–from Pericles' funeral oration and William Jennings Bryan's "Cross of Gold Speech" to Malcolm X's powerful words on the Black Revolution and Earl of Spenser's tribute to his sister, Diana, Princess of Wales. 944pp. 5⅜ x 8⅜. 40903-1

THE BOOK OF THE SWORD, Sir Richard F. Burton. Great Victorian scholar/adventurer's eloquent, erudite history of the "queen of weapons"–from prehistory to early Roman Empire. Evolution and development of early swords, variations (sabre, broadsword, cutlass, scimitar, etc.), much more. 336pp. 6⅛ x 9¼. 25434-8

AUTOBIOGRAPHY: The Story of My Experiments with Truth, Mohandas K. Gandhi. Boyhood, legal studies, purification, the growth of the Satyagraha (nonviolent protest) movement. Critical, inspiring work of the man responsible for the freedom of India. 480pp. 5⅜ x 8½. (Available in U.S. only.) 24593-4

CELTIC MYTHS AND LEGENDS, T. W. Rolleston. Masterful retelling of Irish and Welsh stories and tales. Cuchulain, King Arthur, Deirdre, the Grail, many more. First paperback edition. 58 full-page illustrations. 512pp. 5⅜ x 8½. 26507-2

THE PRINCIPLES OF PSYCHOLOGY, William James. Famous long course complete, unabridged. Stream of thought, time perception, memory, experimental methods; great work decades ahead of its time. 94 figures. 1,391pp. 5⅜ x 8½. 2-vol. set.
Vol. I: 20381-6 Vol. II: 20382-4

THE WORLD AS WILL AND REPRESENTATION, Arthur Schopenhauer. Definitive English translation of Schopenhauer's life work, correcting more than 1,000 errors, omissions in earlier translations. Translated by E. F. J. Payne. Total of 1,269pp. 5⅜ x 8½. 2-vol. set. Vol. 1: 21761-2 Vol. 2: 21762-0

MAGIC AND MYSTERY IN TIBET, Madame Alexandra David-Neel. Experiences among lamas, magicians, sages, sorcerers, Bonpa wizards. A true psychic discovery. 32 illustrations. 321pp. 5⅜ x 8½. (Available in U.S. only.) 22682-4

THE EGYPTIAN BOOK OF THE DEAD, E. A. Wallis Budge. Complete reproduction of Ani's papyrus, finest ever found. Full hieroglyphic text, interlinear transliteration, word-for-word translation, smooth translation. 533pp. 6½ x 9¼. 21866-X

MATHEMATICS FOR THE NONMATHEMATICIAN, Morris Kline. Detailed, college-level treatment of mathematics in cultural and historical context, with numerous exercises. Recommended Reading Lists. Tables. Numerous figures. 641pp. 5⅜ x 8½.
24823-2

PROBABILISTIC METHODS IN THE THEORY OF STRUCTURES, Isaac Elishakoff. Well-written introduction covers the elements of the theory of probability from two or more random variables, the reliability of such multivariable structures, the theory of random function, Monte Carlo methods of treating problems incapable of exact solution, and more. Examples. 502pp. 5⅜ x 8½. 40691-1

THE RIME OF THE ANCIENT MARINER, Gustave Doré, S. T. Coleridge. Doré's finest work; 34 plates capture moods, subtleties of poem. Flawless full-size reproductions printed on facing pages with authoritative text of poem. "Beautiful. Simply beautiful."–*Publisher's Weekly.* 77pp. 9¼ x 12. 22305-1

NORTH AMERICAN INDIAN DESIGNS FOR ARTISTS AND CRAFTSPEOPLE, Eva Wilson. Over 360 authentic copyright-free designs adapted from Navajo blankets, Hopi pottery, Sioux buffalo hides, more. Geometrics, symbolic figures, plant and animal motifs, etc. 128pp. 8⅜ x 11. (Not for sale in the United Kingdom.) 25341-4

SCULPTURE: Principles and Practice, Louis Slobodkin. Step-by-step approach to clay, plaster, metals, stone; classical and modern. 253 drawings, photos. 255pp. 8⅜ x 11.
22960-2

THE INFLUENCE OF SEA POWER UPON HISTORY, 1660–1783, A. T. Mahan. Influential classic of naval history and tactics still used as text in war colleges. First paperback edition. 4 maps. 24 battle plans. 640pp. 5⅜ x 8½. 25509-3

THE STORY OF THE TITANIC AS TOLD BY ITS SURVIVORS, Jack Winocour (ed.). What it was really like. Panic, despair, shocking inefficiency, and a little heroism. More thrilling than any fictional account. 26 illustrations. 320pp. 5⅜ x 8½.
20610-6

FAIRY AND FOLK TALES OF THE IRISH PEASANTRY, William Butler Yeats (ed.). Treasury of 64 tales from the twilight world of Celtic myth and legend: "The Soul Cages," "The Kildare Pooka," "King O'Toole and his Goose," many more. Introduction and Notes by W. B. Yeats. 352pp. 5⅜ x 8½.
26941-8

BUDDHIST MAHAYANA TEXTS, E. B. Cowell and others (eds.). Superb, accurate translations of basic documents in Mahayana Buddhism, highly important in history of religions. The Buddha-karita of Asvaghosha, Larger Sukhavativyuha, more. 448pp. 5⅜ x 8½.
25552-2

ONE TWO THREE . . . INFINITY: Facts and Speculations of Science, George Gamow. Great physicist's fascinating, readable overview of contemporary science: number theory, relativity, fourth dimension, entropy, genes, atomic structure, much more. 128 illustrations. Index. 352pp. 5⅜ x 8½.
25664-2

EXPERIMENTATION AND MEASUREMENT, W. J. Youden. Introductory manual explains laws of measurement in simple terms and offers tips for achieving accuracy and minimizing errors. Mathematics of measurement, use of instruments, experimenting with machines. 1994 edition. Foreword. Preface. Introduction. Epilogue. Selected Readings. Glossary. Index. Tables and figures. 128pp. 5⅜ x 8½.
40451-X

DALÍ ON MODERN ART: The Cuckolds of Antiquated Modern Art, Salvador Dalí. Influential painter skewers modern art and its practitioners. Outrageous evaluations of Picasso, Cézanne, Turner, more. 15 renderings of paintings discussed. 44 calligraphic decorations by Dalí. 96pp. 5⅜ x 8½. (Available in U.S. only.)
29220-7

ANTIQUE PLAYING CARDS: A Pictorial History, Henry René D'Allemagne. Over 900 elaborate, decorative images from rare playing cards (14th–20th centuries): Bacchus, death, dancing dogs, hunting scenes, royal coats of arms, players cheating, much more. 96pp. 9¼ x 12¼.
29265-7

MAKING FURNITURE MASTERPIECES: 30 Projects with Measured Drawings, Franklin H. Gottshall. Step-by-step instructions, illustrations for constructing handsome, useful pieces, among them a Sheraton desk, Chippendale chair, Spanish desk, Queen Anne table and a William and Mary dressing mirror. 224pp. 8⅛ x 11¼.
29338-6

THE FOSSIL BOOK: A Record of Prehistoric Life, Patricia V. Rich et al. Profusely illustrated definitive guide covers everything from single-celled organisms and dinosaurs to birds and mammals and the interplay between climate and man. Over 1,500 illustrations. 760pp. 7½ x 10⅛.
29371-8

Paperbound unless otherwise indicated. Available at your book dealer, online at **www.doverpublications.com**, or by writing to Dept. GI, Dover Publications, Inc., 31 East 2nd Street, Mineola, NY 11501. For current price information or for free catalogues (please indicate field of interest), write to Dover Publications or log on to **www.doverpublications.com** and see every Dover book in print. Dover publishes more than 500 books each year on science, elementary and advanced mathematics, biology, music, art, literary history, social sciences, and other areas.